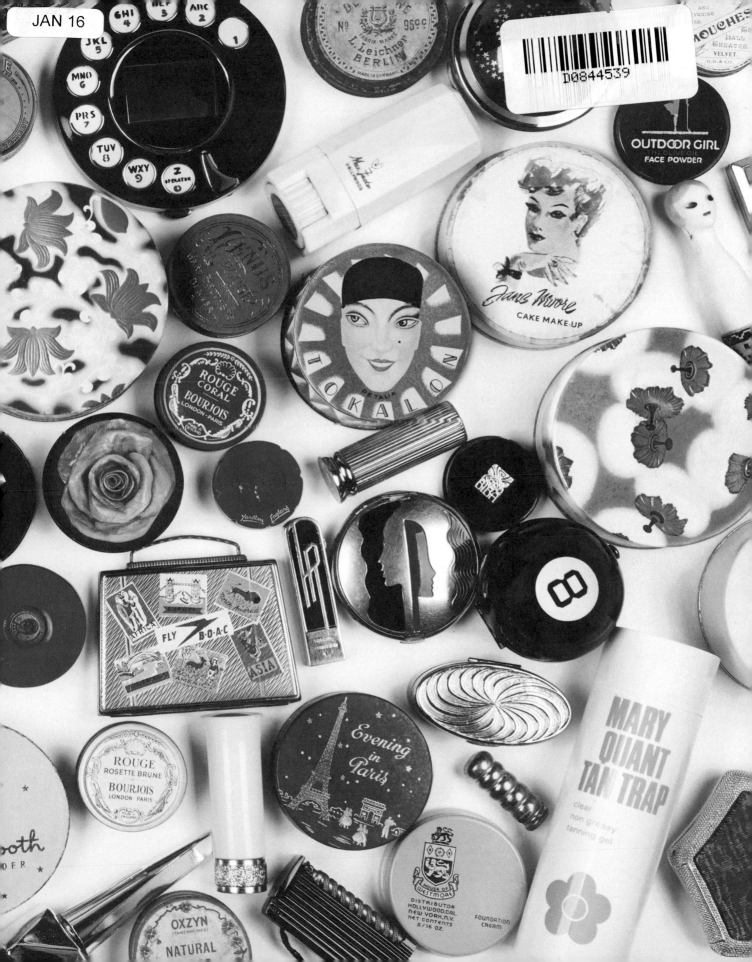

FACE PAINT

FACE PAINT

THE STORY OF MAKEUP

Lisa Eldridge

Abrams Image, New York

Editor: David Cashion
Designers: Robin Derrick with Danielle Young
Production Manager: True Sims

Library of Congress Control Number: 2014959338

ISBN: 978-1-4197-1796-3

Printed and bound in the United States
10 9 8 7 6 5 4

Abrams Image books are available at special discounts when
purchased in quantity for premiums and promotions as
well as fundraising or educational use. Special editions can
also be created to specification. For details, contact
specialsales@abramsbooks.com or the address below.

THE ART OF BOOKS SINCE 1949
115 West 18th Street
New York, NY 10011
www.abramsbooks.com

To my mother,
whose makeup got me into all of this in the first place

Contents

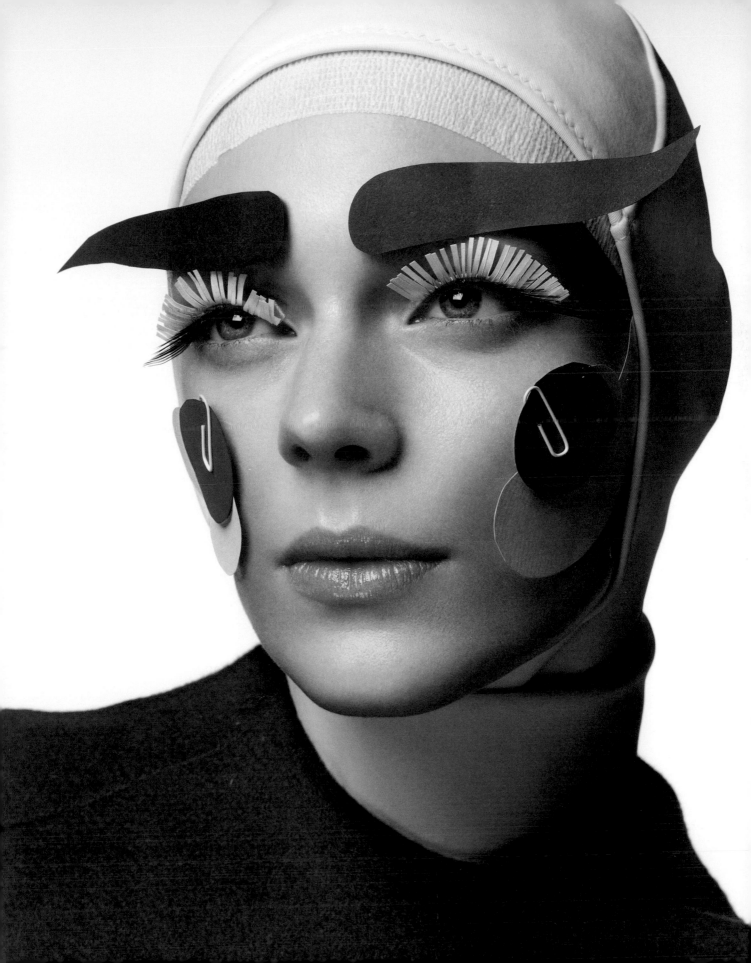

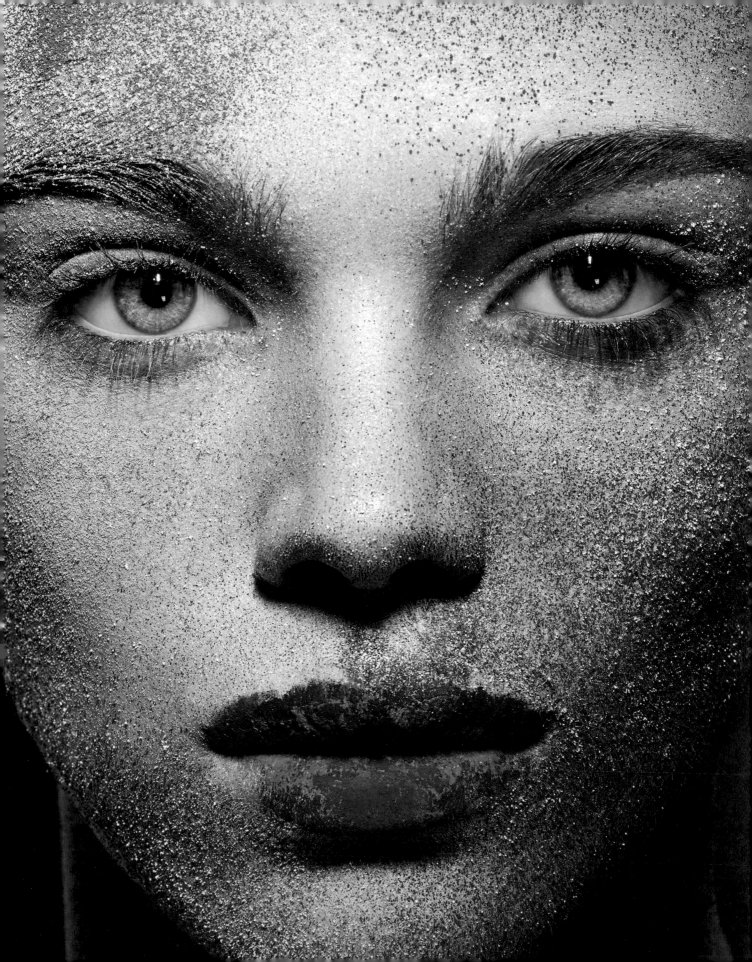

Introduction

Although we have been painting ourselves in a variety of ways for thousands of years, the reasons why—and how—we wear makeup in the twenty-first century have changed dramatically. Now when we put on our makeup, we have literally hundreds of trends and styles to choose from. There's a full spectrum of color and a multitude of affordable (and not so affordable) products at our fingertips—with the freedom to use these products as we want, without censure—something that was not the case until fairly recent times. But to really understand how painting our face has evolved into a fine art, we need to look back and track our ever-evolving relationship with makeup, tracing the journey that has led to beauty becoming the multibillion-dollar industry it is today.

I have been fascinated by makeup since I was a child—initially captivated more by the colors, smells, sense of history, and objects themselves, than the desire to apply it. But when I was thirteen, I decided I wanted to be a makeup artist after a family friend gave me a book about theatrical makeup for my birthday, and ever since then, face paint from the past, present, and future has been my life. I started collecting vintage items like powder boxes and antique pots of blush in the early 1990s and I'll never forget the rush of excitement discovering my first vintage makeup finds at a stall in the Portobello Road Market in London.

We've been altering our skin with paints and oils and dabbling in artistry since the Ice Age.

Makeup was ablaze with color.

I still get a thrill when I'm able to add new rarities to my collection. For the past twenty years, I've been painting the faces of models and celebrities for glossy magazines, advertising campaigns, and runway shows all over the world; in addition to making TV shows and videos demonstrating to regular women how they can translate the professional techniques and trends I've mastered to their own faces. I have also worked for many years as the creative director for some of the world's biggest cosmetic brands: including Shiseido, Boots No7, and, most recently, Lancôme. Through working with these international brands I've been able to learn how makeup is made, marketed, and sold, and understand fully the ways in which perceptions of beauty differ throughout the world. The production of makeup is something that has captivated me in a way that I never believed it would (I wasn't exactly the best chemistry student at school). I have embraced the science and technology involved in the future of makeup with as much vigor as my fascination with its history. What started with a love of the colors and objects themselves, and progressed with an education into how it's made, has now come full circle with this book.

The most difficult thing about researching and writing this book has been deciding what to leave out. There were enough intriguing stories, quirky anecdotes, and riveting research to fill a volume ten times this size, but, in the end, I had to choose the elements that I thought were the most interesting; I hope you agree. In terms of the structure, I've chosen to organize it thematically rather than chronologically; partly because I found it more interesting that way, but also because, like so often in history, things overlap, repeat, and develop in an organic, not-always-linear way. I've also had to be disciplined in sticking to the subject at hand. The history of makeup is intrinsically linked with the development of perfume, skincare, and hair care but these subjects are so huge in their own right that I only could touch upon them when absolutely necessary. I've dotted my personal "Makeup Muses" throughout the book. These women not only changed ideas of what a woman could be, but redefined how a woman could look. Trailblazing, rule-breakers, all; these women have inspired many of the looks we wear today.

This is a passion project and a story that I believe deserves to be told. My ultimate dream is that anyone who reads this book will never look at their makeup bag in the same way again and might even look at the history of women from a new perspective.

The natural world provided everything needed for the ancient makeup bag.

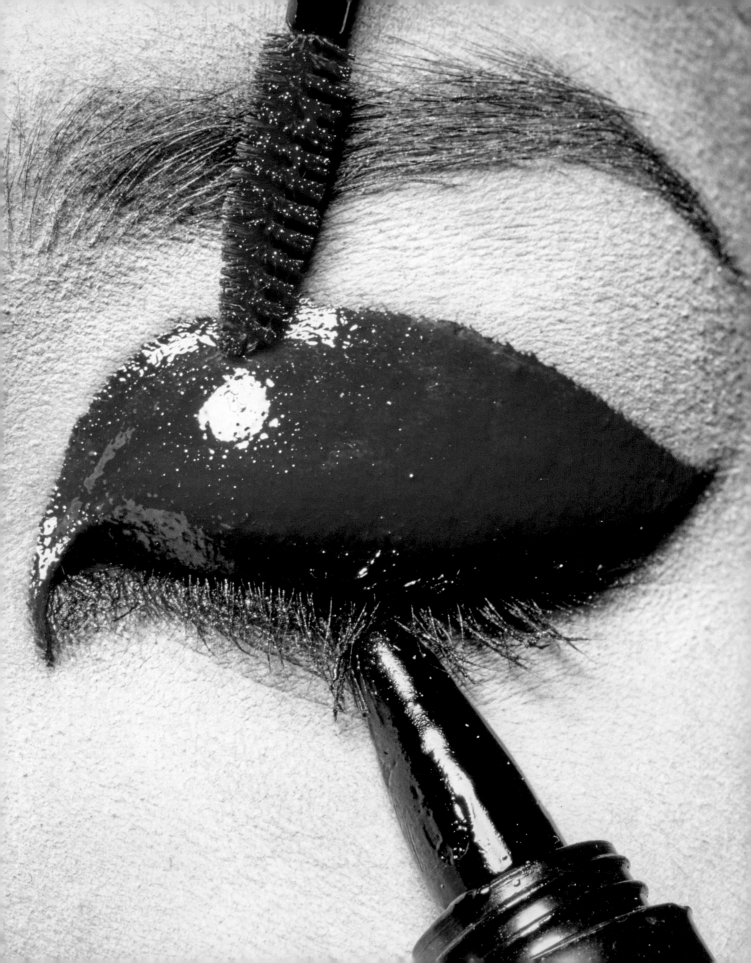

PROLOGUE

The Painted Face

The modern definition of cosmetics, according to the US Food and Drug Administration, covers anything that is "rubbed, poured, sprinkled, or sprayed on, introduced into, or otherwise applied to the human body . . . for cleansing, beautifying, promoting attractiveness, or altering the appearance."[1] Going by this definition, we've been altering our skin with paints and oils and dabbling in artistry and artifice since the Ice Age. But what drives our desire to paint ourselves?

Anthropologists believe that the very first instances of face and body painting would have been a form of protection from the elements or used as camouflage or as part of a ritual. Large quantities of red ochre (a pigment that takes its reddish color from the mineral hematite) discovered in excavations of South African caves are estimated to date back 100 to 125,000 years ago. The fact that there are no cave paintings or decorated artifacts at these sites has led archaeologists to believe that the ochre was used to paint the face and body—"prehistoric cosmetics," as Steven Mithen, professor of archaeology and anthropology at Reading University, describes them. We know that paint was also used to instill tribal allegiance and to scare the opposition (a good example of this is the ancient Britons, who painted their faces blue with dye produced from the leaves of the woad plant

Painting our faces is as much a part of human nature as the need to eat and sleep.
Photograph by Irving Penn, © Condé Nast. *Vogue*, November 1994.

"A good painter needs only three colors: black, white, and red."

–Titian

before going into battle). Over time, decorative face painting became associated with beautification, social status, and preserving youthfulness, and from the eighteenth century onward, more closely linked to fashion.

Whatever the motivation to wear it may have been, makeup in antiquity was ablaze with color—an explosion of pigments, paints, powders, and pastes matching modern-day palettes in vibrancy, if not in other aspects. Makeup wasn't something you could just pop out and buy on a whim: It had to be carefully prepared from often complex recipes. It's hard to imagine today, but only in the past hundred years or so have we begun to develop and use cosmetics outside the basic ancient palette of red, green, black, yellow, blue, and white. The natural world provided everything needed for the ancient makeup bag. Ingredients like chalk, manganese dioxide, carbon, lapis lazuli, copper ore, and red and yellow ochre

were used to adorn and embellish in every corner of the globe—from the Aboriginals and tribes of Papua New Guinea to the earliest civilizations of Mesopotamia and Egypt—suggesting that painting our faces is as much a part of human nature as the need to eat and sleep. In this book, I uncover the earliest cosmetics, and, in doing so, discover the origins of modern makeup and reveal how much the cosmetics we use today owe to the paints and pigments of the past.

The history of makeup is an enormous, unwieldy topic covering thousands of years, and there is a huge amount that we can only guess at. We're lucky that archaeological discoveries, along with references in art and literature, have allowed us to piece together a good understanding of makeup practices throughout history: what colors of face paint were available and popular, how they were made, and, crucially, what was thought and said about women who painted their faces.

The cosmetics of today owe a lot to the paints and pigments of the past.

The Ancient Palette

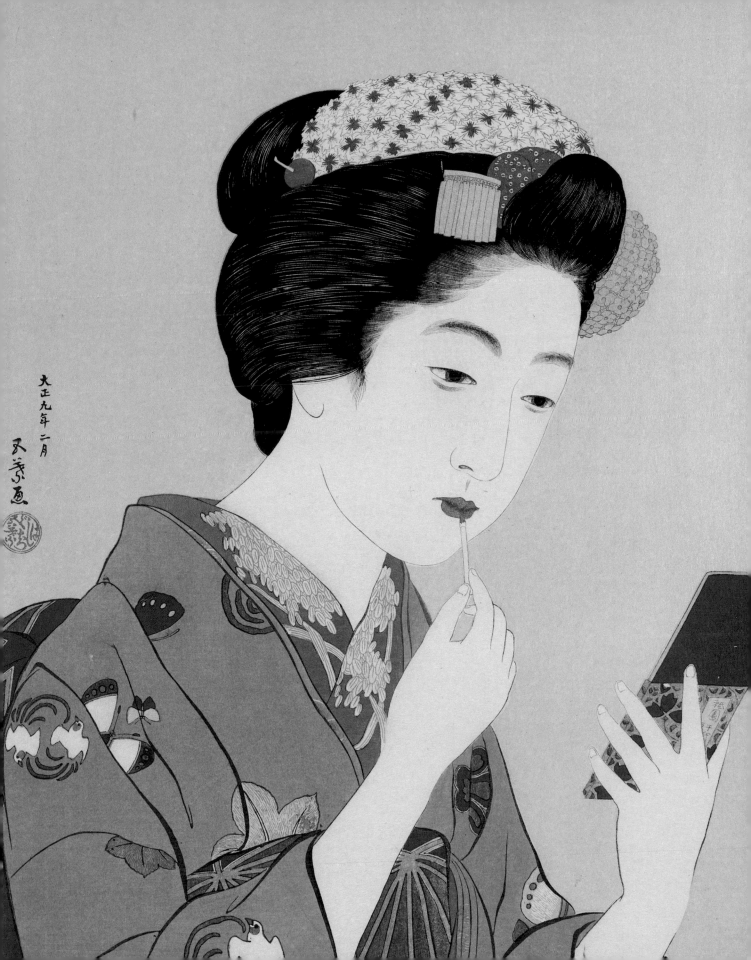

Red

BEAUTY'S MOST ENDURING SHADE

Rouge is the longest-standing makeup item in existence and the most multipurposed, having been used to color lips and cheeks for thousands of years. Although the extent to which rouge has been used varies throughout history, depending on the fashion and social perception of makeup during the time in question, the power of red has rarely waned. These days rouge is available in a huge number of guises, from traditional powder blush to liquid stains, lipstick and lip gloss, and creams and gels for lips and cheeks. But why is it the most popular and enduring item in our makeup kit? And what has driven generations of women around the world to color their faces with rosy hues?

Perhaps it's best to begin with the color itself, and the wealth of associations it brings with it. Though its meaning differs from culture to culture, red is invariably associated with desirability, love, passion, youth, and health. In Eastern cultures, red is generally seen as a symbol of happiness, which is why brides in China, India, and Vietnam traditionally wear red for their weddings, and it also has theatrical associations, featuring prominently in the makeup worn in Chinese opera and Japanese Kabuki. Obviously, it has other very different connotations, too—it's the color of blood, danger, and revolution, and has political affiliations with the Far Left. If we think purely in terms of makeup and what it is meant to

Painting on a red mouth has the uncanny knack of seeming to belong to antiquity and tradition whilst simultaneously appearing decidedly modern and daring.

achieve, then the point of rouge is to add a flush of color to the skin. So it's clear that one reason for its appeal, as evolutionary psychologist Nancy Etcoff points out, is purely biological: "Blush on the cheeks and red on the lips are sexual signals mimicking youth, nulliparity [not having given birth] . . . and the vigor of health."[1] Another scientific reason behind the age-old appeal of red is the fact that it has the longest wavelength of any color perceived by humans, meaning that it stimulates a stronger subconscious response in us than any other shade.[2] Think about walking into a red room and the effect it has upon you, or how shades of red immediately draw your eye. Etcoff again summarizes it neatly: "Red, the color of blood, of blushes and flushes, of nipples, lips, and genitals awash with sexual excitement, is visible from afar and emotionally arousing."[3]

The earliest rouge would have been sticks of red ochre pigment made by mixing iron oxides with animal fat or vegetable oil. These types of sticks would not have been dissimilar in shape and size to the chunky eye-shadow sticks you can find in many brands today. Until the nineteenth century, when it became available to purchase from pharmacies, rouge was handmade from a variety of substances, creating a wide range of tones and textures. Cochineal and kermes, types of insects, were dried and used to produce carmine pigment, a blood-red tint; although extremely poisonous, minerals such as red lead, cinnabar, and mercuric sulfide were used to create a flaming flush; vegetable and plant extracts—including carthamin from safflowers, alkanet root, crushed mulberries and strawberries, red beet juice, and red amaranth—were all used to create a wide palette of reds and pinks, ranging from the delicate to the intense.

Some of the most refined examples of face paint and cosmetics date back to ancient Egypt, from as early as 6,000 BC. The Egyptians were sophisticated chemists and they loved makeup, blending

Tribal Red

It's not just our lips and cheeks that we have painted red over history. Many ancient and modern-day tribes are known for their considerable use of red paint on their faces and bodies. The anthropologist Alfred Gell suggested one reason for this is that a "new or modified skin is a new or modified personality,"[4] which is a compelling argument, but there are so many other reasons why tribes may choose to embellish their faces and bodies. It's impossible to overestimate the importance of tradition and, on the flip side, the encroaching influence of the modern world. The Himba, an African tribe living in northern Namibia, have been breeding goats and cattle since the sixteenth century. The women of the tribe are known both for their unique hair, which is braided in different styles according to their age and marital status, and their use of a mixture of red ochre and animal fat, which they rub daily all over their faces, bodies, hair, and jewelry. The ochre mix, called *otjize*, gives their skin an amazing red glow that echoes the color of the earth and is considered the pinnacle of beauty in the Himba culture. Though its primary purpose is aesthetic, it also protects their skin from the effects of the sun.

ingredients to prepare cosmetics, ranging from moisturizer, kohl, lip and cheek rouge, to nail color. They would sprinkle powders made from a variety of natural substances—including ground nuts and minerals—onto a palette, dish, or spoon and blend

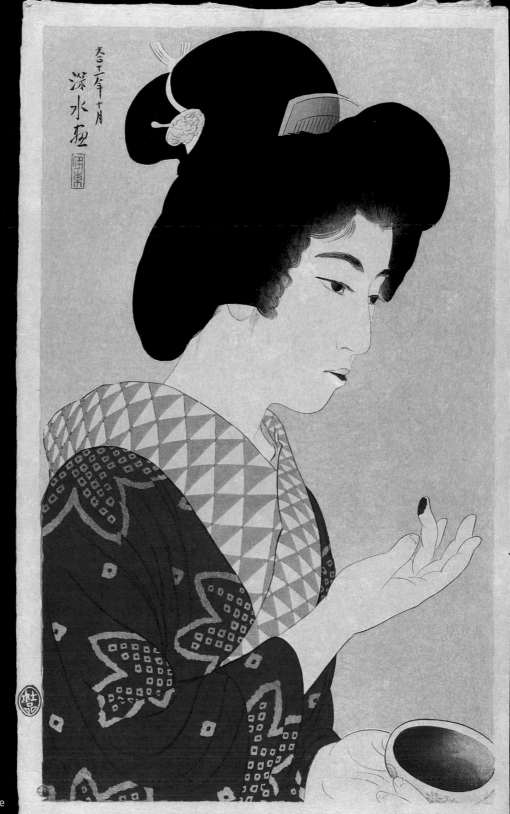

A young geisha in training applies beni (lipstick) from a pot coated with dried safflower; when moistened, it turns a vibrant red. Beni has been applied to the lips this way since the Edo period.

The Trotula

After the writings of the ancient period, the next major text to focus on makeup was the *Trotula*. A group of three books on the subject of women's medicine written in the Italian town of Salerno in the twelfth century, the *Trotula* contains a section titled "On Women's Cosmetics," which focuses on how to preserve and enhance beauty. Through references made in the text itself, it appears that the section on cosmetics was, once again, written by a man—unlike the rest of the *Trotula*, which was authored by women. It provides fascinating insight into the local traditions of the time, including this description of a rouge made in Salerno: "The Salernitan women put root of red and white bryony in honey, and with this honey they anoint their faces and it reddens them marvelously."[6]

them with animal fat or vegetable oil to transform the texture of the mixture so that it would stay put on eyes, lips, or cheeks. Mixing equipment such as palettes, grinders, and applicators have been found among the earliest burials, suggesting that they were not only essential in daily life but also valued in the afterlife. The ancient Egyptians are mainly remembered (in beauty circles) for their incredible eye makeup, but they were also renowned for their bold use of red, painting their lips with a vivid, early form of lipstick made by blending fat with red ochre. Cheek rouge, also made from the same ingredients and possibly blended with wax or resin, gave cheeks a lacquered red luster that would have been garishly offset by emerald-green eyelids and licorice-black kohl-rimmed eyes.[5]

If you explore the use of makeup through ancient times, it soon becomes clear that the freedom and rights accorded to women during a given period are very closely linked to the freedom with which they painted their faces.

Generally speaking, it's during the times when women were most oppressed that makeup was most reviled and seen as unacceptable. Compared with women of later centuries, Egyptian women actually had a fair amount of autonomy. They could own and inherit land and property (in fact, an early document known as the Wilbour Papyrus shows that ten to eleven percent of landowners were female), control their own businesses, and instigate legal proceedings against men. Physical exertion was not frowned upon, and some lower-class Egyptian women would have worked as laborers.[7] Considering this, it makes perfect sense that though ancient Egypt was one of the earliest societies to use makeup, it was also one of the most experimental and accepting. Unfortunately, later civilizations would not prove to be so open-minded.

In Iran, the earliest evidence of rouge comes from the city of Shahdad in the province of Kerman, where archaeologists found massive quantities of white powder in every tomb. At the bottom of the vessels used for storing the white powder, which seems to have been used as a foundation by both men and women, they found very small metal bowls or saucers painted red, believed to have contained rouge for lips

> *"Red protects itself. No color is as territorial. It stakes a claim…"*
>
> —Derek Jarman, *Chroma*

or cheeks. Known as *surkhab*, *ghazah*, or *gulgunah*, the rouge was made from powdered hematite or red marble, and even from plain red earth, to which a natural red dye like *runas* (madder) would have been added. Excavations of very early sites, such as those at Shahdad, show that rouge may have already been in use before the Bronze Age, and recent finds from the tombs of Iranian women dating back to the fifth and fourth centuries have uncovered rouge that was applied with a reddened cotton pad, which seems to have been the method of application right up to the Qajar dynasty (1796 to 1925).[8]

In ancient Greece, from as early as the fourth century BC, women adopted rouge to add a youthful flush to their lips and cheeks, daubing it onto the apples of the cheeks in a similar way to how we apply modern blusher. The rouge used by the Greeks was made from a host of natural substances, including seaweed and paederos, a root similar to alkanet, cultivated in central and southern Europe for its dye, which was extracted using oils and spirit of wine. Later, a red pigment called vermilion, created from the powdered mineral cinnabar, derived from red mercuric sulfide, was used to create a flush, but as with any mercury derivative, it would have been poisonous if used over a long period. Although makeup was worn, anything obvious was widely frowned upon, especially by the male elite who believed that a woman's main role in life was to be virtuous and stay in the house and oversee its running. As the Greek philosopher Aristotle

put it, "As between the sexes, the male is by nature superior and the female inferior, the male ruler and the female subject."[9]

Although we might now think of cities as progressive places, it was the women of Athens who led the most restricted and controlled lives of all. Encouraged to stay inside, women were not only excluded from the outside world but from the whole political life of the city around them. From the sixth to fourth centuries BC, women were "excluded from property ownership, politics, law and war."[10] They were not recognized as citizens with rights and consequently had to remain under the control and protection of a male relative who would decide when and whom they married. A government office even existed to regulate their public behavior.[11] Every aspect of women's lives was monitored and judged, so it's little surprise that their use of makeup could be controversial. An exception to this rule was the hetaerae, or courtesans, who generally wore a lot more makeup and were, ironically, afforded more rights. They were also allowed to attend the symposia and control their own money. Interestingly, courtesans, professional mistresses, and prostitutes being afforded more freedom and power than other women (in addition to wearing more makeup) is a pattern that has repeated throughout the ages.

The Greek writer Xenophon's *Oeconomicus*, a dialogue focusing on the subject of household management, clearly states the opinion that the use of rouge

is dishonest, as it misrepresents a woman's natural appearance:

"Would I then seem more worthy to be loved," I said, *"as a partner in the body if I tried to offer you my body after concerning myself that it be healthy and strong, so that I would be really well complexioned, or if instead I smeared myself with vermilion, applied flesh color beneath my eyes, and then displayed myself to you and embraced you, all the while deceiving you and offering you the vermilion to see and touch instead of my own skin?"*[12]

Considering the lack of education and rights afforded to women in ancient Greece, it's logical to find that everything written about makeup was recorded by men. But what might be startling was just how much men had to say about it. The sheer volume of words dedicated to the subject is quite something. Whether in poetry, prose, or letters, cosmetics crop up again and again. What's more, makeup use is described, praised, or censured in great detail, proving how divisive a subject it was.

Of the men who wrote about makeup, the writings of Xenophon are key to our understanding of how the ancient Greeks painted their faces—and later, the Roman poet and writer Ovid is equally important. Unlike Xenophon, Ovid was a rarity of the time in that he seemed to actually approve of the use of cosmetics. He admittedly stressed the need for women to be virtuous above all else, as a sort of moral disclaimer, but his didactic poem *Medicamina Faciei Femineae* ("Female Cosmetics") contains a variety of recipes for skin treatments. Unlike some of the remedies advocated by Roman writer and philosopher Pliny the Elder, which included the attractive-sounding ingredients mouse dung and owls' brains, Ovid's recipes were likely to have been successful.[13] Written

in the second century AD, his instructional poem *Ars Amatoria* is wonderfully modern in the advice it offers on relationships (rather like an ancient dating manual), with the third volume giving extensive advice to women on the preparation and etiquette of cosmetic treatments, referring to the fact that women would know to use "carmine to give yourself the rosy hue which Nature has denied you,"[14] and also mentioning rose and poppy petals as blush ingredients.

In spite of the mistrust and censure with which they were often regarded, cosmetics continued to be part of daily life, and were widely available throughout the Roman period. A huge variety of makeup containers (pyxides) containing cosmetics have been found by archaeologists—some made from basic, inexpensive materials such as wood and glass, which would have held the makeup of the lower classes, to more ornate containers, made from precious metals, which would have been owned by the rich and noble classes. This suggests that makeup wasn't a luxury and would have been worn by all women, rich or poor.

The number of anecdotes and depictions of makeup in Roman literature, art, and sculpture also gives us a brilliant insight into the daily lives and social roles of women in Roman society. However, just as in ancient Greece, male attitudes toward makeup appear to have been overwhelmingly negative, and it was largely viewed as something to criticize or satirize. It's understandable, then, that Roman women who used rouge to color their cheeks and, to a lesser extent, their lips, did so in a moderate way. Toxic cinnabar and red lead were applied, as well as other less

Late sixteenth-century portraiture suggests that fashionable and noble women wore their blush in the shape of an inverted triangle applied to the apple of the cheeks, extending down. In paintings, it appears smooth and well blended, but in reality it would probably have looked much harsher and more garish.

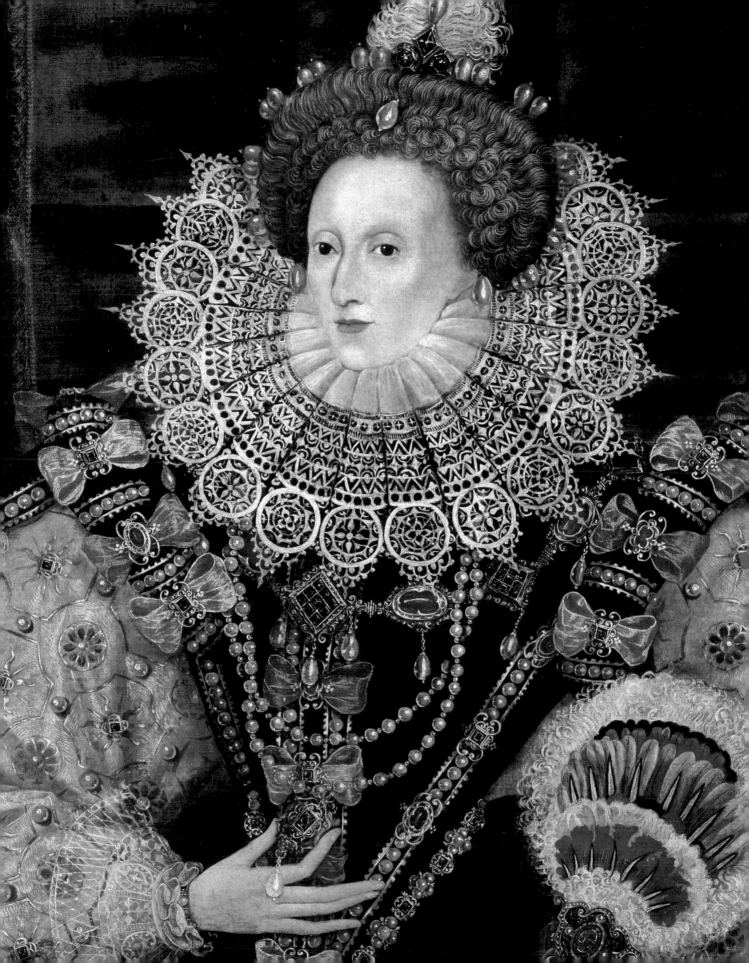

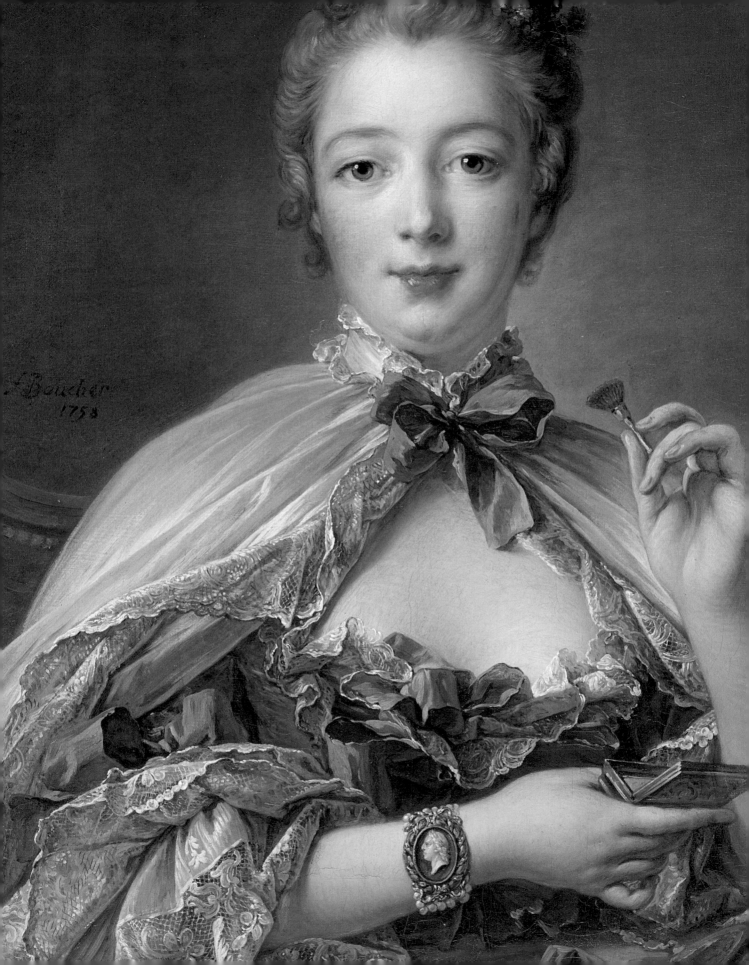

A portrait of Madame de Pompadour by Boucher. Pompadour at her toilette using a petite brush to apply the Pompadour Pink color of blush, which she popularized. She is wearing a cape to shield her dress from cosmetic powder. A rare example of the art of painting on cosmetics being replicated through the art of painting itself.

poisonous ingredients, including rubric (red ochre), orchilla weed, red chalk, and alkanet. It follows that cosmetics were usually applied in private, in a small room that would have been strictly the domain of women. Rich women could also employ the services of female slaves known as *cosmetae* (ancient-day makeup artists) to help perform their beauty routines.

It's interesting to note that for the longest periods in history, light and moderate use of rouge was the standard, while during other, shorter periods, excessive and exaggerated application was very much the fashion. The opposite of the delicate, restrained use of rouge is the "more is more" approach of the sixteenth century in Europe. Venice was the capital of fashion and the playground of the rich. With a constant stream of parties and balls taking place, heavy makeup was de rigueur in Venetian circles and probably quite necessary to mask any ill effects of the night before. The Italian influence spread to France when Florence-born noblewoman Catherine de' Medici (queen consort of Henry II of France from 1547 to 1559) encouraged the use of makeup and perfume in the court. In England, the heavy use of rouge at this time among the aristocracy can be partly attributed to the fact that the use of cosmetics was royally sanctioned by Elizabeth I, who was often portrayed with a visibly whitened and rouged face, as can be seen in the many surviving portraits of her.

Cochineal-, madder-, and ochre-based mixtures were all used for lips and cheeks, as well as the toxic vermilion (like that used in ancient Greece). Makeup was carried in "sweet coffers" that contained all the cosmetics an Elizabethan woman would require: ceruse (the obligatory porcelain-pale powder), rouge, and decorative patches. As a contrast to their highly prized pallor, Elizabethan women of the court and nobility added a flourish with rouge all over the cheeks and lips, giving the impression that they were

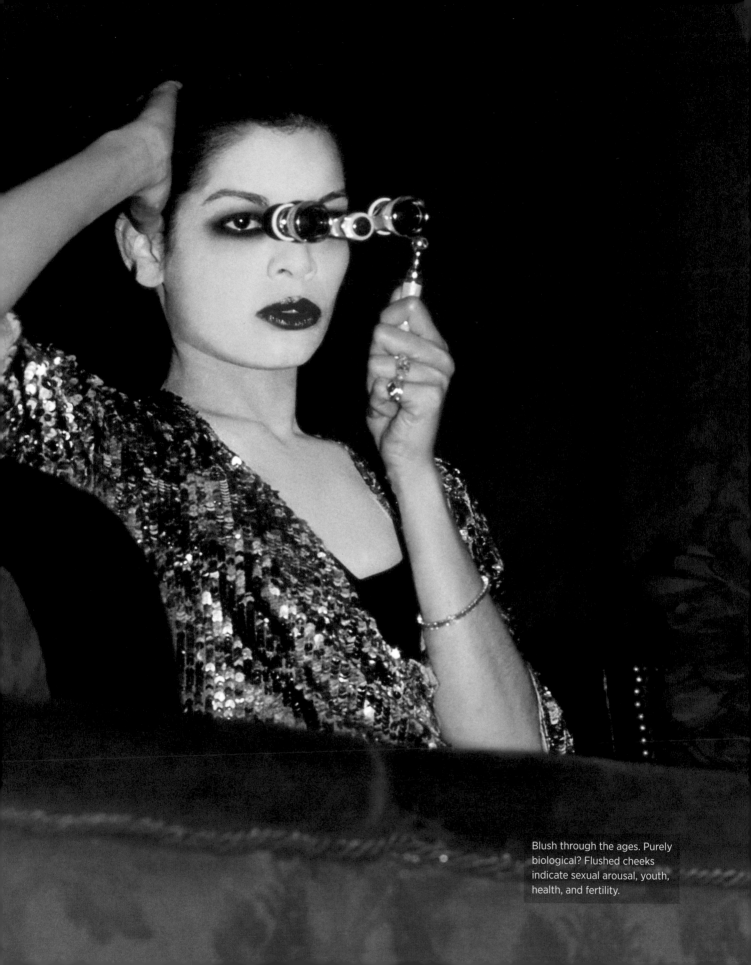

Blush through the ages. Purely biological? Flushed cheeks indicate sexual arousal, youth, health, and fertility.

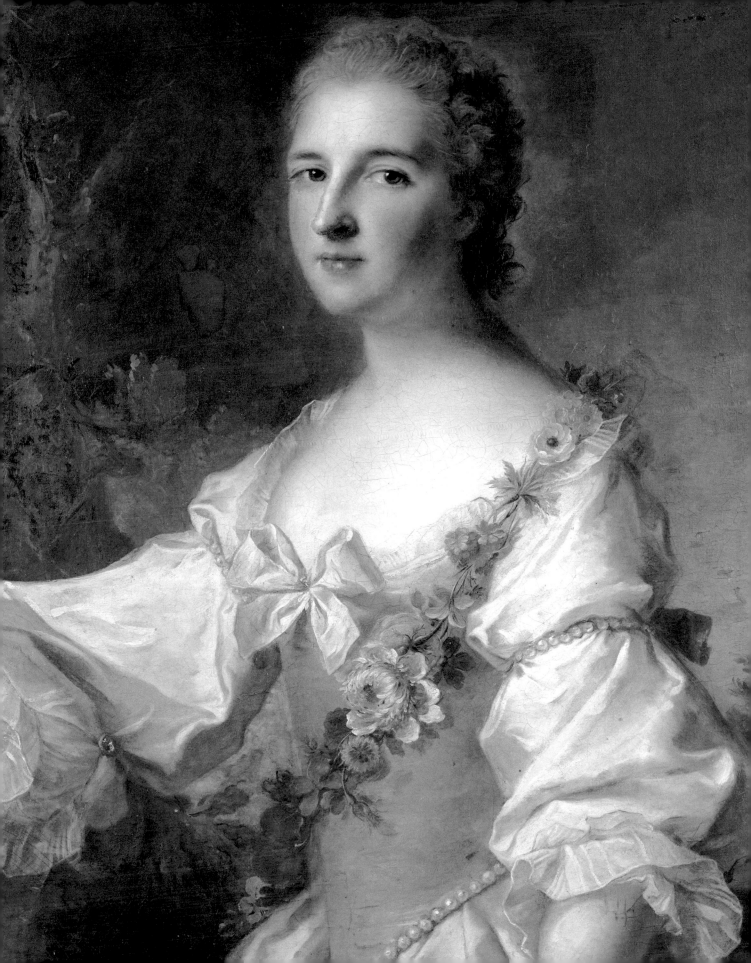

"Red is the color of life, of blood. I love red."

—Coco Chanel

painted. As one unnamed Elizabethan satirist commented: "An artist needs no box of paints to work, but merely a fashionable lady standing nearby to use for pigments." The problem, as the poet John Donne would later astutely observe, was all in the perception: "What thou lovest in her face is colour, and painting gives that, but thou hatest it, not because it is, but because thou knowest it."[15] The color that rouge gave lips and cheeks conformed to the beauty ideals of the time and could be flattering—but men did not want to be made aware of its artificiality. Early Christian writers had created a powerful association between makeup and deception that was hard to shake, with Saint Cyprian declaring that the act of painting the face and "staining" the cheeks was "to drive out all truth, both of face and head, by the assault of their own corruption."[16] The pervasion of the idea of makeup creating a "false face" during the Renaissance period can be seen in Shakespeare's writing too, notably in *Hamlet* when Hamlet cuttingly says to Ophelia, "I have heard of your paintings too, well enough; God has given you one face, and you make yourselves another." The Danish critic Georg Brandes went so far as to comment that, "if there is anything which Shakespeare hated with a hatred somewhat disproportionate to the triviality of the matter . . . it is the use of rouge."[17]

It's not surprising then that at the end of Elizabeth's reign, with the royal stamp of approval no longer in place, the use of face paint became more discreet.

In England, moving into the seventeenth century, the fluctuating fashion for how to wear rouge—and makeup in general—can be linked to the influence of both the prevailing politics and puritanical religion. In 1650, a motion was put forward under Oliver Cromwell in the Long Parliament "that an Act against the Vice of Painting, and wearing black Patches, and immodest Dresses of Women, be read on Friday Morning next."[18] The bill was read once before being dropped. It seems clear that makeup was so prevalent in English society and culture by this point that it simply could not be controlled. Double standards were very much at play, as men secretly appreciated the effects of makeup when applied well and discreetly: The general consensus was that makeup was unacceptable, but if it *must* be used, then it should appear natural. Beautifying clearly had its benefits, as demonstrated by London diarist Samuel Pepys, who wryly noted, when describing how a woman had accidentally spat on him, "after seeing her to be a very pretty lady, I was not troubled by it at all."[19]

In Europe, the mid-eighteenth century was also renowned for being a time when rouge overload was common. The beauty ideal suggested by the portraits of the time was pale skin with rose-flushed cheeks (similar to those of the sixteenth century)

The most enduring shade of face paint, red inspires a primal response and conjures strong and at times contradictory emotions.

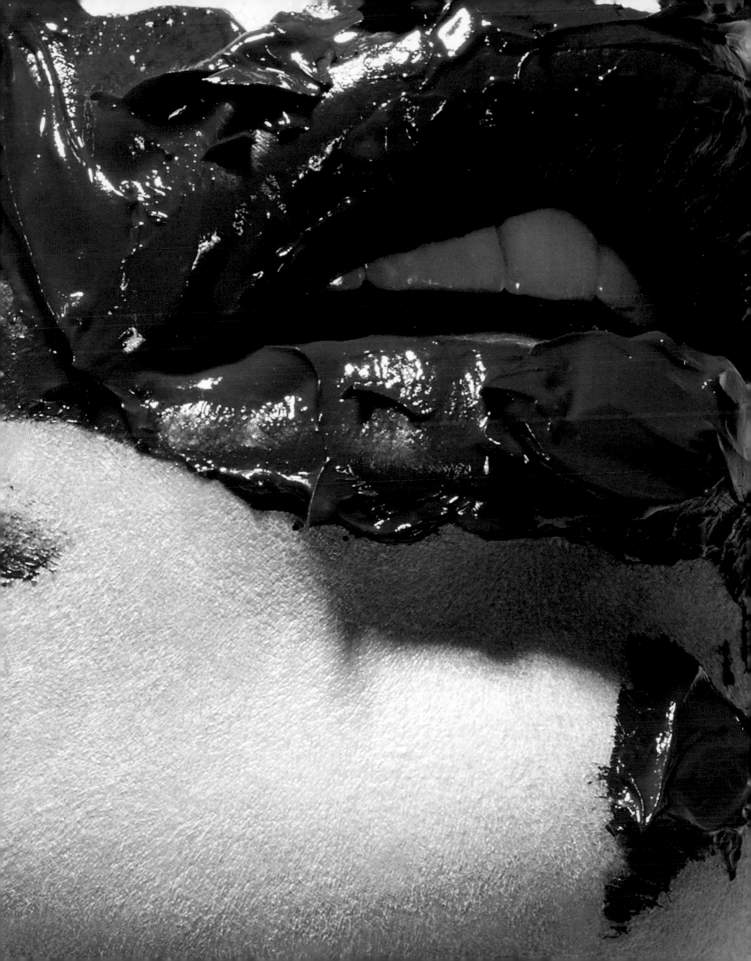

and dark, defined brows. Makeup was all about status and being seen to be à la mode—the flamboyant manner in which rouge in particular was worn was so very apparent that there's no way it could have been intended to look natural. Especially in France, which was now the focal point of fashion and the center from which Europe took its aesthetic cue, painting your face was very much a part of life at court. Getting dressed and rouging your face in front of an audience was part of a public toilette practiced by aristocratic women—although there was a strong element of performance involved in the ritual, with most of the work being done beforehand and without the court onlookers (a little bit like today's behind-the-scenes videos of fashion shoots). Madame de Pompadour, the long-standing mistress of King Louis XV of France, was famously portrayed with noticeably rouged cheeks, and she became so associated with the color in the public consciousness that a certain shade of deep pink she was fond of became known as Pompadour pink. A portrait by François Boucher from 1758 shows her seated at her dressing table, in the act of painting her face, applying rouge from a compact using a small brush—a rare example of the art of painting on cosmetics being replicated through the art of painting itself. Like paint, rouge came in many shades, and was used artistically. In his personal papers, published in 1877, Count Axel von Fersen, a Swedish aristocrat, describes seeing a French noblewoman apply her makeup. He says that she had six pots of rouge and another pot containing something that appeared more black than red. According to Morag Martin in *Selling Beauty*, the count "realized it contained 'the most beautiful red one could see.' She then added to this first layer from the other six pots, two at a time."[20] Aristocratic men also used rouge at this time, as did children, particularly in court. However, there were subtle (or not so subtle) variations in the shades used. By 1780, rouge was available to buy

in perfumeries in France, so anyone with the money to spend could use cosmetics to color their lips and cheeks, although the middle classes used less, and applied it in a subtler way than the aristocracy did. According to French writers Edmond and Jules de Goncourt, "the rouge of the lady of quality was not the rouge of the court, nor the rouge of a courtesan; it was merely a soupçon of rouge, an imperceptible shade."[21]

The excessive makeup worn in France attracted censure in England; although used, cosmetics were still considered artificial and false by many. Eighteenth-century portraits of women in England and the United States suggest that both countries favored a more pared-back look than their French contemporaries. Writing from Paris in 1775, Horace Walpole summarized the different attitudes toward rouge in an amusing letter: "I found an Englishwoman at the Opera last night by her being covered with plumes and no rouge, which made her look like a whore in a salivation; so well our countrywomen contrive to display their virtue!"[22] But the gap would not remain for much longer—following the French Revolution, there was an overall shift to a more natural look.

Changing trends aside, with the increase in availability, women carried on using rouge, and by the late eighteenth century there were a huge number of varieties available. Vegetable rouges became more sought after as the dangers of lead and mercuric sulfide became better known, and a type of rouge known as Spanish wool was incredibly popular, although it had been around since the seventeenth century. Available in a variety of colors and sizes, Spanish wool was fabric that had been dyed with cochineal or something similar, cut into pads about 1.5 inches (4 cm) across, which could be dabbed onto the lips and cheeks in order to stain them. A portable version, called Spanish paper, was made

> # *"What red can do for the spirit, it can also do for the face."*
> —Sophia Loren, *Women & Beauty*

up of pigment impregnated into paper that could be carried around in a pocketbook. Rouge was also available in small pots and glass bottles or on saucers, and would be applied with the fingers, a camel-hair brush, a hare's foot, or a powder puff, depending on the formulation.

However, the arrival of the nineteenth century marked yet another shift in attitudes toward makeup, and rouge in particular. The declaration of England's Queen Victoria that makeup was vulgar meant that a pale, virtuous look was now preferred. The resulting backlash against painted faces meant that women who wanted to create a rosy glow could either resort to pinching their cheeks and biting their lips to encourage a natural flush or be very cautious with their use of cosmetics. While pale, unmade-up skin and luxuriant hair were considered ladylike, obvious rouging was seen as belonging to the realms of the theater or signifying a woman of what was euphemistically phrased "low morals." At the same time, by the 1850s the production of cosmetics had become a national industry with its center in Paris. This marked the beginning of commercially available rouge on a scale that had never been seen before, and by the turn of the century rouge was available to buy in dozens of shades and textures.

As Victoria's reign came to an end, the association of her son, the future King Edward VII, with some of the most famous stage actresses of the time, such as Lillie Langtry and Sarah Bernhardt, meant that rouge was treated with less vehemence and scorn. As the writer and satirist Max Beerbohm wrote in his "Defence of Cosmetics" (1896), later titled "The Pervasion of Rouge":

For behold! The Victorian era comes to its end and the day of sancta simplicitas is quite ended . . . we are ripe for a new epoch of artifice. Are not men rattling the dice-box and ladies dipping their fingers in the rouge-pot? . . . No longer is a lady of fashion blamed if, to escape the outrageous persecution of time, she fly for sanctuary to the toilet-table; and if a damsel, prying in her mirror, be sure with brush and pigment she can trick herself into more charm, we are not angry. Indeed, why should we ever have been?[23]

Beerbohm was writing satirically, of course, but his words touched a nerve regardless and proved to be more true than might have been anticipated as, moving into the Edwardian period, cosmetics became more acceptable.

Marie Antoinette

"I put on my rouge and wash my hands in front of the whole world," Marie Antoinette wrote in 1770. Appearance and beauty were all about status for the French queen, even before she was crowned, and the painting of her face and ritual of her toilette were both deeply symbolic and a complex political performance.

Such is her cultural status now as a fashion and beauty icon—as demonstrated by Sofia Coppola's lavish 2006 film—that it seems surprising that Marie Antoinette was not actually considered to be an exceptional beauty. Of the "defects" her mother found in her daughter's appearance, the worst were apparently her uneven hairline, aquiline nose, and projecting lower lip called the Hapsburg lip.[24] Marie Antoinette was aware of her perceived deficiencies, asking her first lady-in-waiting Madame Campan to "give me notice when flowers shall cease to become me" at the age of just twenty-five.[25] Her most beautiful feature, according to many of her contemporaries (and highlighted glowingly in the many portraits of her), was her brilliant, white complexion, not only of her face but also her neck, shoulders, and hands.[26]

Her famous toilette ritual was described by Madame Campan as "a masterpiece of etiquette."[27] The first "private" toilette included the washing of face and body, the application of whitening face paint or powder, and the fixing and powdering of hair. The "public" toilette began at noon, and was all about makeup and final touches—with the application of rouge being the most popular to attend. In her biography of Marie Antoinette, Antonia Fraser notes that at this point, the process became very complicated, as anyone (anyone with the "Rights of Entry," that is) could appear at any time, and had to be greeted appropriately, delaying the whole process. To further slow things down, the queen could not reach for anything, and had to wait until she was handed the next styling item.

When the rouge was applied, in "huge precise circles of a color not far from scarlet,"[28] it was far from natural-looking, in keeping with the upper-class fashion (red, as well as rouge, was an important symbol to aristocratic men and women, as it quickly set them apart from the masses and indicated their high status).[29] After her makeup was finished, the men in the audience left, and Marie Antoinette could (finally) be dressed.[30]

It may seem completely old-fashioned now, but the court was dependent on outward symbols of status, and Marie Antoinette's mother pushed her to take on these symbols before she became dauphine and later the queen. And it worked: Her strict toilette regime created styles that infiltrated the toilettes of women around Europe and helped secure her precarious position in the French court.[31] By the 1780s, though, Marie Antoinette was using her powder sparingly and her rouge had all but disappeared.[32] Although she was merely following the emerging trend toward naturalism in Europe, she was inadvertently shedding all the outward symbols that signaled her status and disrupted the system of Versailles. The toilette ritual changed with each new prison during her incarceration: Before her execution, all that was left of the vast and complex toilette, according to Fraser, was "a box of powder, a 'big fine sponge' and a little box of pomade."[33]

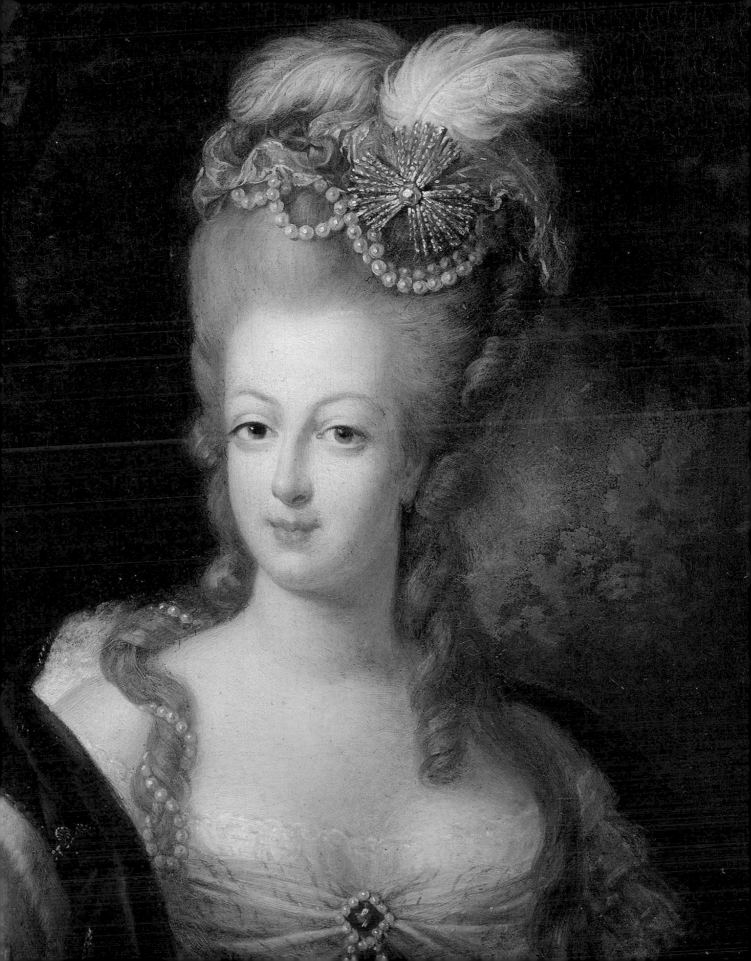

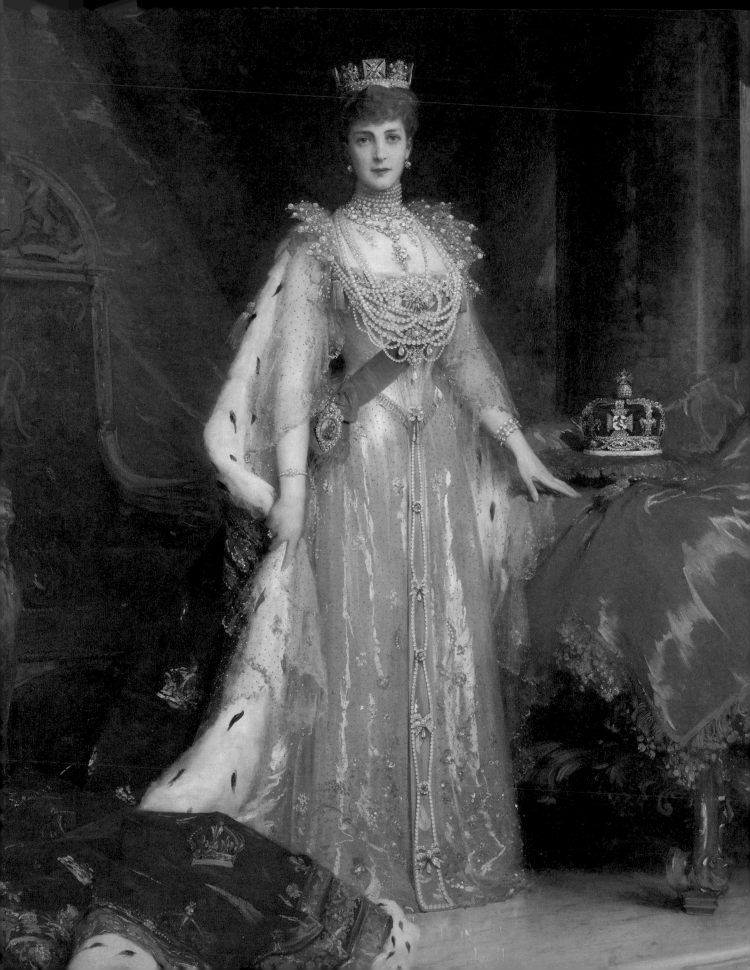

Queen Alexandra

Alexandra of Denmark, born in Copenhagen in 1844, was Princess of Wales from 1863 to 1901 (the longest time any woman has held that title) before becoming the queen consort of Great Britain from 1901 to 1910, following the death of Queen Victoria. Alexandra's family rose to prominence when her father was chosen to succeed the Danish throne. When she was sixteen, it was arranged that Alexandra should marry the Prince of Wales (later King Edward VII), an event that took place in 1863.

Edward was known for being a playboy (he had well-publicized affairs with many actresses and society women), but despite this, his marriage to Alexandra was said to be generally happy, and it was fairly popular, for a royal marriage. Alexandra was renowned for her beauty, grace, and charm, and her style of dressing was much imitated. She often wore high necklines and chokers, apparently to cover a small scar on her neck. Whatever the reason, it set the fashion for the next fifty years. She was one of the first women of the Edwardian era to openly wear powder and rouge, making it permissible for other women: Though actresses were already doing the same thing, Alexandra gave makeup the royal stamp of approval and a level of acceptability that no one else could. Makeup or not, she was also said to have looked extraordinarily young. An article in a 1907 edition of US *Vogue* (when Alexandra was sixty-three) stated, "Queen Alexandra of England has long been the wonder of the world because of her remarkable appearance of youth . . . ," though it also made clear that this freshness was not entirely without any effort on the queen's part.

Alexandra was a very different figurehead from her austere predecessor, Queen Victoria. Not only did Alexandra wear makeup, but she was also a keen horsewoman and enjoyed hunting—not the pursuits of a typical Victorian lady. She is said to have enameled her face—painting it first with a white base, over which red or pink would be applied—rather heavily during her later years, when her legendary youthfulness started to suffer (which would probably have set tongues wagging). Though she was not permitted to have any influence on diplomatic affairs, she was the first queen to sit in on a debate at the House of Commons in 1910, showing that she truly was a new woman of the Edwardian era.

not to wonder how closely related modern skin-brightening cosmetics are to the many historical methods for attaining lighter skin. Perhaps more importantly, we should ask where this desire came from, and how it has changed over time.

It's interesting that cultures that had no knowledge of each other's existence, such as ancient Greece and ancient China, not only used similar lead-based ingredients in their skin-lightening cosmetics but also shared the same desire to use these products in the first place. Skin color is of course linked with race, but, although it's not something we might consciously think about, skin tone is also closely connected to gender. Regardless of ethnicity, women tend to be paler than men, as they have less hemoglobin (the red pigment in blood) and melanin (the brown pigment in skin and hair) in their body. Skin tone is also a signifier of fertility, a point that evolutionary psychologist Nancy Etcoff makes, noting that the difference in skin tone between boys and girls occurs only at puberty and that "thereafter women are lighter during ovulation than during the infertile days of their cycle." She also observes that "a woman's hair and skin tend to be permanently darkened after the first pregnancy, forever changing the girlish complexion of youth."[1] Light (or lighter) skin is therefore a symbol of youth and a signifier of the fact that a woman hasn't had a child, which, antiquated though it may seem now, is something that has been traditionally prized in the past.

Of course the suggestion of fertility isn't the only explanation as to why lighter skin has been so consistently sought after over time. Before tanning became fashionable, skin that showed no effects of sun exposure was directly tied to social status, particularly for women, whose place throughout history has more often than not been cloistered and confined to the home. The desire for alabaster skin can be traced back to before the semi-legendary times of the Trojan War and is mentioned in the epic poems of Homer, in which the goddess Hera is described approvingly as "white armed." More evidence survives from the

Why Lead?

But why, it seems reasonable to ask, did the Greeks use lead as their whitener of choice? When researching this period, and the use of lead powder, I was interested to discover that ancient Athens owed much of its great wealth to the Laurion mines. Located close to the city, they produced a vast amount of silver—reportedly ten thousand tons in the fifth century BC—the discarded by-products of which were mountains of white lead pigment (lead wasn't specifically mined until much later). It's my belief that the widespread use of lead as a key ingredient in skin-whitening cosmetics in Athens and the proximity of the silver mines can't be coincidental.

Sparta

There were some Grecians who steered clear of makeup altogether: The women of the city-state of Sparta, a military-orientated society that prized strength above everything else, were accorded very different rights from those of other Greek women. Spartan girls were unique in that they were formally educated, and although they were not able to work or earn money, they were allowed to own and inherit land (unlike the majority of Greek women and girls, who had to marry the closest surviving male heir on their paternal side in order to inherit land—even if they were already married to someone else). What's more, physical fitness was considered to be as important for Spartan girls as it was for boys, which meant that they exercised, took part in races, and drove carriages. In short, they spent a lot more time outside than their Athenian counterparts, and their skin would have looked different and been richly tanned because of this. The Greek writer and historian Plutarch wrote that Lycurgus, the lawgiver of Sparta, outlawed the use of makeup in the city, meaning that the Spartan ideal of beauty probably would have been quite different from that upheld by the rest of Greece at the time.[2]

golden age of Greek culture and particularly from Athens, enabling us to reconstruct both what Greek women applied to their skin and something of the social conventions that surrounded the use of makeup. We know that a white or pale complexion was associated with upper-class women, who spent the vast majority of their time indoors, away from the skin-darkening sun. The Greeks made their own skin lightener from lead carbonate, as Greek philosopher, and observer of chemistry, Theophrastus describes in his treatise *On Stones*:

> *Lead is placed in an earthen vessel over sharp vinegar and after it has acquired some thickness of a kind of rust, which it commonly does in about ten days, they open the vessels and scrape it off. They then place the lead over the vinegar again, repeating over and over again the same process of scraping it till it is wholly*

gone. What has been scraped off they then beat to powder and boil (with water) for a long time and what at last settles to the bottom of the vessel is white lead.

This end product is what would have been used as a skin-lightening powder, as proven by the archaeological digs that have uncovered pyxides containing traces of white lead in the graves of wealthy Greek women.

Though it seems to have been acceptable—for those who could afford it—to even out one's skin with a layer of white lead, it appears there was a fine line between highlighting a pale complexion and masking one's appearance like a courtesan, or hetaera. The wife in Xenophon's *Oeconomicus* is reproached for wearing makeup that hides her true appearance: "Well, one day Socrates, I noticed that her face was made up: she had rubbed in white lead to look even

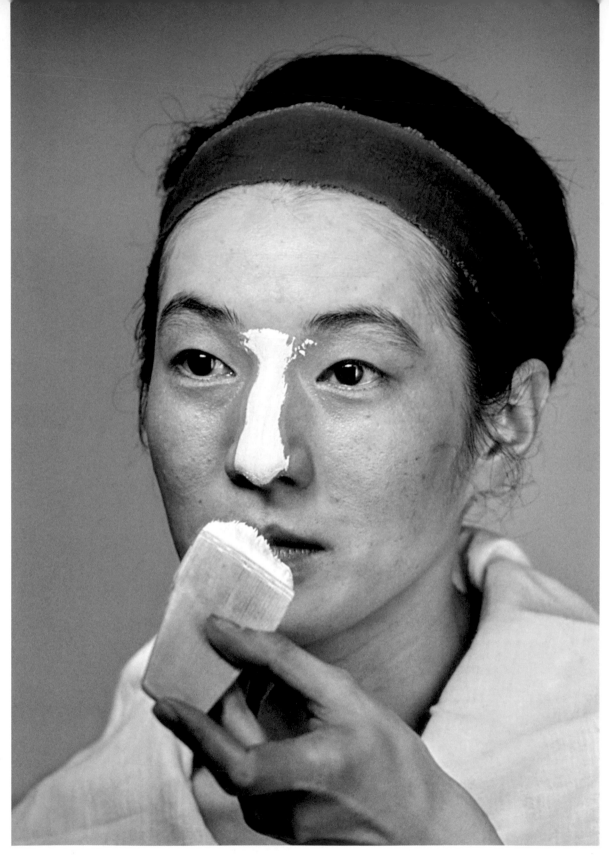

This Japanese Geisha tutorial photographed by Irving Penn for US *Vogue* in 1964 demonstrates the growing interest in Asian beauty culture in the latter half of the twentieth century and which continues today. Photographs by Irving Penn, © Condé Nast. *Vogue*, December 1964.

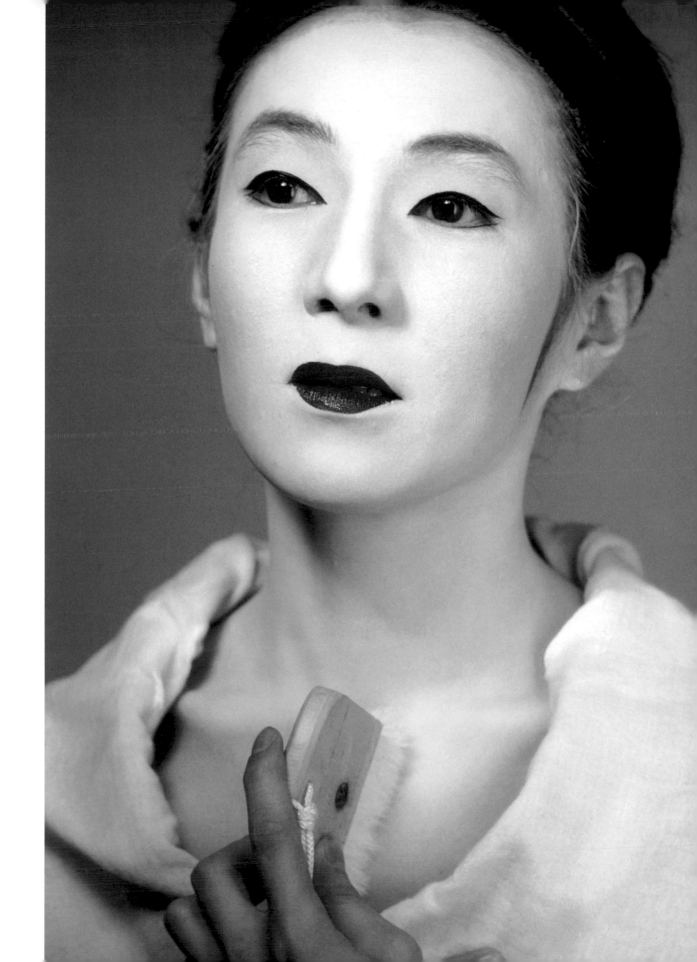

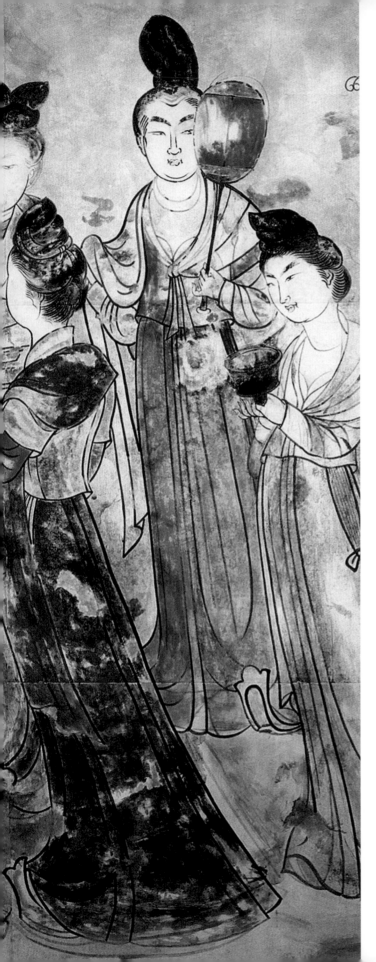

whiter than she is." The ancient Greek poet Eubulus compares less-made-up wives with heavily made-up courtesans in his comic play *Stephanopolides* ("By Zeus, they are not plastered over with white lead . . .") and other references in the literature of the time clearly indicate that when it came to *psimuthion*, less was more. Though the white powders and pastes used would have acted as a pretty effective sunblock, they also would have been highly toxic, and over time they would have, ironically, made one's skin look withered and old—the opposite of the desired effect.

A bright complexion and light skin were also central to the Roman ideal of femininity in the ancient world, and as we've already seen when tracing the use of rouge, a considerable amount of textual evidence about cosmetics has survived, although once again, it is all written by men. Ovid's *Ars amatoria* included instructions for skin treatments and cosmetics, such as this recipe for a nontoxic skin whitener:

> *Now, when you have had your full of sleep, and your delicate limbs are refreshed, come learn from me how to impart a dazzling whiteness to your skin. Strip of its straw and husk the barley which our vessels bring to our shores from the fields of Libya. Take two pounds of peeled barley and an equal quantity of vetches moistened with ten eggs. Dry the mixture in the air, and let the whole be ground beneath the mill-stone worked by the patient ass. Pound the first horns that drop from the head of a lusty stag. Of this take one-sixth of a pound. Crush and pound the whole to a fine powder, and pass through a deep sieve. Add twelve narcissus bulbs which*

Tang court ladies in a fresco painting at Lady Li Xianhui's tomb. Although ceruse usage fell out of favor during the Sui Dynasty, it came back into fashion amongst court ladies during the Tang dynasty.

have been skinned, and pound the whole together vigorously in a marble mortar. There should also be added two ounces of gum and Tuscan spelt, and nine times as much honey. Any woman who smears her face with this cosmetic will make it brighter than her mirror.[3]

While Ovid's suggestions were generally sensible, other authors preferred to highlight the artifice of cosmetics. Roman satirists couldn't resist the allure of absurd, exotic, or repellent ingredients, and one of the most notorious materials, cited by many authors, was a skin-lightening preparation called *crocodilea*—crocodile dung. Typically, we know this fact because it was often mentioned by men arguing against the use of cosmetics, but it was also described by Pliny the Elder, who explained that the particular land-dwelling crocodile whose dung was used in skincare lived on a diet of herbs and flowers, so that its intestines smelled "pleasantly fragrant." He recommended that crocodilea be mixed with starch, chalk, or dried starling droppings to lighten and tint the skin. Roman women may indeed have applied reptile feces to their faces, but some modern historians suspect that crocodilea was in fact the popular name of a white clay sourced in Ethiopia, the land believed by the Romans to be the source of the Nile, well known to be a river in which crocodiles thrived.

If you think of cultures historically associated with pale or white skin, East Asia certainly springs to mind—particularly Japan, where the eggshell-white maquillage of the geishas is a cliché of national identity. The admiration of white or pale skin in the region is timeworn, with ancient China being one of the first civilizations to strive to enhance pallor: One of the first skin whiteners to be recorded was rice powder, a harmless substance made by finely grinding the grain into rice bran and used cosmetically by both the Chinese and Japanese.

Empress Wu Zetian ingested pearl powder, which was thought to stimulate skin healing, as well as applied it to her face to brighten her complexion.

White lead was also discovered to be an effective whitener, but it is difficult to pinpoint when lead-based pigments were first used for cosmetic purposes in ancient China. Some sources suggest ceruse may have been in use in very ancient times, as far back as the Shang dynasty (c. 1600–1046 BC), partly due to a literary allusion to powder made from roasted lead, and partly because it's possible that

> *"White may be said to represent light, without which no color can be seen."*
>
> —Leonardo da Vinci

the manufacturing of lead pigments in ancient China dates back as far as lead metallurgy—the process of separating the metal from its ore—itself.

Ceruse was made by combining lead and sharp vinegar, which was left to steep until it formed a skin, after which the process was repeated until the lead became a powder, a procedure remarkably similar to the Greek and later Roman methods. Ceruse continued to be used, at least by upper-class women who could get hold of it, for roughly the next 350 years; it was briefly out of favor during the Sui dynasty, as the empress did not use it, but became popular again under the Tang emperors. It was in this latter period that the growth of trade meant that ceruse spread to Japan, where it was used by ladies of the court until the late sixteenth century, by which point it became widely available to all women.

Pearl powder, which has recently made a comeback, dates back to AD 320. Made, as its name suggests, from crushed pearls, it was originally used in traditional Chinese medicine to treat a wide variety of ailments before becoming a popular skin whitener. China's only female ruler, Empress Wu Zetian (AD 625–705), regularly took pearl powder internally, and used pearl cream on her skin for its brightening and beautifying properties. When she ascended the throne at the grand age of sixty-five, her beauty was legendary and her skin rumored to be "as radiant as a young woman's." According to the *Bencao gangmu* (*Compendium of Materia Medica*), an ancient Chinese

medical text, pearl could stimulate new skin growth and healing, as well as reduce sun damage and age spots. Recent scientific studies have confirmed this,

It Takes an Army

Emperor Nero's second wife, Poppaea, maintained an elaborate beauty routine that reputedly required a hundred slaves to be carried out. To keep Poppaea's skin bright, her maids applied a daily face mask of moistened meal, in which she slept. Each morning the hardened crust of flour was washed away with ass's milk. Poppaea also bathed regularly in ass's milk, for its skin-lightening and softening properties, before applying a layer of chalk and white lead to her skin. Further applications of meal paste mixed with lemon juice were used to bleach her freckles. There's plenty of scientific evidence for milk baths, as milk contains lactic acid, known to be an effective exfoliant, though white lead obviously would have been toxic. A version of this skincare routine soon became popular with most Roman women wealthy enough to afford the ingredients, and the slaves that were needed to prepare it.[4]

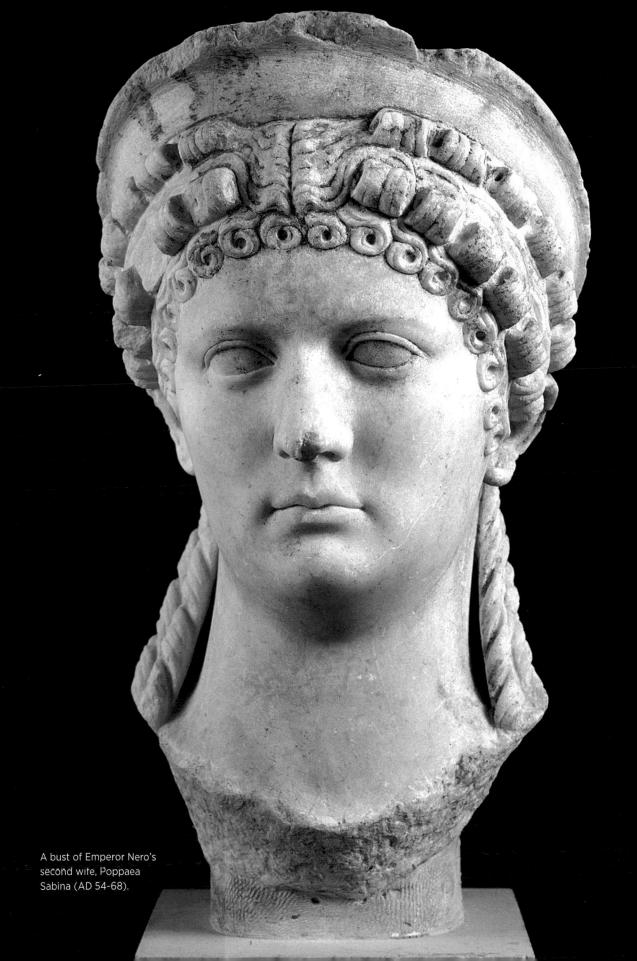

A bust of Emperor Nero's second wife, Poppaea Sabina (AD 54-68).

There Will Be Blood

In addition to the use of pastes and potions, bloodletting and leeches were both employed to induce a fairer complexion, according to popular mythology. In medieval Europe, bloodletting was used to treat a wide range of ailments and illnesses, from gout to the plague (probably without much success for the latter).

The popularity of bloodletting in the form of leeches or cupping (simply slashing a vein and catching the flow in a cuplike vessel) may seem bizarre to us now, but it can be explained by the belief in the importance of the humoral system during the Middle Ages and the Renaissance. Stemming from the Roman physician Galen's principle of humoral theory, this system was made up of the four classical elements—fire, earth, water, and air—and it was thought that

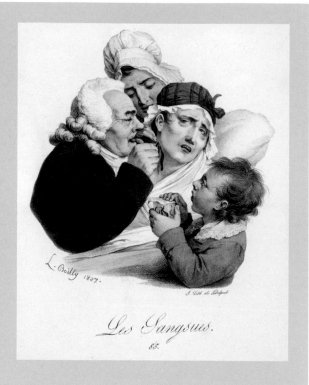

perfect health would be achieved if all the elements were in balance. Physicians believed that all four elements were present in the blood, so loss of blood was meant to help balance the humors and return the patient to general good health. For example, the *Trotula* recommends that "blood be drawn from the vein which runs under the foot" as a solution to a lesion on the womb.[6]

Although I couldn't find any concrete evidence of bloodletting used for beautification purposes, the idea that the loss of blood could bring about or restore health is not a huge jump away from believing that blood loss could improve appearance and enhance beauty. Stories exist of Renaissance women asking their physicians to place a leech behind each ear to drain their faces of blood as a form of pre-party beauty prep in order to achieve a fashionable pallor. We must assume, though, that only the rich could afford to have physicians perform these practices solely for beauty purposes, unless they were to undertake the practices themselves.

uncovering that pearl powder can actually stimulate the skin's fibroblasts, help to regenerate collagen, and generally improve radiance.[5]

Like the Chinese, Koreans revered flawless pale skin and believed it to be the epitome of female beauty—an aesthetic gold standard that remains today. Ancient Korean poets praised skin "like white jade," and it was the Koreans who introduced the Japanese (around AD 600, when Korea began to trade with Japan and China) to the bleaching qualities of

nightingale droppings, which have recently been adopted by Western beauticians to cleanse, soften, and whiten the skin. The droppings had originally been used to remove dye from silk in order to produce decorative patterns in cloth used for kimonos. Ingeniously, the Japanese combined the droppings with finely sieved bran flour to make a skin lightener that could be applied by patting a small cloth bag of the powder over the skin. White skin became highly fashionable in Japan during the Asuka period and

continued into the Heian period (AD 794–1185) and beyond. In AD 692, a Buddhist priest made a lead-based whitener, which he presented to the delighted Empress Jito—though she may not have been quite so pleased had she realized the toxic preparation would eventually eat away her beautiful, unblemished skin. This period, the era of "peace and prosperity" was a high point of Japanese culture, when after several hundred years of cultural domination by China and Korea, the Japanese began to develop their own artistic and literary identity. Although trade with China continued, the imperial court decided to sever official relations and go it alone. With the long period of peace that ensued, aristocratic culture became highly refined, and exquisite taste became the most highly prized attribute of the sophisticated courtiers, both male and female. In the Heian court, a demanding but subtle rule of taste was the major regulator of aristocratic behavior, and negotiating these rules with skill was almost the only route by which an ambitious aristocrat might obtain a good reputation. Rejecting Chinese fashions, the ladies of the imperial household developed a new standard of beauty, in which the body was completely hidden under layers of luxurious silk robes, leaving their heavily whitened faces and necks as the focus of attention.

If whitening was a subject of ridicule for moralists in pagan Rome, it was even less attractive to early Christian writers. The Roman Empire became officially Christian in AD 325, and over the next century a new heightened morality spread throughout all aspects of daily life. Whitened skin moved from being distasteful to sinful, for the simple reason that using makeup suggested that God's creation wasn't quite good enough in its original state, and that female vanity wished to improve upon it. Clement of Alexandria, a Christian theologian, was particularly vehement in his views on the subject: "If anyone were to refer to these women as prostitutes, he would make no mistake. For they

turn their faces into masks."[7] As we will see, these theological objections to cosmetics were to have a long life; male paranoia and anxiety over the use of cosmetics became absorbed into the teachings of the church. During the Renaissance, ideas about beauty were rigid—and ideas about makeup were even less flexible. Generally, the idea (one that by now should appear familiar, having explored the attitudes prevalent in ancient Greece and Rome) was that painting your face was unacceptable, but if you had to do it, then it should be indiscernible. As Jacqueline Spicer, an expert in cosmetics culture in Renaissance Italy, points out, women did not have the option to express themselves through their use of makeup, but rather through one model that they had to conform to.[8]

In spite of this, the effort to maintain fair skin across Europe (and the Far East) continued throughout the Middle Ages. While the use of other cosmetics was moderate during this time, it continued to be desirable to have blemish-free, sun-shaded skin. Part of the reason for this was that, again, paleness was synonymous with high social status, whereas weather-beaten or tanned skin signified someone who was forced to work outdoors, and was therefore from the lower classes. In times of disease and ineffective medicine—which the Middle Ages very much were—clear, fair, blemish-free skin was a visible barometer of health and an indicator of fertility, which explains why women spent an inordinate amount of time in the quest for it, regardless of how dearly it cost them or how noxious the substances used might be. What's more, with the rise of Christianity in Europe, it's not surprising that the new role model for femininity, behavior, and beauty was the Virgin Mary—a trend that continued well into the fifteenth century and beyond.

Ethereal was in, and medieval women experimented with numerous concoctions to give their skin the desirable luminosity associated with virginal

Death in Venice

Venetian ceruse (also known as spirits of Saturn) was the most fashionable, expensive, and toxic skin whitener available during the sixteenth century, from the city "famous for heavily painted women as well as for the finest ceruse or white lead, a basic ingredient for face-painting."[9]

It has always been unclear to me what exactly made Venetian ceruse any different from regular ceruse. It's my belief that there was very little difference between them, and that Venetian ceruse was in fact the first upmarket makeup "brand"—marketed as being better, more exclusive, more expensive, and more desirable than other very similar (if not identical) products. A book originally published in 1688 contains a recipe for ceruse called "Magistery of Saturn or Lead."[10] After describing a mixture of water, vinegar, and lead, which is dried and washed, the author states that this product is a simple ceruse used as makeup. Later, he cautions the reader to choose their ingredients for the recipe carefully:

> be sure to chuse a true Ceruse of Lead, such as we call Venetian Ceruse, and not that which is counterfeited, as being mixed with Chalk, Whiting, or other like Substances, having neither the brittleness, weight, nor whiteness of the true Ceruse, or that of Venice.[11]

This suggests that ceruse is the name of the actual cosmetic and Venetian ceruse is the main ingredient (and also the finished product): a pure white lead powder, not a mixture of lead and other white substances. So, essentially, Venetian ceruse and ceruse contained the same ingredients, but Venetian ceruse possibly contained a more intense, concentrated form of lead—in the same way as expensive face creams today might boast they contain a "higher dose of active ingredients."

Mainly favored by European aristocracy, who would've been able to afford it, the purity of the lead in Venetian ceruse, along with its opacity and satin-smooth finish, made it the ultimate and most desirable white foundation. The trouble was, the more one used, the more one needed to cover up the ill effects it caused. With long-term application, skin became discolored, gray, and withered with hints of yellow, green, and purple—so one ultimately ended up looking like dried-up, old fruit. Continued use also rotted the wearer's teeth, produced bad breath, and caused hair loss and even permanent lung damage. Venetian beauties of the time, including the grand dame of the fashion world, Queen Catherine de' Medici of France, were also fond of the brightening combination of mercury (the go-to ingredient for fading spots and erasing freckles) and arsenic, pepped up with a touch of animal musk. Ironically, musk and its components can actually trigger hypopigmentation—showing yet again that the more money one had to spend on beauty products, the worse one could ultimately look.

Venice was the epicenter of fashion at the time, and the naming of Venetian ceruse is perhaps the first example of a product being connected to a desirable location through its name. This location-based trend first appeared in ancient Egypt and continued throughout the classical civilizations. Interestingly, despite Paris later becoming the focal point of the beauty world, Venice retained its appeal, as shown by the fact that hundreds of years later Elizabeth Arden marketed her first range of expensive cosmetics as "Venetian."

The decadent parties of sixteenth-century Venice and the excessive makeup worn continues to fascinate makeup artists, filmmakers, and fashion photographers to this day.

beauty. The perception of color in medieval times was very different from what it is now: In a world where light was difficult to come by, especially in the long, dark winter months of northern Europe, color was measured by its brightness, so anything glowing or luminous was revered. If you consider that for much of this period the only type of art that regular people got to see were the (often magnificent) stained glass windows in churches and public buildings, in which the images portrayed were illuminated by the light shining through, then you can see why light had such significance. Jacqueline Spicer explains that a continuous distinction was made between "whiteness" and "fairness." The latter was associated with what was described at the time as "glistening"[12]—what we would think of as glowing skin—which is remarkably close to the language used to promote skincare products today that often promise to deliver glowing or luminous skin.

The beauty products women used to achieve this effect were largely homespun. Working-class women and those living in rural areas would have grown the ingredients required to prepare potions for lightening skin themselves, or bought them from passing peddlers and salesmen. Recipes for making these mixtures were kept by local wisewomen or passed down through families. Medieval writers documented the use of skin lighteners and brighteners with recipes that included chickpeas, barley, almonds, horseradish seeds, and milk—all pretty harmless. It's ironic that those with fewer means would have been forced through necessity to use ingredients for their homemade beauty treatments that were a lot kinder to the skin than the lead-based alternatives that continued to be available. In terms of beautiful skin, it

paid to be poor. That being said, these DIY creations still required a huge investment of time and some pretty obscure-sounding components. You could be forgiven for thinking that this recipe from the *Trotula* was something Harry Potter had to whip up in a potions class:

For whitening the face, take root of bistort and clean it, and root of cuckoo-pint. Grind them in a mortar with animal grease and mix them with warm water, and strain through a cloth. And afterward stir well and thus let it sit all night. And in the morning gently remove the water, pouring in fresh water; water made from honeysuckle as well as from roses is the best thing for this. You should do this for five days. This is done to repress the herbs' harsh properties lest they cause lesions to the face. On the sixth day, having thrown out the water, expose to the sun and let it dry, and afterward take three parts of white lead and one part of camphor, and one dram each of borax and gum arabic. We dissolve the borax in rose water, rubbing it between the hands. All these we mix in rose water. Note that when you wish to whiten the face, take from this mixture a quantity the size of a bean and mix it with cold water, and rubbing a little between the hands, with both hands we anoint the face, but first we should wash the face with water and soap. Then we sprinkle the face with cold water, and we place on it a very delicate cloth; this should be done either in the morning or in the evening. And note that it lasts three days or four.[13]

Throughout Europe, from the Dark Ages to the Golden Age, snow-white skin continued to be the epitome of beauty during the Renaissance. Idealized images of women (created, it's worth noting, by male

Lola Montez was among those crusading for better, less harmful, and more natural ingredients in makeup during the mid-nineteenth century.

artists) in paintings, frescoes, and sculptures tell us a huge amount about the period's beauty ideals and aspirations. Women in European paintings from this time are voluptuous, with ivory skin, often offset by deep red lips and flushed cheeks—which, in reality, would have to have been created by the use of cosmetics, yet the obvious application of face paint was considered to be dishonest. As well as the ubiquitous lead paste, arsenic, and mercury, raw egg whites were employed to prime the skin, topped with whitening pastes to create a lacquer-effect foundation.

Although physicians cautioned women on the danger of some of the ingredients, and the Church of England considered cosmetics to be the work of the devil, women continued to aspire to "virginal white," applying lethal ceruse as foundation to the face and décolletage, with some rather unpleasant side effects:

The ceruse or white Lead, wherewith women use to paint themselves was, without doubt, brought in use by the divell, the capitall enemie of nature, therwith to transforme humane creatures, of fair, making them ugly, enormious and abominable . . . a man might easily cut off a curd or cheese-cake from either of their cheeks.[14]

The Ceruse or white lead which women use to better their complexion is made of lead and vinegar which mixture is naturally a great drier; and is used by chirurgions [surgeons] to drie up moiste sores.[15]

Giovanni Lomazzo goes on to describe the women who use ceruse as quickly becoming "withered and gray-headed." Not a desirable look, or the one intended. And there may have been other side effects: The fashion for high foreheads around this time could very well have been due to the fact that lead paint caused hair loss and bald patches.

Women may have been forced to shave or pluck the remaining unsightly patches with the result that their hairline gradually moved backward. Despite the numerous drawbacks, by 1685, most aristocratic European women (and men) were layering on the white face paint.

The fashion for a painted, porcelain complexion continued until the English Restoration and the French Revolution, after which makeup was toned down. Yet pale skin continued to be the ultimate beauty goal, for reasons of class and social standing. Chaste, respectable women were expected to protect their fine skin from the sun's rays with parasols: Exercise was a no-no and seen as too much exertion for "delicate" ladies. It was a faux pas to appear to be wearing any makeup, so the more garish (and poisonous) topical skin whiteners were less popular, as they looked too obvious on the skin. Instead, white zinc oxide powder was used, as it gave the necessary whiteness but looked more natural on the skin. Lavender and blue-tinted face powders also became popular for evening use, as they gave the face an incandescent paleness and counteracted the yellow glow of candlelight and oil lamps. Undetectable makeup was the "in" style during the Victorian era. The prevalence of tuberculosis during this period and its hold on the imagination of writers and artists also led to a (what now might seem rather strange) reverence for "consumptive beauty."

As women sought to appear to have perfect skin while using less makeup, skin-lightening skincare and ingestibles became popular. Lotions and potions containing hydrochloric acid (muriatic acid), ammonium, hydrogen peroxide, arsenic, and mercury compounds were all the rage for their freckle- and

Throughout many periods of European and East Asian History a pale powdered face, of varying degrees, has been considered the height of beauty.

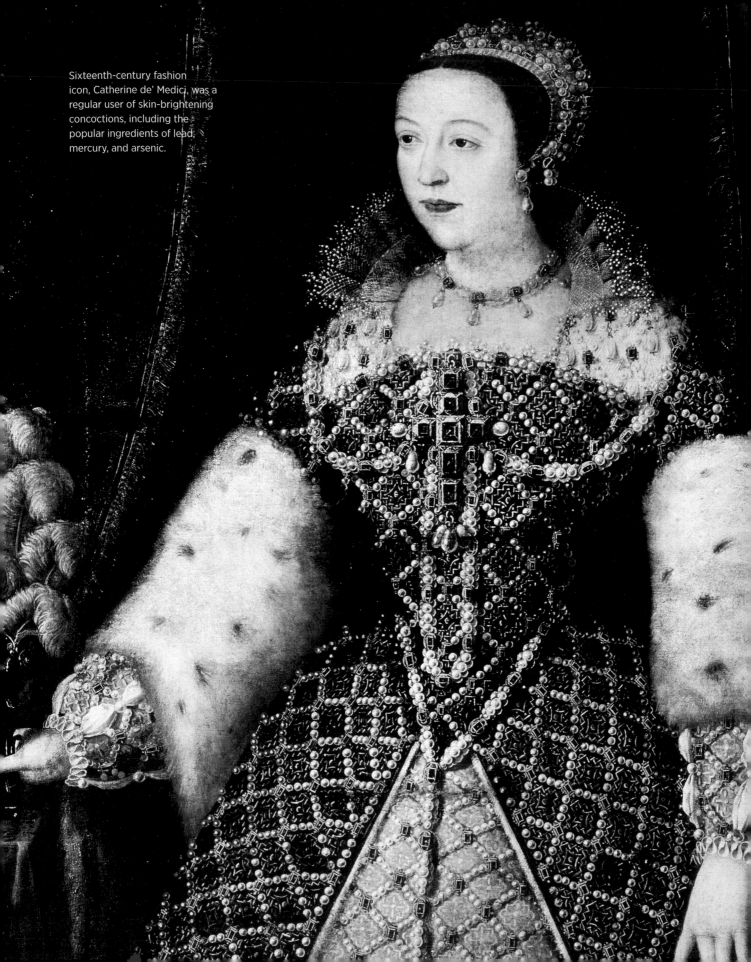

Sixteenth-century fashion icon, Catherine de' Medici, was a regular user of skin-brightening concoctions, including the popular ingredients of lead, mercury, and arsenic.

Before tanning became fashionable, skin that showed no effects of sun exposure was directly tied to status.

pigmentation-fading properties. A famous beauty of the time, Lola Montez, a self-styled authority on skincare and cosmetics, began a personal crusade to steer women away from artificial cosmetics. In her book, *The Arts of Beauty*, which was published not long before her early death, Montez shared tips and tricks, along with recipes gathered from across Europe, many of which promoted the virtues of skin whitening. Accredited to the court of Spain, this recipe promised "a polished whiteness to the neck and arms":

Infuse wheat-bran, well sifted, for four hours in white wine vinegar; add to it five yolks of eggs and two grains of ambergris, and distill the whole.[16]

However, she was wholly against women ingesting ingredients such as chalk, slate, and tea grounds, describing these methods as destructive to the health. Montez was just one of many women (and men) in the early Victorian era who crusaded for the moderate use of makeup and the end to artifice in beauty. But it didn't last. Even before Queen Victoria's death, the use of skin whiteners and other cosmetics such as rouge was becoming popular among women of all classes. On the positive side, less harmful products for achieving fair skin were discovered and the rise of women's journals meant that women shared their findings and became more savvy about

potentially harmful whiteners like arsenic and lead. French chalk and powder of magnesia achieved a more natural finish, and were unlikely to poison the wearer. By the end of the century, cosmetic manufacturing was beginning to be a big business and attitudes were changing quickly.

Well into the 1900s, white lead-based powders were sold all over the Western world and the United States. Though today the FDA monitors products available to consumers for safety, it has not yet set limits on the amount of lead allowed in cosmetics, unlike in the EU, where it is illegal to sell cosmetics with any lead. It would be fair to presume that we modern women have come a long way from swallowing arsenic in order to alter our complexions. But when it comes to our skin, are we taking steps backwards? It's disturbing to learn that history is repeating itself, with toxic skin whitening a growing trend once again. It's not just the chemicals used that are damaging. Some companies sell products which are actually safe to use, however, their advertising propogates a message about lighter skin being superior that is far more destructive than the products themselves. And with regulations and their enforcement varying from country to country, millions of women (and some men) throughout Africa, the Middle East, and parts of Asia are once again using damaging chemicals to lighten the color of their skin, encouraging cosmetic skin lightening to reach its ancient status once again—a sobering thought.

Elizabeth I and Lettice Knollys

It's hard to think of a more dramatic beauty icon than Elizabeth I, the ruler of England and Ireland for forty-five years. When we think of Elizabeth, or the period of English history named after her, an image from one of her portraits usually springs to mind: titian hair, porcelain skin, and a formidable expression and carriage that convey her sentiment that though "a weak and feeble woman," she had "the heart and stomach of a king."

Perhaps unsurprisingly for someone whose image would have come under intense scrutiny, Elizabeth is said to have been very vain and preoccupied with being the most youthful and beautiful in court. She certainly knew the value of controlling her own image, as Robert Cecil, her secretary of state and adviser, attested around 1570: "Many painters have done portraits of the Queen but none has sufficiently shown her looks or charms. Therefore Her Majesty commands all manner of persons to stop doing portraits of her until a clever painter has finished one which all other painters can copy. Her Majesty, in the meantime, forbids the showing of any portraits which are ugly until they are improved."

Apart from the portraits that made it past Elizabeth's scrutiny, we can draw on surviving descriptions of her appearance. A visitor to the royal court commented that, at the age of twenty-four, "although her face is comely rather than handsome, she is tall and well-formed, with a good skin, although swarthy; she has fine eyes and above all, a beautiful hand with which she makes display."

Elizabeth used various cosmetics to lighten the appearance of her "swarthy" skin (inherited, perhaps, from her mother, Anne Boleyn, who is reported to have had olive skin). Snow-white skin was the epitome of beauty in England and throughout Europe during the Elizabethan age, and a wide range of products were used to make skin appear fair, translucent, and smooth, ranging from egg whites and alum to deadly Venetian ceruse—all of which Elizabeth is reported to have used at different stages in her life. We know that she used cosmetics, as she was portrayed with a visibly made-up face, and when described by the court poet Richard Puttenham, the implication seems clear that her beauty was enhanced by cosmetics: "Two lips wrought out of rubie rocke / Like leaves to shut and to unlock."

In 1562, Elizabeth is known to have contracted smallpox, and the scars this left on her skin, along with the general effects of aging, led her to apply ceruse (in particular Venetian ceruse, which gave her an especially ghostly finish). Unfortunately, though a highly effective skin lightener, ceruse was also incredibly toxic, and would've left Elizabeth's skin looking gray and withered. Over time, Elizabeth would have needed to use more and more ceruse just to cover up the damage caused to her skin—and rouge too, to disguise the aging process (and perhaps distract from the effects of the ceruse).

But the queen's look—the ceruse, rouged cheeks

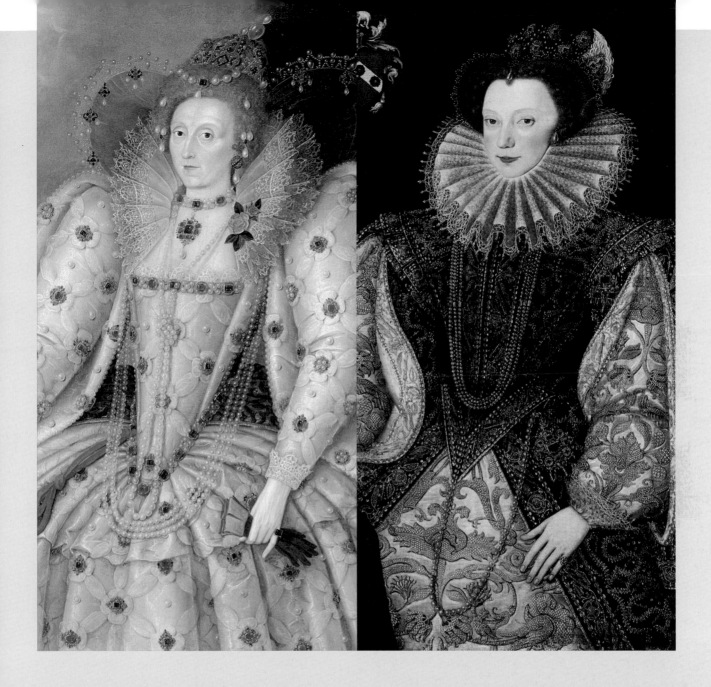

and lips, finely painted on blue veins (to give the illusion of fine and translucent skin), and eyebrows plucked to a high arch—had an intention beyond just bowing to the fashion of the times and maintaining youth: It was designed to convey power and her status as ruler. It's ironic, then, that some believe that the arsenic, lead, and other dangerous chemicals in her cosmetics were to blame for her death from blood poisoning at the grand old age of sixty-nine—though we'll never know whether or not this was the case.

Though Elizabeth is not often considered to have been a conventional beauty, her cousin, Lettice Knollys (whose mother was Anne Boleyn's niece), was thought to be one of the most naturally beautiful women at court during the beginning of Elizabeth's reign and is said to have epitomized the ideal Elizabethan beauty. The most famous painting of Knollys shows her with her flame-colored hair, high forehead, pale complexion, and rose-hued cheeks (whether enhanced by Knollys with rouge, or by the painter, it's impossible to say).

Elizabeth Siddal

The ultimate Pre-Raphaelite icon (described as a "Pre-Raphaelite supermodel"), Elizabeth Eleanor Siddal is famous for her starring role in many of the movement's paintings, particularly the work of her lover and husband, Dante Gabriel Rossetti, as well as her own artwork and poetry.

But her icon status wasn't immediate, as she wasn't considered a typical Victorian beauty; at the time, red hair wasn't seen as desirable and was even considered an ill omen by some. Apparently, a boy in a small town once asked Siddal whether there were elephants where she came from, associating her red hair with exotic destinations.[17] Her origins were not grand: She was working in a shop in Holborn in London when she was discovered by painter William Deverell, who chose her to model for his painting *Twelfth Night* because of her red hair and thin figure. On meeting her, William Holman Hunt described her as a "stupendously beautiful creature . . . like a queen, magnificently tall, with a lovely figure, a stately neck, and a face of the most delicate and finished modelling."[18]

It's as Sir John Everett Millais's *Ophelia* (1852) that most people think of her—a tragic, pale-faced heroine, floating in the river. Part of the permanent collection at Tate Britain, *Ophelia* is the gallery's most popular postcard, and the story of the sitting is legendary. Millais purchased a vintage wedding dress for Siddal to wear and submerged her in a bathtub to re-create the pose of the drowned Ophelia. During one sitting, the lamps heating the water went out without Millais noticing—Siddal didn't mention it and

let the artist continue, which left her with a "severe cold." Millais eventually paid her doctor's bills after her father threatened to sue him,[19] and whether coincidental or not, after this point, Siddal's poor health became chronic. She was diagnosed with consumption and scoliosis, though many now suggest the real reasons for her poor health were undiagnosed. Whatever the case, she soon became addicted to the laudanum she took to ease the pain, which further contributed to the deterioration of her health.

Rather than detracting from her perceived beauty, Siddal's illness seemed to actually increase it—in keeping with the Romantic association of ill health with genius and beauty. In 1853, Rossetti wrote, "Lizzy . . . is looking lovelier than ever, but is very weak,"[20] and the following year, painter Ford Madox Brown wrote, "saw Miss Siddal looking thinner and more deathlike and more beautiful and more ragged than ever, a real artist, a woman without parallel for many a long year."[21] In addition to the laudanum, Siddal was apparently a "devoted swallower" of Fowler's Solution, a so-called complexion improver made from dilute arsenic, which may have poisoned her (according to Bill Bryson's 2010 book, *At Home*).

This Romantic "cult of invalidism" was already in operation in the early nineteenth century. The Napoleonic Wars had limited supplies of cosmetics and put a general damper on the years, helping to create masses of "ill" young women. This was still in full swing just a decade before Siddal began modeling. Young women re-created the "consumptive look" by drinking vinegar to achieve pale skin

and staying up late reading to achieve dark circles around their eyes, and they got the "glazed look" by dropping belladonna in their eyes.[22] Drinking large amounts of vinegar was used as a method to keeping one's weight down,[23] with tips on drinking vinegar appearing regularly in publications throughout the nineteenth century.

Siddal's own work was often medieval or mythological and her iconic status is also based around mythological events. She died in 1862—by accident or by her own intent—after drinking half a bottle of laudanum. There's been speculation that Rossetti burned her suicide note; he did bury his poems with her, but (regretting this gesture) he exhumed the coffin seven years later to retrieve them, after which point another myth was born that Siddal's famous hair had continued growing until it filled the entire coffin.[24]

to spring to mind. Where other types of makeup can be difficult to trace, kohl is recognized as being an ancient Egyptian invention. There's barely a piece of Egyptian art or sculpture that doesn't depict a figure with heavily defined eyes and eyebrows: The frescoes that line the interior of the Valley of the Kings and the Valley of the Queens show both male and female Egyptians sporting thick eyeliner. And even if you aren't familiar with the existing art from this period, kohl has been immortalized as *the* Egyptian makeup item of choice through film and television—think of Elizabeth Taylor's iconic Cleopatra, with dramatically defined and extended dark eyes (as is often the case in Hollywood, the blue sixties eye shadow takes some historical license).

Of course, it's possible that the stylized eyes so synonymous with the Egyptians could have been emphasized or exaggerated for artistic purposes, but we know that they used makeup thanks to the discovery of kohl containers and grinding palettes from a variety of early burial sites. These excavations also suggest that, unlike some other ancient civilizations, Egyptian cosmetics were not the reserve of the wealthy or high-powered, as makeup palettes have been found in the most modest of graves and tombs of both sexes. While poorer Egyptians would have used basic, inexpensive containers like jars, shells, or reeds to hold their kohl and other cosmetics, the wealthy housed theirs in carved ivory containers and used highly decorative mixing palettes, spoons, and applicators.

Generally, the kohl used by the Egyptians was a complex blend of ingredients including crushed

LEFT: Elizabeth Taylor's *Cleopatra* (1963) cemented the image of exaggerated Egyptian kohl in popular culture that has survived to this day.

OPPOSITE: Ancient Egyptian art shows stylized lining around the eyes but, as with all art, historians and archaeologists are unsure how much of this is subject to artistic license.

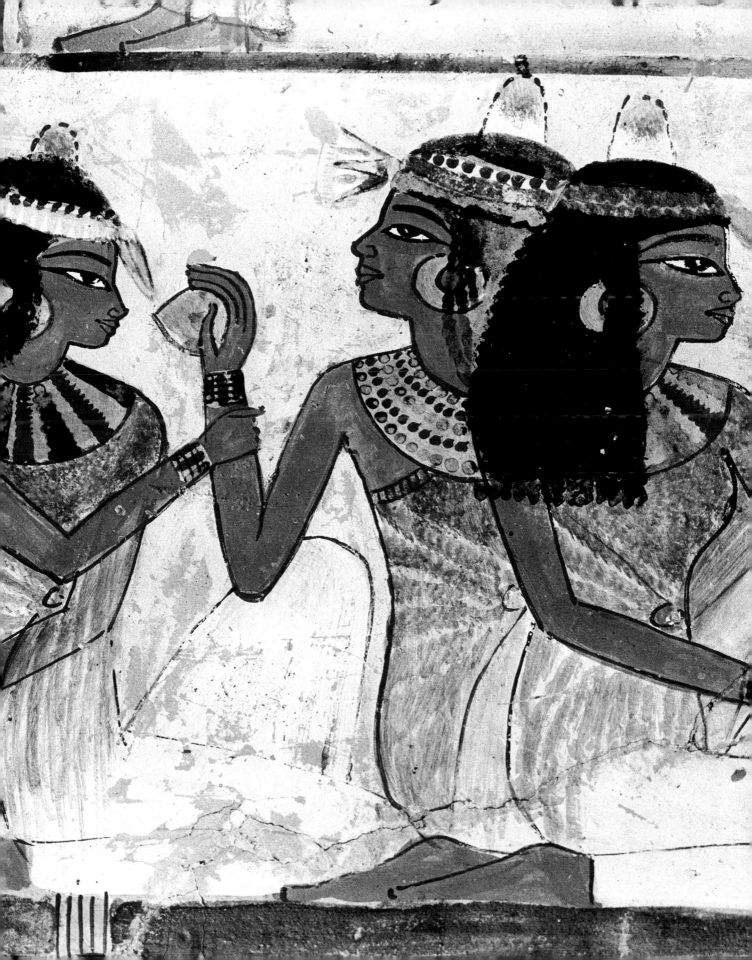

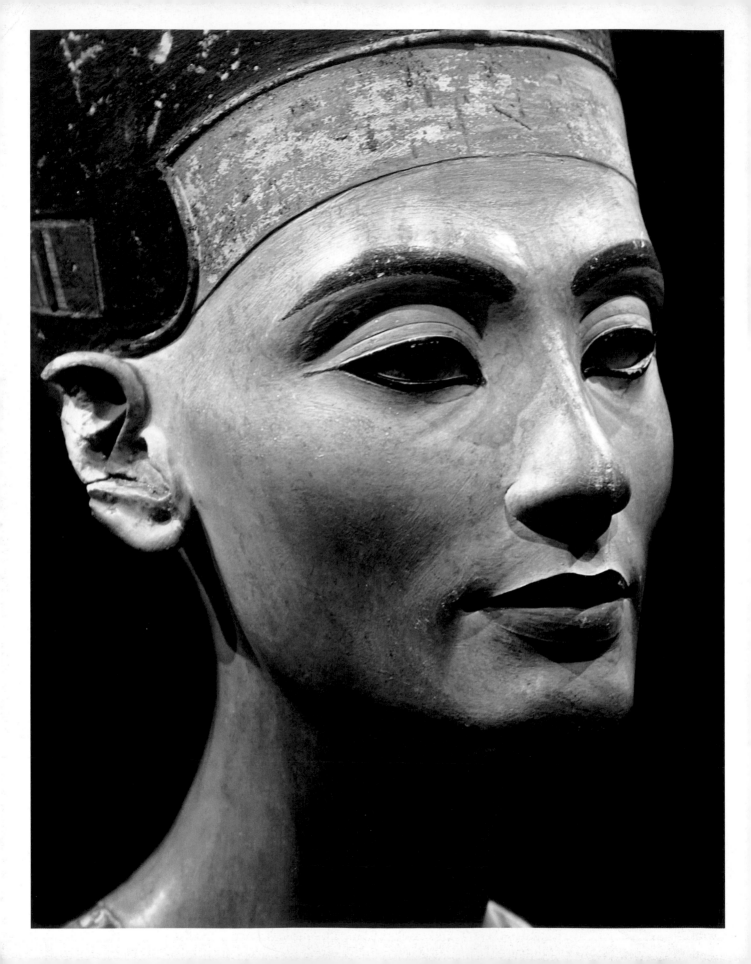

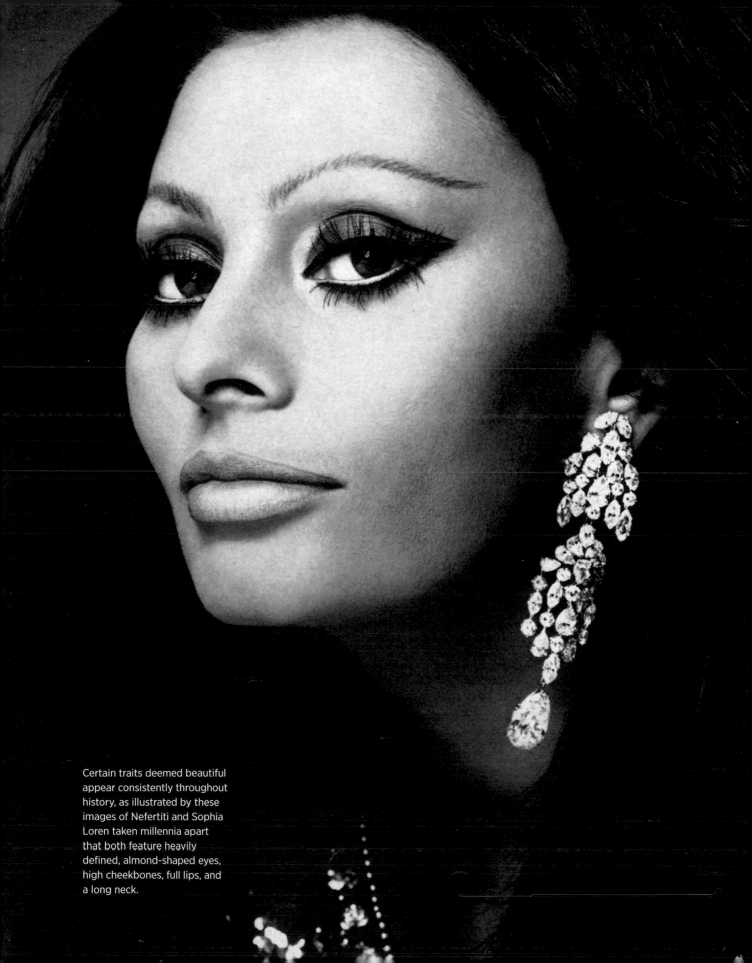

Certain traits deemed beautiful appear consistently throughout history, as illustrated by these images of Nefertiti and Sophia Loren taken millennia apart that both feature heavily defined, almond-shaped eyes, high cheekbones, full lips, and a long neck.

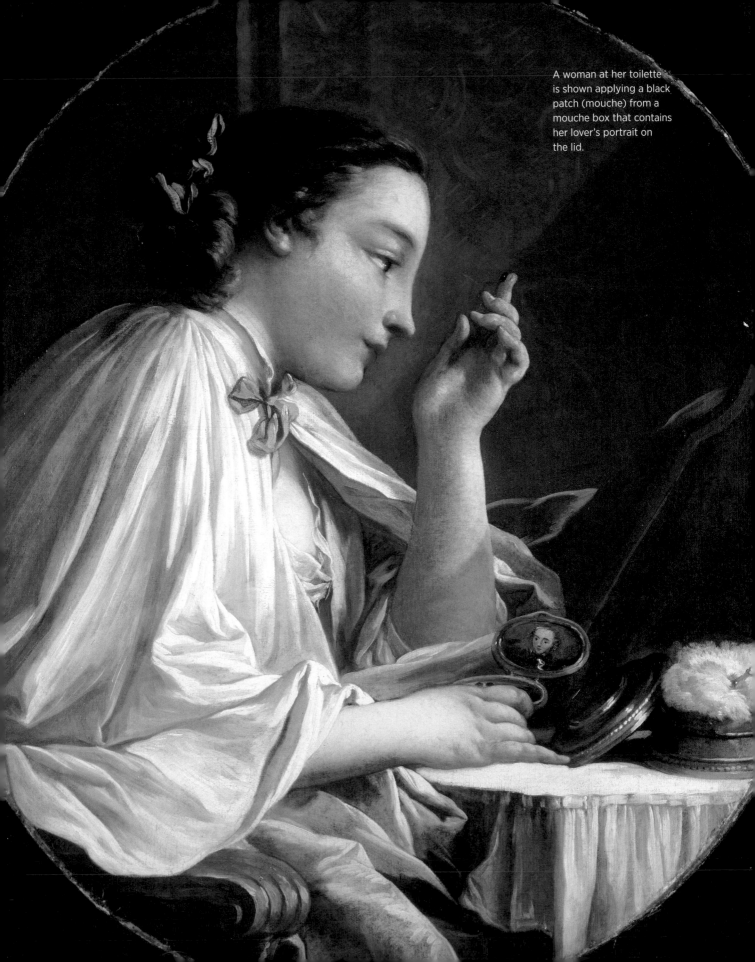

A woman at her toilette is shown applying a black patch (mouche) from a mouche box that contains her lover's portrait on the lid.

Patching Things Up

When you think of beauty marks, Marie Antoinette and ruffled gowns probably spring to mind, but dots or patches were in use long before this. There is evidence that Roman women applied what was referred to as *splenia* to their faces to cover up blemishes. It's at the end of the sixteenth century, however, that they really took off.

Along with the usual whitening pastes and potions that served to conceal uneven pigmentation, scars, and pockmarks, those who could afford to purchased small black patches (*mouches*) made from silk, velvet, satin, and taffeta to hide imperfections or to highlight their porcelain-pale skin. It's no coincidence that patches became popular at this time: The ravages of smallpox meant that many people were left with scarring or pustules, and in the absence of Photoshop, sticking on a patch was the next best thing. Patches were cut into a variety of shapes, including hearts and circles, which were applied to the skin to conceal flaws. When worn in particular positions, they signified different things: If one wore a patch on the right cheek, this showed that you were married, while a decorated left cheek signified that you were engaged. A patch worn by the mouth meant that one was up for grabs, whereas an embellishment at the corner of the eye declared that one was a mistress. In eighteenth-century England, patches took on a political meaning, with supporters of Whigs and Tories wearing patches on opposite sides of the face.

In 1719, Henri Misson, a Frenchman who wrote about his travels in England in the seventeenth century, commented on English women:

> *The Use of Patches is not unknown to*
> *the French ladies; but she that wears*
> *them must be young and handsome.*
> *In England, young, old, handsome,*
> *ugly, all are bepatch'd . . . I have often*
> *counted fifteen Patches, or more, upon*
> *the swarthy wrinkled face of an old Hag*
> *threescore and ten, and upwards.*[2]

antimony (a silvery gray metalloid), burnt almonds, lead, oxidized copper, ochre, ash, malachite (a green pigment made from copper oxide), and chrysocolla (a blue-green copper ore) that were combined to create a black, gray, or green pigment. This would then be stored in containers of stone, moistened with water or oil, and mixed in a cosmetics spoon or palette before being painted on with a specially designed applicator to the rim of the eyes and to the eyebrows. A pot in the British Museum from the tomb of a scribe even specifies the periods of use—"good for every day, from the first to the fourth month of the flood season, from the first to the fourth month of winter, from the first to the fourth month of summer"—suggesting that different forms of the cosmetic may have been used at different times of the year.[3] Amazingly, the kohl available today is not so different from the stuff used millennia ago. The applicators and containers are also eerily similar: Real kohl usually comes in a little box containing a sticklike applicator and a compartment for the makeup itself.

It's not just the tools used to apply the kohl that were remarkably advanced. Recent studies of ancient samples have shown that the Egyptians were incredibly knowledgeable cosmetologists who used two distinct types of kohl and eye paint. The first, *udju*, was made from green malachite originating from Sinai, an area that was considered to be the spiritual dominion

"Black is boundless, the imagination races in the dark."

—Derek Jarman, *Chroma*

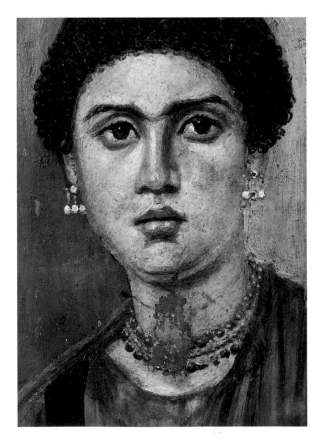

ABOVE: Women in ancient Greece used burnt cork and soot to fill in their eyebrows, which were considered most beautiful when they connected across the bridge of the nose.

OPPOSITE: Although the mainstay of Middle Eastern, North African, and South Asian makeup for thousands of years, the modern day practice of wearing kohl in the West can be traced back to the discovery of Nefertiti's bust in 1912, which immediately set a trend for dark eye makeup that spread to many countries throughout the world.

associations, but most often depicted as a falcon. The Eye of Horus—known as *wedjat*—was used as a symbol of protection. The symbol of the eye is heavily outlined, so it's easy to see why the connection has been made. Another spiritual association is the link between the goddess Hathor and malachite; perhaps, for Egyptian women, applying the powder to one's eyes was to share in something of the essence of Hathor herself.

Whatever the initial reasoning behind the use of kohl, it's likely that what started out as a basic or practical need later became decorative. Color may have been added as an afterthought to unguents and ointments used to keep out dust, but we know that fashions in kohl application changed throughout Egyptian history. In the Old Kingdom (c. 2686–2181 BC), emerald-green eye shadow and kohl was the most popular combination for eye defining and brow shading, applied from the inner eyebrow to the tip of the nose. Later, in the New Kingdom (c. 1550–1070 BC), black replaced green as the color of choice. King Tutankhamen's sarcophagus depicts the pharaoh with heavy eyeliner that extends from the outer corners of the eyes to the temples.[5]

Although there's not a great amount written about cosmetics in the first Persian empire (550–330 BC), the sculpted eyes of the carvings and reliefs of Persepolis emphasize the importance given to eyes and eyebrows, not only aesthetically but also symbolically as a source of spiritual knowledge. In Persia, kohl was

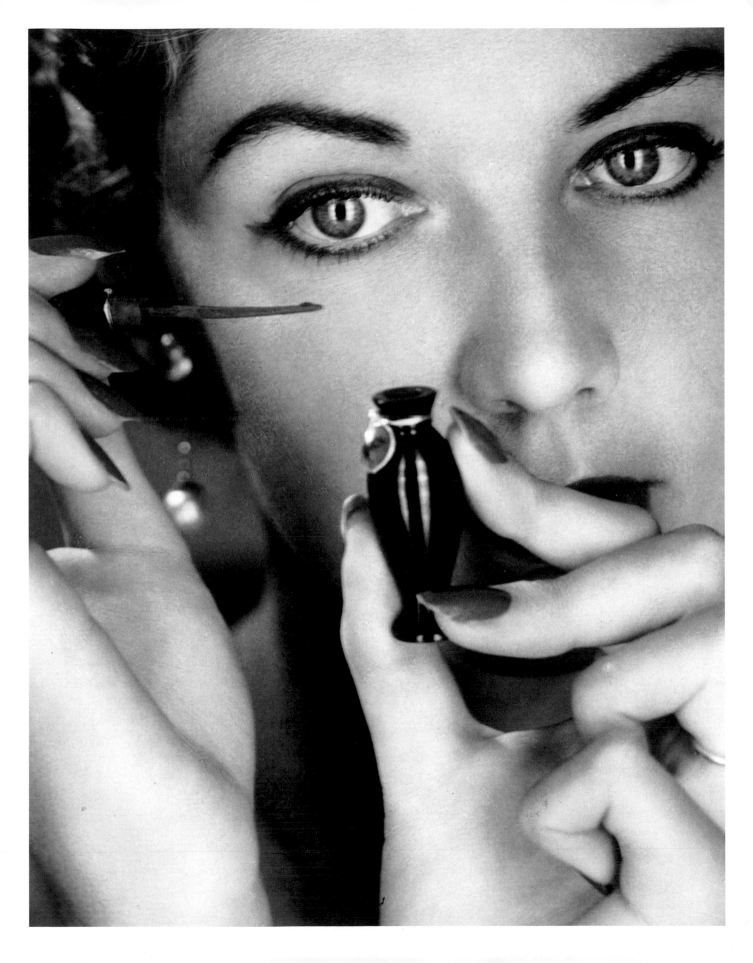

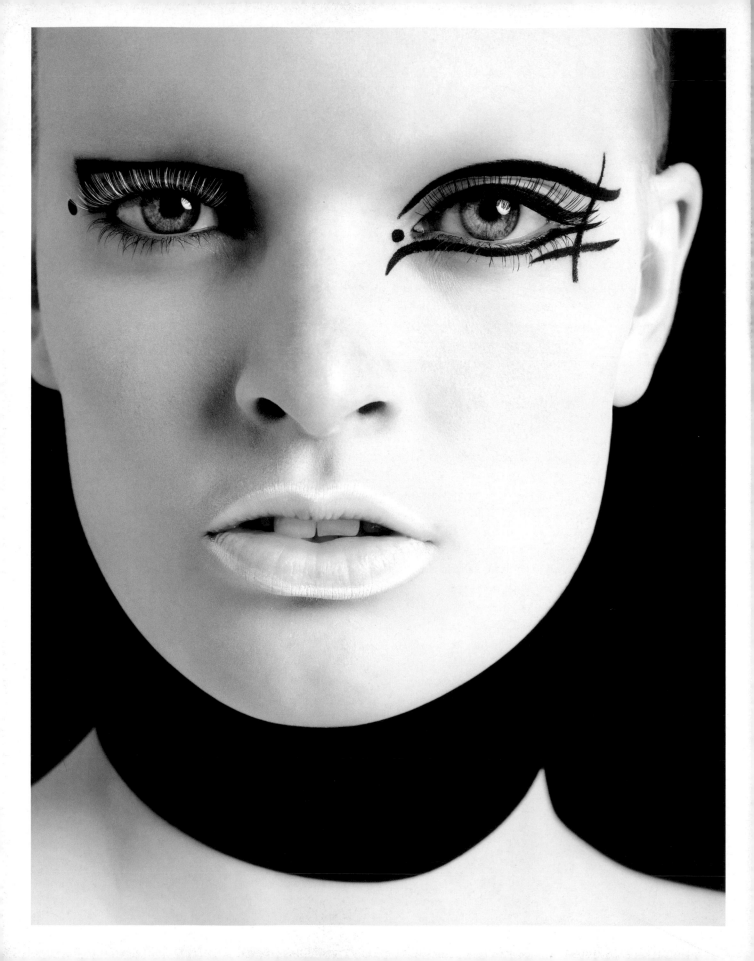

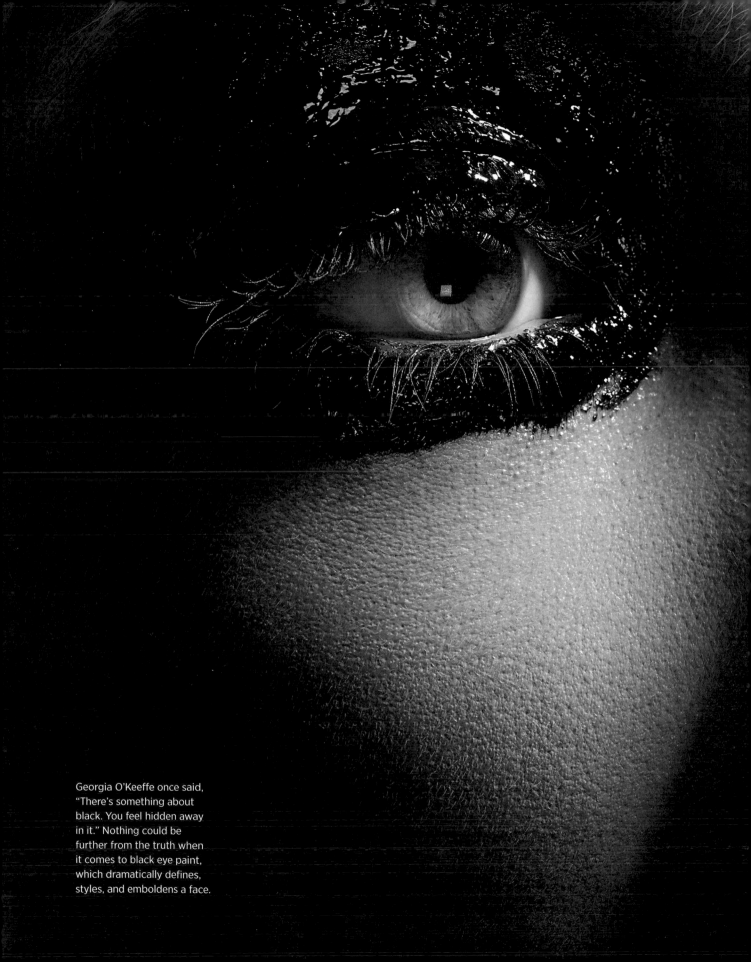

Georgia O'Keeffe once said,
"There's something about
black. You feel hidden away
in it." Nothing could be
further from the truth when
it comes to black eye paint,
which dramatically defines,
styles, and emboldens a face.

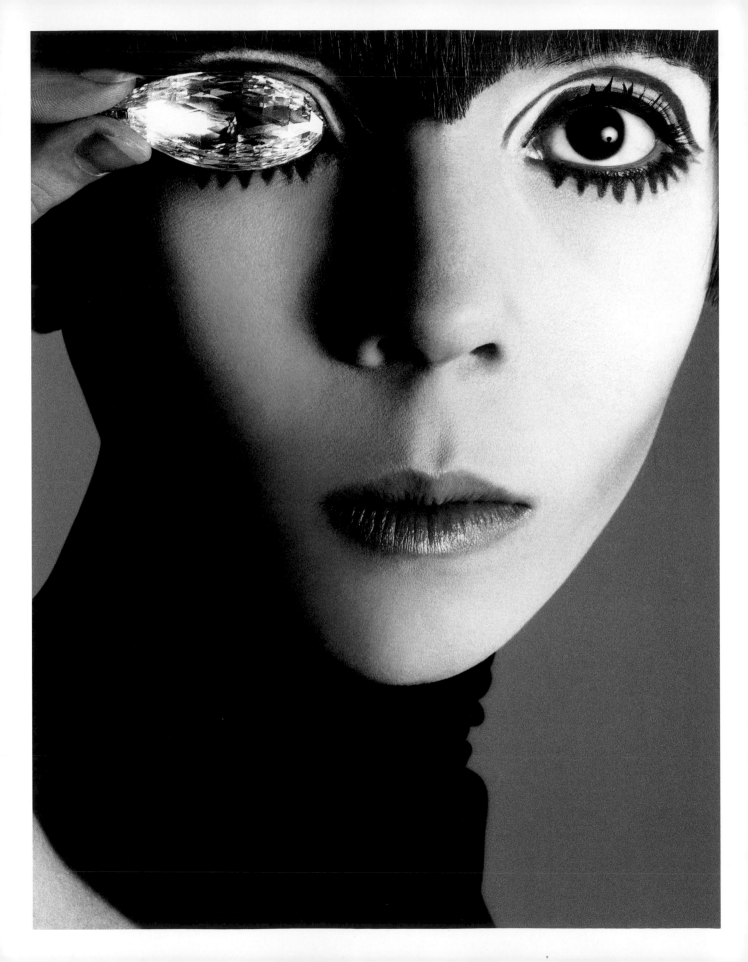

"I've been forty years discovering that the queen of all colors was black"

—Pierre-Auguste Renoir

the oldest and most important of the seven items of cosmetics (referred to as *haft qalam arayish*) and was applied for ritualistic and therapeutic purposes, just as in Egypt. Also known as *surma* (*kuhl* or *atwad* in Arabic), kohl was obtained from a variety of substances, though mainly from powdered iron ore. The *Farhang-e Anandraj*, an ancient text, describes how surma was obtained by grinding a shiny stone such as antimony until it was reduced to a soot-like powder that could be used on the eyes.[7] The trend for this style of makeup persists: Even today, a Middle Eastern bride would be nothing without kohled eyes.

Like their Persian counterparts, Athenian women favored a combination of antimony, burnt cork, and soot to emphasize their eyes. Eyebrows were also darkened with a soot-based mixture (and, if they met above the nose in a Frida Kahlo–esque fashion, then so much the better, as this was considered a sign of beauty; this was also the fashion for Roman women who used antimony, lead, or soot to color and fill in their brows). The addition of white powder to eye makeup was thought to cure eye disease in Greco-Roman times, most likely as it contained nitric oxide. However, the use of obvious eye makeup in Rome was considered to be the reserve of "disreputable" women, due to the belief that direct eye contact between a man and a woman was explicitly linked to sexuality and eroticism.

Black eye makeup is so popular today that it's hard to imagine a time when it wasn't used. But despite the fact that kohl was the ancient cosmetic of choice—and continued to be used throughout India, South Asia, the Middle East, and parts of Africa for religious, health, and cosmetic purposes—the preference in Europe following the decline of the Roman empire for pale, rouged skin with minimal eye adornment was constant from the medieval to the Edwardian age. Thus, obviously blackened eyes went out of fashion for well over a thousand years, reemerging as a makeup mainstay in the 1920s. The discovery of Tutankhamen's tomb in 1923—and the fascination with all things ancient and exotic that it provoked—played a major part in eyeliner's comeback (as we shall see), as did Hollywood and the fact that women were beginning to feel comfortable wearing more conspicuous makeup without fear of social disapprobation. Since then, trends and technology have changed, but our love of black paint has stayed constant. In the twenty-first century, you're as likely to see a graphic black liner on a Bollywood film set as on the streets of Berlin or the catwalks of Paris.

Black paint has been used to define eyes with numerous styles and designs throughout history, and although eyeliner is available in many vibrant shades today, black remains the primary color of choice. Penelope Tree, 1967. Photographed by Richard Avedon.

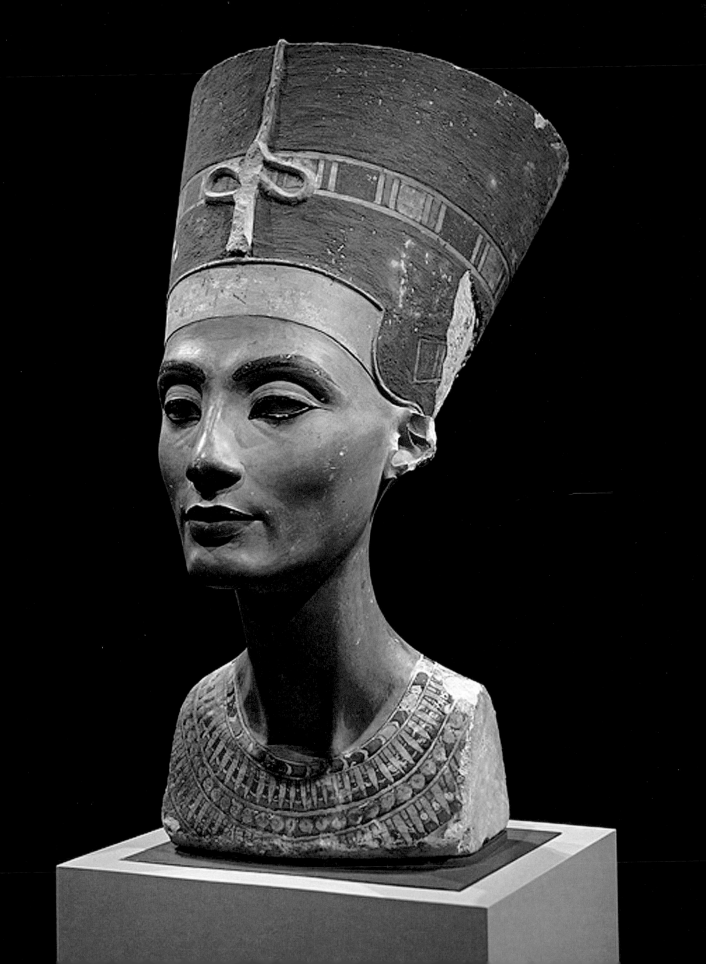

Nefertiti

The most famous Egyptian queen alongside Cleopatra, Nefertiti is synonymous with ancient beauty—even her name itself means "the beautiful one has come." The main reason she continues to figure so prominently in our collective imagination as a beauty icon is the famous bust of her likeness, made of limestone and covered with layers of painted stucco. Created around 1340 BC by the royal court sculptor, Thutmose, and discovered in 1912, it is now displayed in its own room in the Berlin Egyptian Museum (though the Egyptian authorities have been requesting its return for many years).

One of the most important and famous works of Egyptian art, it also provides an interesting insight into ancient beauty values. X-rays and scans were performed on the bust in 1992 and 2009, with the latter scan providing enough detail to see the wrinkles on the limestone core of the sculpture and showed that the "inner" and "outer" faces differ in some aspects. The inner face has less-prominent cheekbones, creases and wrinkles around the edge of the mouth and cheeks, a bumpier nose, and less depth at the corners of the eyelids. The original article written on the 2009 scan notes that the face seen on the limestone core could have been a realistic depiction of the queen, leading newspapers to claim that, through the tweaks made to the outer layer of her 3,300-year-old bust, Nefertiti was the first woman to have been "retouched." Ancient Egyptian women were usually depicted in art as idealized figures, and there's a consensus that signs of aging such as sagging breasts and wrinkled faces are only shown in representations of the lower classes,[8] which Nefertiti's hidden wrinkles bear out.

Idealized outer layers or not, Nefertiti's high cheekbones, arched and defined eyebrows, enigmatic painted smile, and black outlined eyes are strikingly similar to the makeup styles that were popular in the twenties and remain so today. When the bust was first displayed to the public in 1924, the global reaction was immediate: It was a sensation. Following the discovery of Tutankhamen's tomb in 1922, Egyptomania was everywhere and most certainly had a strong influence on the makeup trends of the time. In 1929 UK *Vogue* ran a beauty article titled "The Kohl Pots of Egypt," describing the toilette of Tutankhamen's wife, Queen Ankhesenamen, who was Nefertiti's daughter. Though what is considered beautiful undeniably varies between cultures and different periods of time, it is hard not to view Nefertiti's beauty—which continues to speak to us thousands of years after she died—as something transcendent and timeless. As Nancy Etcoff has commented, "the general genetic features of a face that give rise to perception of beauty may be universal."

Meena Kumari

Born as Mahjabeen Bano in 1932 in Mumbai, India, Meena Kumari came to fame during the golden era of Bollywood cinema. She remains one of the most iconic Bollywood actresses and was certainly one of the most prolific, acting in an astonishing thirty-four films between 1952 and 1960, and appearing in ninety-three films in total over the course of her career.

Bollywood is one of the most popular and successful film industries in the world. Although the first-ever Bollywood film was silent and only forty minutes long, today the films are known for being hugely vibrant, colorful, all-singing, all-dancing visual feasts that really captivate an audience, and normally last around three to four hours (with an intermission!).

Bollywood makeup is an elaborate and highly stylized affair, featuring many elements, and incorporating the traditions of Indian and South Asian weddings and festivals and special-occasion makeup. Heavily kohled eyes in classic shapes are combined with sumptuous golds and rich, jewel-colored tones, along with lots of lashes and well-defined brows, which all help to convey emotion and expression through the eyes. *Bindi* and *mehendi* (the decoration of the palms of the hands and feet) are also used decoratively and to illustrate characters and situations (although the significance differs from culture to culture). Makeup complements the lavish costumes and jewelry perfectly.

Makeup artists in Bollywood were traditionally men, and for most of its history the union forbade women to work on set in that capacity. Reasons cited for this have ranged from protecting men's livelihood to the belief that women would get jealous of the female stars and do a poor job in making them up, sabotaging their potential beauty. It wasn't until November 2014 that India's Supreme Court declared that the union ban on women working as makeup artists in the country's film industry was illegal and discriminatory and must not be allowed to continue.

In 1951, when Kumari was nineteen, she signed up to star in a film directed by Kamal Amrohi. This would change her life: A year later, after a courtship carried out in part through letter writing, Kumari and Amrohi were secretly married. In 1952, the film they had worked together on, *Baiju Bawra*, was released. It was hugely popular and launched Kumari into stardom. *Filmfare*, the equivalent of *Photoplay* magazine in India, wrote that she "has an exciting photogenic face—the sort that cosmetic manufacturers dream of,"[9] and they featured her on their list of the most beautiful actresses. It was a prophetic comment, as the cosmetics manufacturers wouldn't have to dream for long: She became a spokesperson for Lux soap (which was sold as a beauty product by Unilever) at the end of 1953, and her image was everywhere.

Between 1961 and 1964, Kumari began working on *Pakeezah*, a new film written by Amrohi. It took a record fourteen years to film—a stressful time during which Kumari and Amrohi went through a messy and painful divorce. In 1972, only weeks after it premiered, Kumari died from liver disease caused by alcoholism at the age of just thirty-nine. *Pakeezah* would become one of Bollywood's biggest-ever hits and the breathtakingly beautiful Meena Kumari subsequently became known as "the Queen of Tragedy."

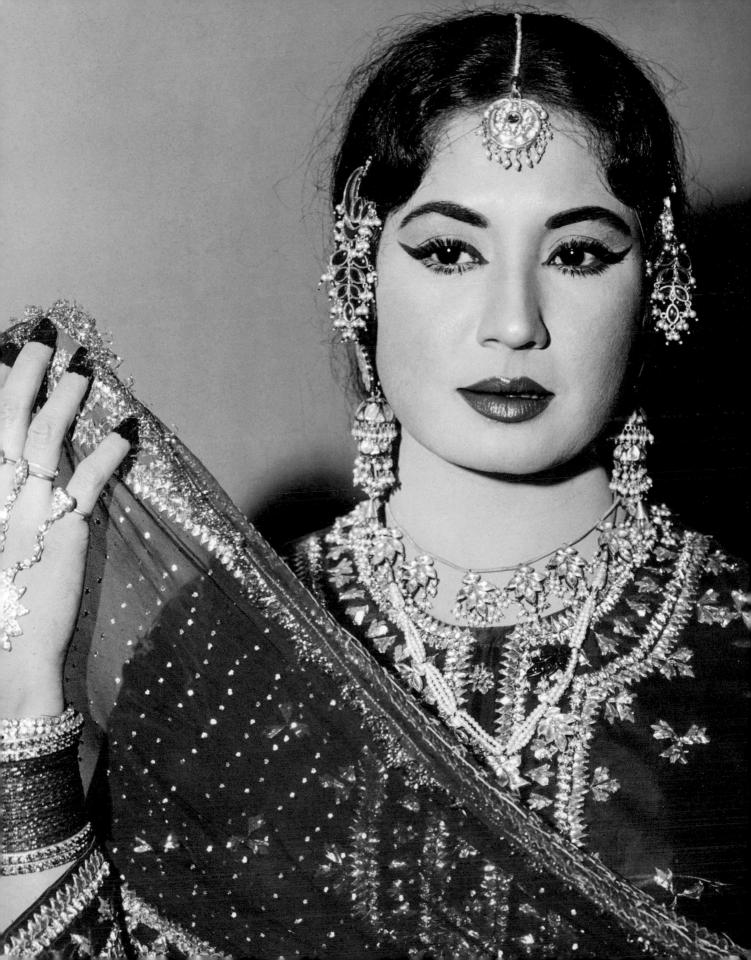

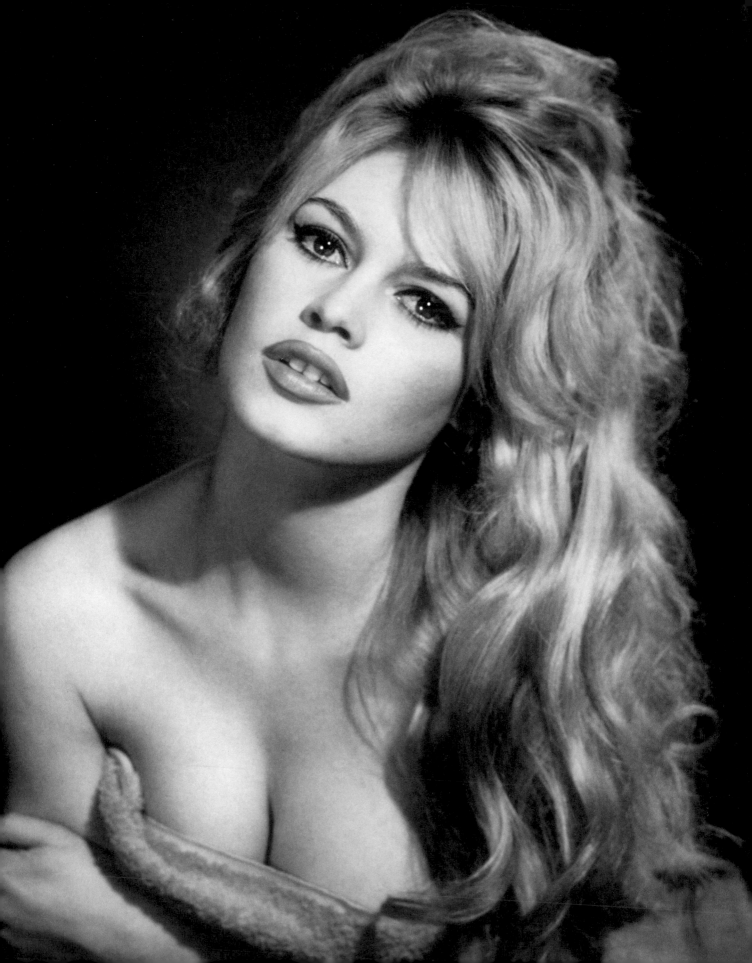

Brigitte Bardot

Born in 1934 in Paris into a well-connected family, Brigitte Bardot began modeling at a young age, appearing in women's magazines and on the cover of *Elle* in May 1949 at the age of fifteen. Three years later she married journalist and film director Roger Vadim and appeared in her first film, *Crazy for Love*. She appeared in several more films over the next four years, but it was 1956's controversial *And God Created Woman* that really made her a star—and introduced the bikini to the world. Interestingly, like Twiggy and Marilyn Monroe, Bardot had her breakthrough after dyeing her naturally brownish hair blond: With this, a bombshell was born.

Her biographer, Ginette Vincendeau, has written that Bardot (known as BB) "set radically new standards of looks and behaviour for women . . . Bardot uniquely combined the 'new' (iconoclastic sexuality, agency, new looks, the insolence of youth) and the 'old' (the object of desire who knew exactly how to strike a pin-up pose)."[10]

Like Twiggy, BB also set trends with her makeup.

The opposite of the round, wide-eyed mod look, she favored a sultry, winged eyeliner in an elongated feline shape, smoky winged-out lids, and full pale lips enhanced to their maximum poutiness with lip liner. Although Bardot very often did her own makeup, Odette Berroyer was employed as her makeup artist, working on many of her movies and appearances from 1955 to 1973, and the evolution of her eye makeup during this time suggests that Berroyer may have had a key part in creating her iconic appearance. The two women were close, and BB even bought Berroyer a flat near her home in 1978.

In 1961, BB was the face of French cosmetics brand Aziza, advertising their eye products with the line "For Bardot and for you, the pure allure of eyes by Aziza." Whether she was a paid ambassadress or they simply used her image without permission is unclear. BB retired in 1973 and became known for her passionate animal activism, though in recent years she has also caused controversy through some of her comments on race, sexuality, and religion.

Audrey Hepburn

Audrey Kathleen Hepburn-Ruston was born in Brussels in 1929. When she was five, she started at an English boarding school, which is where she first began to study ballet. Her time there was cut short by the declaration of war, after which she returned home. Unfortunately, Holland wouldn't stay neutral for long, and Germany invaded in 1940.[11] Hepburn and her family were eventually liberated on her sixteenth birthday in 1945.[12]

When she moved to London after the war, she was told that the five years of malnutrition she had suffered during the occupation meant that she would never be able to dance professionally. It was a huge blow. In 1951, Hepburn was discovered by Colette, the author of the novel *Gigi*, who asked her to play the title part in her book's theater adaptation that same year. This would launch Hepburn's career. Soon after, she got the part in *Roman Holiday* (1953), the role that—apart from Holly Golightly—would come to define her and for which she won an Oscar for Best Actress. Director William Wyler famously said of her, "She completely looked the part of a princess. A real, live, bona fide princess. And when she opened her mouth you were sure you'd found a princess."

Alexander Walker, the author of a biography on Hepburn, took it further, saying that *Roman Holiday* "defined Hepburn's personality and talents for the rest of her life: innocence and good sense, wide-eyed eagerness for life, a gift for happiness, a vulnerability that invited protection, but also an air of natural independence. Her liberated princess had her hair cut by a barber in the film, and the androgynous gamine style was set as the Hepburn look for a generation or more of female filmgoers."[13]

If *Roman Holiday* established her as the gamine, doe-eyed princess, then it was her 1961 portrayal of the fragile, beautiful Holly Golightly in *Breakfast at Tiffany's* (loosely adapted from Truman Capote's novella) that would cement her status as one of the twentieth century's greatest icons.

Throughout her career, Hepburn always worked with Italian makeup artist Alberto de Rossi. She is quoted in an interview as saying, "not only is Alberto simpatico, he's a really great makeup artist. When he is finished with me, I have the assurance that I look much better than I really am."[14]

De Rossi is credited with creating her legendary eye makeup, which Hepburn's son Sean described as being a slow process of applying layers of mascara and then separating each eyelash with a pin. "I remember her saying when he died, crying as though she had lost a brother, that she would rather not work again."

Hepburn's makeup changed quite a bit between the fifties and sixties. In the fifties, her brows were very thick and dramatically penciled in, and she mainly wore red lipstick. In the sixties, although her eye makeup stayed pretty much the same in her signature doe-eyed style, her brows were much lighter and she wore a very soft peachy-pink shade of lipstick, as was typical of the time.

In 1988, she became a Goodwill Ambassador for UNICEF. She was passionately devoted to her cause, visiting over twenty countries in order to spread awareness of poverty. She was particularly interested in helping children and founded Audrey Hepburn's Children's Fund, which is still providing funding to support healthcare and education for children.

Section Two

The Business
Of Beauty

While beauty concerns have been present since the earliest human
civilizations, it is only in recent history that the business of cosmetics
has evolved into the immense industry we recognize today.

Media and Motivation

CREATING THE DREAM

These days we are surrounded by imagery. Whether we are looking through a magazine, watching TV, browsing our phones, or walking down the street, images are impossible to avoid. We've already seen that the motives and desires behind makeup use in the West and Far East remained pretty static for a thousand years; what created and accelerated a massive change was the birth of print media, broadcast, and the consumer society.

First take a moment to imagine a world without advertisements and consider how much calmer our visual and emotional pulls might be. Then try and envision a world with barely any imagery at all. It's an unnerving thought, but less than a thousand years ago this was the world that humans occupied. Of course, cave painting, hieroglyphs, and other forms of ancient art existed, but there were no realistic images of ourselves. Early religious iconography and paintings in places of worship provided the first imagery viewed by regular people of all classes, and though the images were often dazzling and sumptuous, they were largely symbolic, meant to be revered, and lacking in realism.

The types of images people were exposed to even two hundred years ago were very different from what we are used to now. With no methods of communication except speaking and writing available, in order to see something you would have had to go and

Women's magazines, which appear commonplace now, are actually a fairly recent creation, not unlike the commercial beauty industry itself.

physically look at it. With no means of seeing facsimiles of other people, the modern concepts of a "beauty role model" to try to look like someone else

I SECRETI DE LA
SIGNORA ISABELLA
CORTESE,
NE' QVALI SI CONTENGONO
cofe minerali, medicinali, arteficiofe, & Alchimiche,
& molte de l'arte profumatoria, appartenenti
a ogni gran Signora: Con altri bel-
lifsimi Secreti aggiunti.

CON PRIVILEGIO.

IN VENETIA,
Appreffo Giouanni Bariletto.
1 5 6 5.

ABOVE: As printing became easier and less expensive in the sixteenth century, pamphlets with beauty advice and recipes began to spread quickly and were available to all, regardless of class.

OPPOSITE: Fashion plates became a popular addition to women's magazines in the nineteenth century, and more expensive magazines had better plates, like this hand-colored etching from *La Belle Assemblée* in 1827.

didn't really exist. With a lack of easy transport, most people wouldn't have had a clue how anyone outside their town or village (let alone in another country) looked. Aristocratic and royal beauty trends would not have been visible outside court: Royal portraits hung in palaces and grand houses, creating a microcosmic world of hair, fashion, and makeup trends that rarely traveled farther than palace boundaries—and if they did, it would literally take years (if not decades) for them to filter down. It was a far cry from today's fast-paced "get the look from last night's red carpet ceremony" style media.

The invention of the printing press would be the first step toward changing this forever. The earliest known system of printing was invented in China around AD 1041, but it was the invention of the printing press with movable characters by Johannes Gutenberg in Germany around 1450 that heralded a sea change in the exchange of information. For the first time, ideas—from science and politics to literature—could be shared among a wide audience. Of course, this included information about the production and use of cosmetics. Beauty "secrets" and recipes would have been passed down through the female members of a family or kept by the village wisewoman, and handmade with ingredients sourced and grown locally. After the invention of printing and publishing, this knowledge spread like wildfire.

Renaissance Pamphlets

During the Renaissance in Italy, a culture emerged in which cosmetics were widely promoted on the streets, with recipe books sold for the equivalent of "a flash of wine"—in other words, they were exceedingly cheap. Pamphlets were circulated among communities, and some featured beauty advice and recipes sold by peddlers who offered the ingredients as well as the instructions.

These manuals evolved to become a popular genre, known as books of secrets—medical handbooks with a domestic slant (instructions for preserving food might sit alongside a recipe for rouge) that encompassed science, magic, and religion. The most famous of these manuals, and one of the earliest examples of this genre—itself part of an older tradition going back to the twelfth-century *Trotula*, and further back to ancient Egyptian texts such as the Ebers Papyrus—is *Gli Experimenti*, a collection of recipes and experiments collated by Italian noblewoman Caterina Sforza around 1500. This text is extraordinary for many reasons, not least the fact that it was written by an educated woman whose life we know something about, which was very rare; in fact, it is the first beauty book that we are able to definitively confirm as being female authored. Like other books of secrets, *Gli Experimenti*'s content appears to have been drawn from the traditions of the community around Sforza as well as knowledge gleaned from classical medicine (like the teachings of Galen, for example). A modern-day beauty guru, Caterina established one of the earliest known beauty communities, writing and receiving letters from many sources to discuss, exchange, and collect recipes for *Gli Experimenti*. Jacqueline Spicer, an academic who has translated *Gli Experimenti*, points out that though 66 of the 454 recipes are classified as cosmetic, the actual number of recipes concerning beauty and cosmetics—from making skin clear and blemish-free to dyeing hair—is much higher at 192. Spicer also notes that the non-cosmetic recipes range from making things look like gold, to poisoning people, showing the author's eclectic range of talents and interests.

Later titles followed *Gli Experimenti*, such as *The Secrets of Lady Isabella Cortese* (1561)—rare in that, like Sforza's work, it was (purportedly) written by a woman—which was so successful that it reprinted six times, indicating a public hungry for this

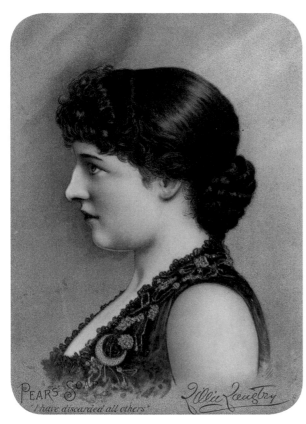

Stage actresses held an important position during the early days of the cosmetic business, and regularly promoted beauty products in theatrical programs and newspapers. Here, Lillie Langtry promotes Pears soap.

community-sourced miscellany of medical and cosmetic knowledge. Since female authors were not the norm, it also seems correct to assume that the vast majority of these beauty pamphlets would have been written by men.

In the seventeenth century, there was a female-driven print rush in which cosmetics were strongly defended. In England, alongside *The Gentlewoman's Companion* (1673), there was also *A Discourse of Auxiliary Beauty* (1656), which argued that: "Nor is the *face* more to be unconsidered, or neglected, than other parts of our bodies."[1] Similarly, *The Ladies Dictionary*

(1694) argued that makeup was not meant to trick or deceive, but to serve a useful purpose. This usefulness was further debated in *Several Letters Between Two Ladies Wherein the Lawfulness and Unlawfulness of Artificial Beauty in Point of Conscience Are Nicely Debated* (1701). With religious and moralistic stances shifting, and a ready audience, cosmetics began to move away from being seen as "an assault on the Divine handiwork, a distortion of the truth," in the words of Saint Cyprian. What emerged instead, throughout much of Europe, was a beauty culture.

The earliest magazine aimed specifically at women in England was *The Ladies' Mercury*, first published in 1693. Bearing little resemblance to today's women's magazines, it comprised an advice column on love and relationships, written by men. During the following century, other women's magazines appeared, mostly featuring the name "lady" in the title. As with the British magazine *The Lady*, a version of which still exists today, these periodicals mostly catered to upper-class women and were meant to "educate" in addition to entertain.[2] They were filled with material deemed appropriate and suitable for women rather than articles or features about *being* a woman. This trend in content began to change in the Georgian period, and certainly by the mid-nineteenth century, as magazines sought to expand their audiences and the idea of womanhood became more defined. Almost fifty new women's magazines appeared from 1880 to 1900, and much like etiquette guides (for which a strong market had emerged), they instructed women in how to dress and act.[3] These new magazines created and distributed an ideal of womanhood, implying that women could only achieve this standard through following the advice written in magazines—a mind-set that many would argue has continued to this day. Advancing the pursuit of this feminine ideal from an aesthetic angle, fashion illustrations became popular at this time, with most women's magazines

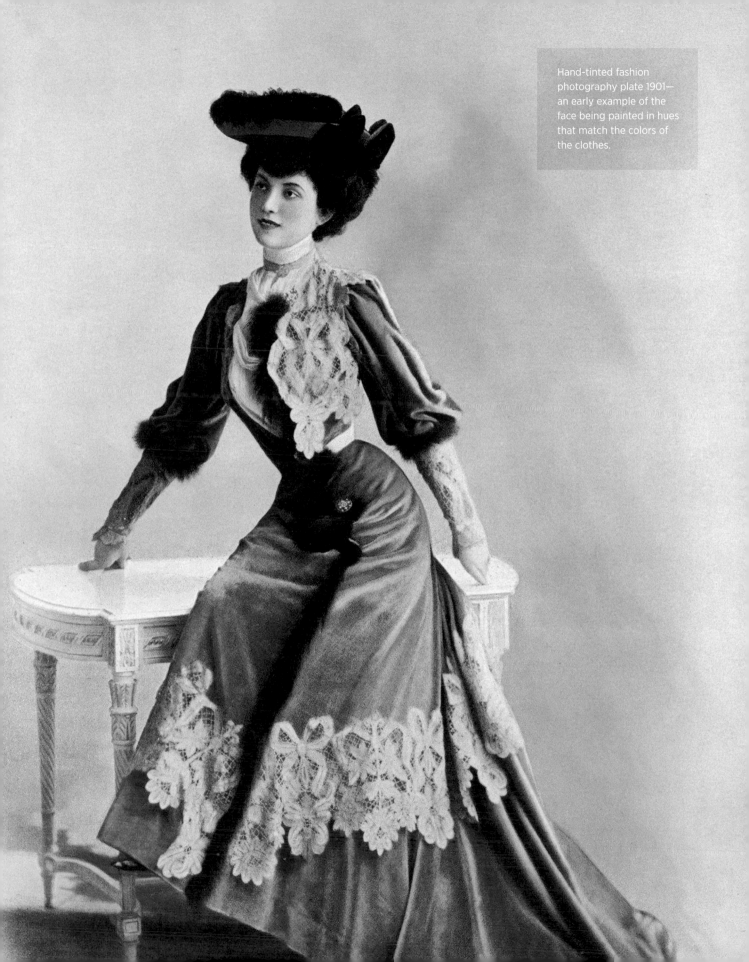

Hand-tinted fashion photography plate 1901— an early example of the face being painted in hues that match the colors of the clothes.

At the end of the nineteenth century, actresses—such as the divine Sarah Bernhardt—began to rise up the social ladder, which helped to alter societal views on makeup. The fascination with, and acceptance of, performers was fundamental in the rise of the makeup industry.

featuring at least one plate, and the more expensive fashion-focused magazines sometimes including up to six colored plates. These pictures provided more information than just what to wear, demonstrating appropriate hairstyles and accessories while exemplifying an ideal of female beauty.

One of the first British fashion magazines, *La Belle Assemblée*, was published in 1806. It contained colored plates of Regency fashion styles, and though it never discussed cosmetics, its illustrations depict women who are quite obviously rouged and lipsticked, with flushed cheeks and small, dark rosebud lips. Similarly, one of the first European magazines, the French *Les Modes*, founded in 1901, featured images of society women wearing various designers, often with conspicuous makeup. In several 1901

issues of *Les Modes*, the featured models and upper-class women display makeup that coordinates with the color of their clothes. For example, the image on the previous page shows a woman in a brown dress wearing a brownish-orange shade blush and brown lipstick. The color would have been hand painted onto the image, but the similarity of the shades used (in comparison to the consistently pink-rouged cheeks shown in *La Belle Assemblée*) strongly suggests that fashion and makeup were really beginning to merge. Images in magazines are all about picking up ideas, and a plate like this would have prompted a woman to think about matching her makeup with her outfit—a new concept at the time. Although advertisements for beautifying services or products, such as hairdressers or perfume, are included in *Les Modes*, cosmetics

Billie Burke

Billie Burke, best remembered today for playing Glinda the Good Witch in *The Wizard of Oz*, made her name on the theater stages of London and New York during the reign of Edward VII, and she played a substantial part in bridging the Victorian and World War I attitudes toward makeup in the United States. From June 1912 until January 1914, she wrote a column for the *Chicago Day Book*, covering various topics in the world of women (though she later wrote articles that addressed men's interests as well).[4] Many of Burke's columns focused on removing the stigma from cosmetics; one is entitled "Billy [sic] Burke Says It's All Right to Make Up Your Face—But Make It Look as If Nature Did It" (March 15, 1913). Very much ahead of her time, she eschewed the long-standing view that makeup is artifice, used for deception and entrapment, writing stridently to one male detractor: "Men insist upon beauty in women, but many of them also decry any endeavor to obtain it." Burke clearly makes the link between her makeup expertise and her acting career but, crucially, points out that what is appropriate for the stage is not right for the everyday: "I am deluged with letters asking me if I believe in using powder. I certainly do; every actress does . . . All actresses are artists in 'make-up'; they have to be. But the make-up for the stage and the make-up for the lights of the streets are very different."

were still very much underground, and so there are no articles or ads explicitly promoting makeup.

It may feel like an about-face after the (relative) progression of the Renaissance, but cosmetics were back underground, as makeup was strongly frowned upon for much of the Victorian era, although skin creams and hair oils were deemed acceptable. This began to change quite rapidly toward the end of the century: Queen Victoria may have associated "vulgar" makeup with prostitutes, but there was another group who relied on it whose social status was rising—actors. Stage actresses were increasingly the icons of the late Victorian period, with their movements recorded by the press, and their images reproduced on picture postcards, song sheets, and theater programs. With the developments in lighting—from

the introduction of gas illumination to limelight and the first completely electrically lit theaters—came necessary developments in stage cosmetics to match. Makeup was part of the daily life of an actor, as shown by the 1894 illustration of Sarah Bernhardt sitting at her dressing table, putting on her face, from the weekly newspaper the *Graphic*. Women wanted to look like performers, and cosmetics companies quickly learned to monetize this desire by getting their products endorsed by actors in ads featured in theater programs. Lillie Langtry, admired and nicknamed the Jersey Lily for her lily-white complexion, was famously paid to be the face of Pears' soap. Queen Victoria's son, the Prince of Wales, who would become King Edward VII in 1901, was known for his affairs with high-profile actresses, further affirming

same year as the column launched—1909—Selfridges opened on London's Oxford Street and became the first British department store to display cosmetics openly.

Women and War

The First World War caused a seismic change in the lives of women. With men sent to the front, women took their place in a variety of positions, whether by working the land or donning factory uniforms, experiencing a previously unheard-of sense of social and financial independence. Cosmetics were not untouched by this change, shifting from being something that must be used covertly to something to be proud of—a symbol of patriotism and keeping up appearances. UK *Vogue* was launched during the war, in 1916, due to shipping restrictions affecting availability of the US edition. But it was still only skincare that was widely advertised, with a 1916 ad from Helena Rubinstein asking, "Is *yours* a 'war face'? . . . Even if your social or professional life does not demand it, your *patriotism* demands that you keep your face bright and attractive . . ." Another ad from 1917 for "skin perfection" declares, "The prestige of English beauty must be maintained," alongside an illustration of a slightly terrifying-looking chin strap meant to remove the "disfigurement" of a double chin.

Women's rights were not a new concern or subject: Organized campaigns for political and social change began to occur in the United Kingdom from 1866—and in the United States from 1848, when the first women's rights convention was held—and by the end of the nineteenth century, the issue of the vote had become the focal point of women's struggle for equality. Though the activity of both the suffragettes and suffragists was put on hold for the sake of national unity after the outbreak of war, in the end it was the social shifts necessitated by the war that

would finally lead to legislative change. In 1918, the British Parliament granted women over the age of thirty the right to vote. It would be another ten years before Parliament lowered the female voting age to twenty-one (the same as for men), while in the United States, women were granted suffrage in 1920.

The decade that followed the end of the war—the Roaring Twenties—would be a time of even more overwhelming change. Hemlines and hairlines shifted (in keeping with the new flapper fashion), as did the perception of what it meant to be a woman generally. In a thirty-year-anniversary piece comparing the fashions of 1892 (when US *Vogue* was first published) with those of 1922, UK *Vogue* described "the strange product indigenous to this generation—the flapper—hair bobbed, lips reddened, cigarette in hand, everybody knows her." Despite this assertion, the ads in fashion magazines continued to focus on a limited array of products—not, noticeably, the rouge, lipstick, or kohl that were readily in use, but the same old face creams, along with some powder, depilatory treatments, and arm and back creams that were now deemed necessary due to the new skin-exposing fashions. Generally, though, makeup continued to be condemned. An Elizabeth Arden ad from a 1922 issue of UK *Vogue* is unswervingly anti-cosmetics: "Elizabeth Arden recommends the closest personal attention to the skin—not the indiscriminate use of cosmetics." Arden's rival, the redoubtable Helena Rubinstein, was also particularly vicious in her rebuttal of cosmetics, with an ad from the same year asking, "Complexions—Cultivated or Camouflaged? Which Shall It Be?" There was a stress on maintaining youth, with much written on both sides of the pond about creams and treatments for the skin and hair that would keep middle age at bay. We may think of anti-aging commentary in magazines as relatively modern, but a 1922 article by journalist Pauline Pfeiffer (also known for being Ernest Hemingway's

The "War Face."

IS yours a "war face"? Before answering the question just glance in a mirror. Does your reflection give you *quite* the satisfaction it gave you in 1914? Perhaps time and trouble have ploughed lines where, before, the skin was smooth and taut; or the complexion is dull and unattractive; in fact, it is probable that the whole face is an index of the cares and war worries that are the lot of 99 women out of every 100 in these troublous times.

Even if your social or professional life does not demand it, your *patriotism* demands that you keep your face bright and attractive so that you radiate optimism. You should therefore call on Madame Helena Rubinstein, the renowned Face Specialist, and see about regaining your good looks. A short course of her unique treatments will work wonders for you, or there is a special half-guinea treatment which will show you exactly how to improve your skin at home.

ECONOMISE by using the Valaze Complexion Specialities — remembering that their marvellous effectiveness and concentrated nature constitute *true economy.*

No charge is made for consultations or for advice through the post, and special "war reductions" are now being allowed.

For Home Treatment :—Valaze Beautifying Skinfood, thoroughly whitens, clears, softens, and rejuvenates the skin. 2/-, 4/6, 8/6, 21/- Novena Windproof Creme, entirely prevents discolouration of the skin through exposure, 3/- and 6/- Eau Verte, whitens the skin, and remedies lines and wrinkles, 7/6 and 15/- Novena Cerate, a special skin-cleansing soothing cream, 2/6, 4/6, and 12/6. Valaze Whitener, unsurpassed for instantaneous whitening of the hands, arms, shoulders, face, and darkened throats. Will not come off until washed off. 2/6 Valaze Bleaching Cream removes discolouration (including fur stains), and whitens the skin permanently, 5/6, 10/6 Valaze Reducing Jelly remedies double chin and restores and preserves the contour of the face, 5/6, 10/6 Valaze Vein Lotion remedies disfiguring "veiny" appearance of the skin, 5/6, 10/6 Valaze Blackhead and Open Pore Paste, soon remedies these disfiguring blemishes, 3/6.

Mme. HELENA RUBINSTEIN,
24, GRAFTON STREET, LONDON, W.
255, Rue Saint Honoré, Paris. 15, East Forty-Ninth Street, New York City.

When WWI began, beauty advertisers urged women that it was more, rather than less, important to beautify; it was their patriotic duty to keep an optimistic, pretty, and cheery face even when weighed down by the daily reality of war.

second wife) in US *Vogue* shows otherwise; it was captioned, "No Matter How Fresh and Vigorous One's Face May Be at Ten, When One Gets On the 'Shady' Side, Vigilance Is Necessary."

It wasn't until the late twenties that makeup really entered the mainstream. By 1929, French *Vogue* was advertising "Rouge Camelon" lipstick, and in US *Vogue*, Helena Rubinstein was applauding the "magic that lies in makeup," and advertising her Cubist Lipstick and Red Raspberry Rouge. (Rubinstein

actually started advertising rouge and lipstick in the United States in early 1923, much earlier than in the United Kingdom, where her company's ads were still strongly anti-cosmetics.) "A Defence of Rouge," the very first pro-makeup feature in UK *Vogue*, did not appear until July 1924. The likely reason for America's early adoption and approval of makeup was, at least in part, due to the immediate impact and success of Hollywood. Compacts, housing powder or rouge, with lipstick often attached, were available in a multitude of designs so that one could match her compact to her outfit. Touching up one's makeup was now officially acceptable. But there was still a faint undercurrent of caution in some ads: Tangee lipstick, advertised in both the United Kingdom and the United States, warned that "your makeup should enhance your personality but never over-dramatize it." Another lipstick brand, Michel, promised that "with MICHEL you are not made up. You are made lovely" (UK *Vogue*, December 1929). Others were more forward-thinking: An ad for Maybelline Eyelash Beautifier from 1929 quotes Milton ("Thy rapt soul sitting in thine eyes") and states that it's "used by leading Stage and Film Stars." While the first lipstick ads were just finally appearing in the United Kingdom, in the United States, attitudes to makeup had really moved on from the previous thousand or so years, and journalists were writing about what makeup to wear with the latest beauty accessory—the suntan.

Many more ads were in color by this point, meaning that the copy had to work a bit less hard to describe the effects of products, with the images assuming more importance. And accessibility was no longer an issue: In the United States, the local drugstore and five-and-dime had brought beauty to the masses with lipsticks available for ten cents a pop, and the same had happened in the United Kingdom with the pharmacy chain Boots. Far from the days of having to write in to request where to actually obtain makeup, a

Harper's **BAZAAR**

August 1940
COLLEGE FASHIONS

ABOVE: Featuring bold makeup on their covers, fashion magazines were instrumental in the proliferation of makeup in mainstream society. (*Harpers Bazaar*, August 1940)

OPPOSITE: By the second half of the 1920s, print advertisements began appearing in color, making it infinitely easier for brands to sell eye-catching colored cosmetic products such as lipstick.

Would your husband marry you again?

FORTUNATE is the woman who can answer "Yes." But many a woman, if she is honest with herself, is forced to be in doubt—after that she pays stricter attention to her personal attractions.

A radiant skin, glowing and healthy, is more than a "sign" of youth. It *is* youth. And any woman can enjoy it.

Beauty's basis

is pure, mild, soothing soap. Never go to sleep without using it. Women should never overlook this all-important fact. The basis of

Volume and efficiency enable us to sell Palmolive for

10c

beauty is a thoroughly clean skin. And the only way to it is soap.

There is no harm in cosmetics, or in powder or rouge, if you frequently remove them. Never leave them on overnight.

The skin contains countless glands and pores. These clog with oil, with dirt, with perspiration—with refuse from within and without.

The first requirement is to cleanse those pores. And soap alone can do that.

A costly mistake

Harsh, irritating soaps have led many women to omit soap. That is a costly mistake. A healthy, rosy, clear, smooth skin is a clean skin, first of all.

There is no need for irritating soap. Palmolive soothes and softens while it cleans. It contains palm and olive oils.

Copyright 1921, The Palmolive Co. 1238

Force the lather into the pores by a gentle massage. Every touch is balmy. Then all the foreign matter comes out in the rinsing.

If your skin is very dry, use cold cream before and after washing.

No medicaments

Palmolive is just a soothing, cleansing soap. Its blandness comes through blending palm and olive oils. Nothing since the world began has proved so suitable for delicate complexions.

All its beneficial effects come through gentle, thorough cleaning. There are no medicaments. No drugs can do what Nature does when you aid her with this scientific Palmolive cleansing.

Millions of women get their envied complexions through the use of Palmolive soap.

The Palmolive Company, Milwaukee, U. S. A. The Palmolive Company of Canada, Limited, Toronto, Ont.

Palm and olive oils were royal cosmetics in the days of ancient Egypt

Boots ad for powder puffs in a 1929 issue of UK *Vogue* boasts of over eight hundred branches throughout Great Britain, while Tangee lipstick is described as "on sale everywhere."

Negative Advertising

From the beginning of the twentieth century, beauty advertising often had a gently chiding—if not blithely threatening—tone, selling products to women by playing on their insecurities. An ad in US *Vogue* from 1909 screams, "VEIL OR NO VEIL? THAT IS THE QUESTION. Are you Proud of your complexion? Of course all girls wear veils *some* times but some girls wear veils *all* times." An editorial feature from the same magazine in November 1922 stresses the opinion that you only have yourself to blame for not looking good (unless, of course, you are "positively disfigured"): "Women have always been more or less interested in cosmetics, but it is only the modern woman who had realized that while all the sex cannot rival Helen of Troy in beauty, still with proper care any woman who is not positively disfigured is justified in believing that she can attain a clear skin and greatly improve the appearance of teeth and hands." A Helena Rubinstein advertisement for various youthful skin procedures from 1923 is particularly scathing: "'Looks' usually account for the fact that some women are escorted to parties, while others are merely 'seen home.'"

Advertisers decided that the best way to get women to buy more beauty products was to frighten them into it. Makeup was sold as 'glamour': The

Overtly negative, sexist, and patronizing beauty advertising that created and played on women's insecurities began in the 1920s and continued into the 1960s when a second wave of feminism hit the western world; although many would argue it still exists (albeit in a less obvious way) today.

philosophy was that the more effort you put in, the more beautiful you could be, and if you didn't put in the effort, well, you only had yourself to blame. The headline of an Elizabeth Arden ad from 1929 reads, "Some husbands are worth holding . . . Mere beauty of face may win a husband, but it takes more than that to hold one in this day of competition." A 1921 ad for Palmolive soap asks, "Would your husband marry you again?" with a later ad (1932) from the same company showing little progression in selling style: "I learned from a beauty expert how to hold my husband—and why so many women fail . . . Keep that schoolgirl complexion." Thankfully, overtly sexist beauty advertisements of this type peaked in the 1950s; afterward, they steadily declined as a second wave of feminism swept through the Western world in the sixties and seventies—although again, many would argue that beauty advertising continues to patronize women to this day.

The Birth of Hollywood

The emergence and boom of the silent movie industry, from 1894 to 1929, had a dramatic effect on the development of cosmetics that continues to reverberate today. The makeup used for silent movies was initially the same as for the theater, although the audience's inability to hear the actors made it even more crucial to emphasize their features to enable them to convey a wide range of emotions. Not only were cosmetics used to help actresses act, but the style and type of makeup that they wore could also signal to the audience the type of character they were playing—from the typically downturned eyebrows of "the fun-loving flapper" (Clara Bow) to the almost black lips and smoky eyes of "the vamp" (Theda Bara).

Reflecting back on this period now, one of the first questions we might ask is: When did actresses evolve

The NEWS MAGAZINE of the SCREEN

PHOTOPLAY

DECEMBER

25 CENTS
30 Cents in Canada

How
Madge
Evans
Grew To
Stardom

JEAN HARLOW
SEE PAGE 34

Latest Beauty Fads
of Hollywood Stars

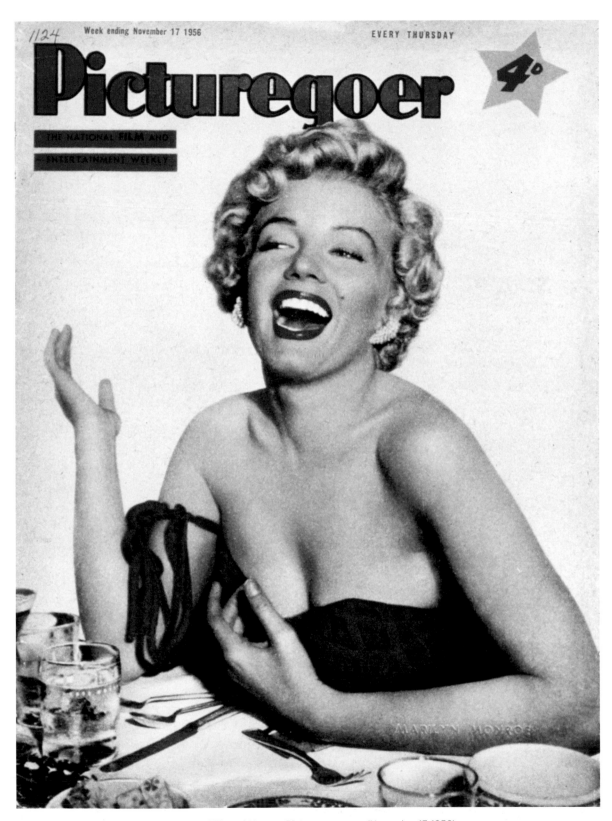

Week ending November 17 1956　　　　EVERY THURSDAY

Picturegoer

4º

THE NATIONAL FILM AND
ENTERTAINMENT WEEKLY

MARILYN MONROE

Jean Harlow *Photoplay* cover (December 1931) and Monroe *Picturegoer* cover (November 17, 1956).
Fan magazines helped to launch stars and enabled readers to recreate their favorite star's look.

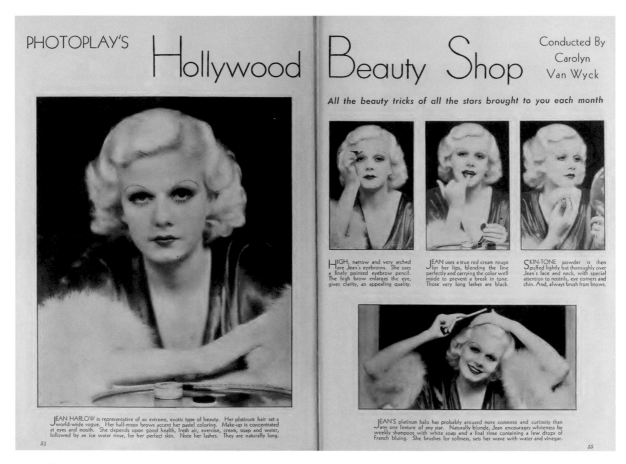

PHOTOPLAY'S *Hollywood Beauty Shop*

Conducted By
Carolyn
Van Wyck

All the beauty tricks of all the stars brought to you each month

HIGH, narrow and very arched are Jean's eyebrows. She uses a finely pointed eyebrow pencil. The high brow enlarges the eye, gives clarity, an appealing quality.

JEAN uses a true red cream rouge for her lips, blending the line perfectly and carrying the color well inside to prevent a break in tone. Those very long lashes are black.

SKIN-TONE powder is then puffed lightly but thoroughly over Jean's face and neck, with special attention to nostrils, eye corners and chin. And, always brush from brows.

JEAN HARLOW is representative of an extreme, exotic type of beauty. Her platinum hair set a world-wide vogue. Her half-moon brows accent her pastel coloring. Make-up is concentrated at eyes and mouth. She depends upon good health, fresh air, exercise, cream, soap and water, followed by an ice water rinse, for her perfect skin. Note her lashes. They are naturally long.

JEAN'S platinum halo has probably aroused more comment and curiosity than any one feature of any star. Naturally blonde, Jean encourages whiteness by weekly shampoos with white soap and a final rinse containing a few drops of French bluing. She brushes for softness, sets her wave with water and vinegar.

53 55

ABOVE: Short makeup tutorials with actresses, such as this one of Jean Harlow in *Photoplay* (May 1933), became a familiar image in magazines and cosmetic advertisements as fans attempted to imitate stars' looks and makeup brands tried to expand from Hollywood to the mainstream.

OPPOSITE: Television enabled cosmetic brands to sell and demonstrate their products directly to millions like never before and allowed advertisers to build stories and make claims about products in an attempt to make them relevant to real women's lives. Despite being viewed on black and white screens, sales of colored makeup items like Revlon's Fire and Ice lipstick and nail polish were phenomenal.

from being regarded not just as experts in makeup—due both to its intrinsic role in their day-to-day work and their advance exposure to new products—but as the individuals on whom women based their own appearance and look?

To try and answer this question, first we need to accept that—like today—film fans identified with stars, and though this identification might have been based on character or personality, it grew to focus on style and beauty. Historian Annette Kuhn, who interviewed many women to understand the role of 1930s Hollywood in everyday life, noted that

"cinema, for this generation of women, extended imaginings of what a woman could be."[6] Movie magazines and fanzines that extended the world of film outside the cinema for fans were hugely popular, and they were the first publications to embrace the "get the look" phenomenon through makeup recommendations and endorsements. They often featured columns that tapped into women's desires to emulate the look of the actresses of the moment. *Picturegoer* (1921–1960) started off as a monthly magazine before becoming weekly. Initially focusing more on film story lines, the magazine soon realized

for you who love to flirt with fire...

who dare to skate on thin ice...

Revlon's 'Fire and Ice'

for lips and matching fingertips. A lush-and-passionate scarlet
...like flaming diamonds dancing on the moon!

'Fire
and
Ice'

Theda Bara

One of America's first movie stars, Theda Bara was unique in that she was completely invented by the studio publicity department; she was an intriguing phenomenon whose films returned more money per dollar of investment than those of any other actress of her time. As the legend goes, Theodosia Goodman became Theda Bara when she was given a screen test in 1915. Despite having no experience, she was selected. William Fox, the movie mogul and founder of Fox, told author Upton Sinclair how it all came about: "One day it was conceived in our publicity department that we had every type of women on the screen except an Arabian. [Our publicity director] conceived a story that Miss Goodman was born in Arabia . . . So we took Arab and spelled it backwards to make Bara and shortened her first name from Theodosia to Theda."[14]

Bara herself reportedly encouraged the campaign: When Fox asked where she was born, she reportedly responded, "It wouldn't be exciting to say Cincinnati, would it? Suppose we say the Sahara Desert instead?" When she was first introduced to the press, she was told not to talk in order to maintain the illusion that she couldn't speak or understand English. The gamble paid off, and the press announced the next day that Fox had discovered the greatest living actress of all time.

The unveiling of Philip Burne-Jones's painting *The Vampire* in 1897, which depicted a pale, dark-eyed woman with a male victim at her feet, introduced the idea of the vampire to the general public, along with Rudyard Kipling's poem (inspired by the artwork) and Bram Stroker's *Dracula*, which was published the same year. Together, they created a vogue for the female vampire—or "vamp"—the irresistible but deadly being that heartlessly sucks the love and life out of men. This character was embraced by Hollywood and was a precursor to film noir's femme fatales. At this time, the movie industry began developing roles for women that were not exactly nuanced. Generally, there were just a couple of types: Vamps and Flappers, both with their hair and makeup style signifying their type to audiences, especially pre-talkies.

Bara's face was the epitome of vampishness: Intense and sensual with heavy-lidded, kohl-rimmed eyes, she soon became famous everywhere. As film makeup departments were just coming to grips with the demands of early black-and-white orthochromatic film, which was oversensitive to blue and thus made Bara's eyes look pale, it's reported that Bara asked Helena Rubinstein to formulate a special intense kohl to help make her eyes appear more expressive on film. Rubinstein later commented, "the effect was tremendously dramatic . . . it was a sensation reported in every newspaper and magazine."[15] Her appearance and femininity were so exaggerated and her movie plots so outlandish that she really presented no threat to conventional morality and the average woman, and her popularity among female moviegoers helped enormously to make the use of cosmetics acceptable. As Bara herself observed, "The vampire I play is the vengeance of my sex upon its exploiters. I have the face of a vampire but the heart of a feminist."

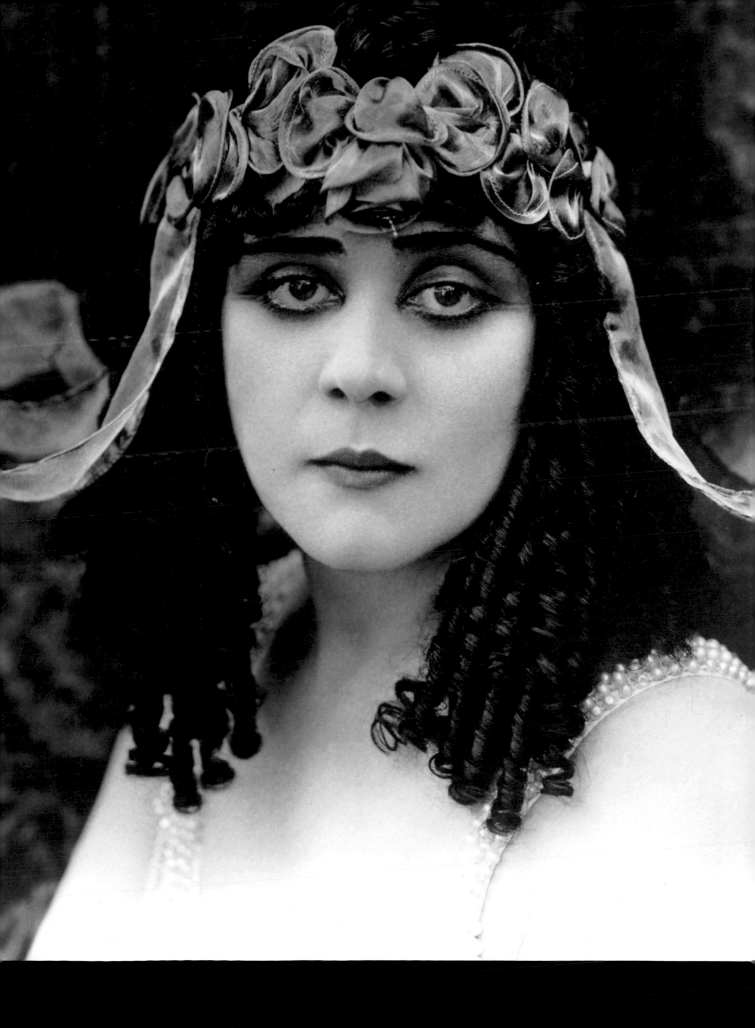

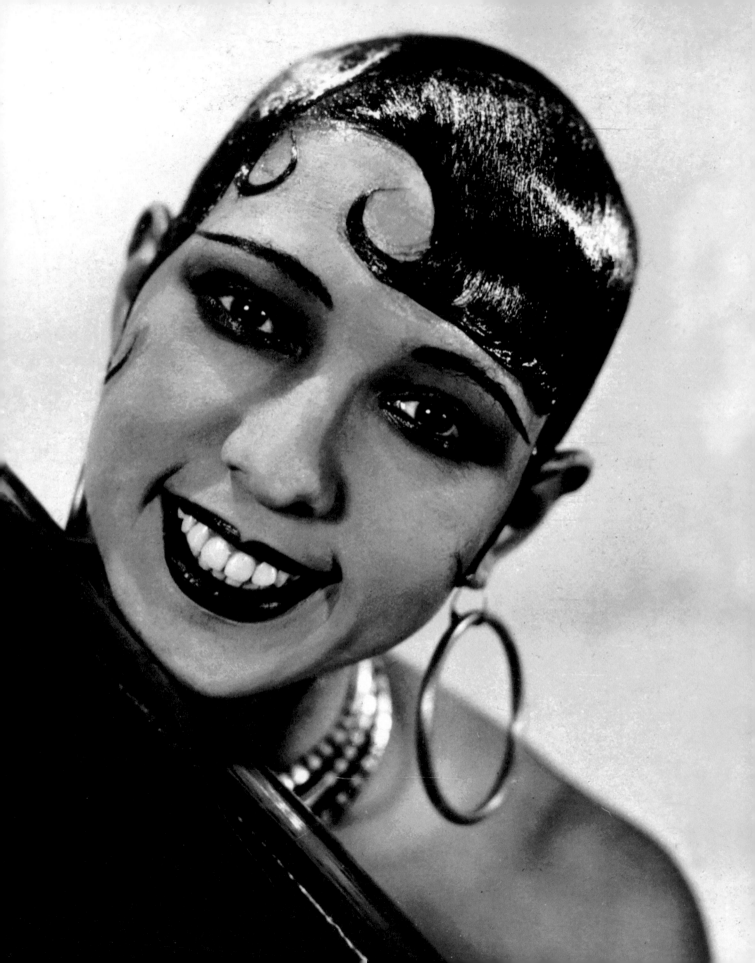

Josephine Baker

Civil rights campaigner, dancer, singer, and actress, Josephine Baker embodied the Jazz Age like no one else. Born in 1906, in St. Louis, Missouri, she began working at an early age, waitressing and cleaning to help support her family, and herself after she ran away.

By her teens, she was touring the United States with a dance troupe. After they disbanded, she managed to get hired as a chorus girl (even though she had originally been rejected for not looking right) by learning all the routines while working as a dresser and then filling in when one of the dancers was ill.

Eventually, Baker was hired to perform in a traveling European variety show, La Revue Nègre, which premiered in 1925 at the Théâtre des Champs-Élysées. Paris was flooded with American artists and writers following the collapse of the gold standard in 1914 and attracted by the weak franc against the dollar. With her sleek, slicked-down bob, smoky eyes, and dark lips, she was the epitome of the modern flapper. Her performance, in a risqué feather skirt, was a huge success, and she became an immediate sensation. She settled in France, and in 1927 joined the Folies Bergère as the star of their new spring show (wearing a costume of bananas strung into a skirt), which only increased her celebrity.

Her dark skin was celebrated in Paris in a way it had never been back home and high-profile beauty campaigns and endorsements followed; she appeared on billboards across Paris advertising a glossy hair pomade called Baker-Fix, and Helena Rubinstein (never one to miss an opportunity) promised that her Valaze Water Lily body cream would give you a "body like Josephine Baker." The vogue for suntans started by Chanel also worked in Baker's favor, and she became the poster girl for the glamorous Riviera set. Ernest Hemingway described her as "the most sensational woman anyone ever saw." Everyone was cashing in on her style: Beauty editors devoted many column inches to achieving her caramel skin tone, advising white women to rub walnut oil into their faces and limbs to create a Baker-esque glow.

Baker was no stranger to cosmetics (or a good costume), traveling with 137 pounds of face powder on her 1929 tour of Europe and South America.

But despite the validation she received in France, and her own avowedly liberal outlook, Baker promoted skin-lightening products and apparently rubbed lemon juice into her skin and bathed in a combination of goat's milk and bleach.

Though she continued to travel and tour, Baker lived in France, and dedicated her later life to human rights. She had played an important role in the French Resistance during the Second World War, acting as an undercover operative, and as an official mark of respect for all she'd done for her adopted country, she was the first American woman to be buried in France with military honors.

Anna May Wong

The first Chinese American movie star in Hollywood, Anna May Wong was born in LA on the outskirts of Chinatown. She was fascinated by the movies that would film there—many studios at the time used it as a substitute for China—and got her first break when she was asked to be an extra in one such film at the age of fourteen. She continued playing bit parts over the next couple of years before leaving school to pursue acting full-time in 1921. With her trademark blunt bangs and typically sleek twenties hair (and, undoubtedly, her supposed exotic heritage…despite the fact that she was American), Anna May Wong was a vamp. Anti-miscegenation laws in the United States at this time prohibited interracial relationships, which meant that she could not play a leading lady unless the leading man was also Asian (even if the lead character was intended to be Asian, the part would inevitably go to a Caucasian actress in Oriental makeup). The frustration of this discrimination, and of only being offered a certain villainous type of role, made her eager to go to Europe when the opportunity presented itself in 1928. She was able to act and live more like an individual there and was much feted, instigating a trend for using powder to achieve her perfect complexion. She returned to Hollywood in 1931 and starred opposite Marlene Dietrich in *Shanghai Express*, but when MGM cast the leading role of the female character Lien Wha in *The Son-Daughter* the following year, they claimed that Wong was "too Chinese" to play the (Chinese) part. It's sad that due to the prejudice of the time and place in which she lived, Anna May Wong's career never took off as it should have, but she remains an incredibly important trailblazer, and her influence in the beauty world continued when US fashion designer Anna Sui used her as the inspiration for the makeup and hair of her A/W 2014 show.

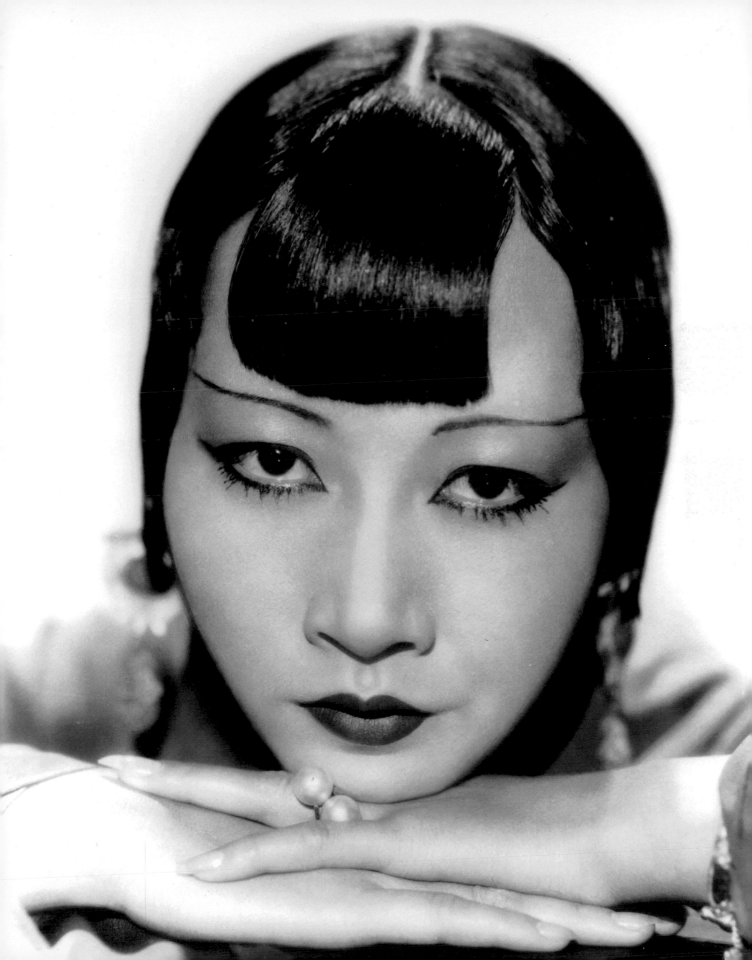

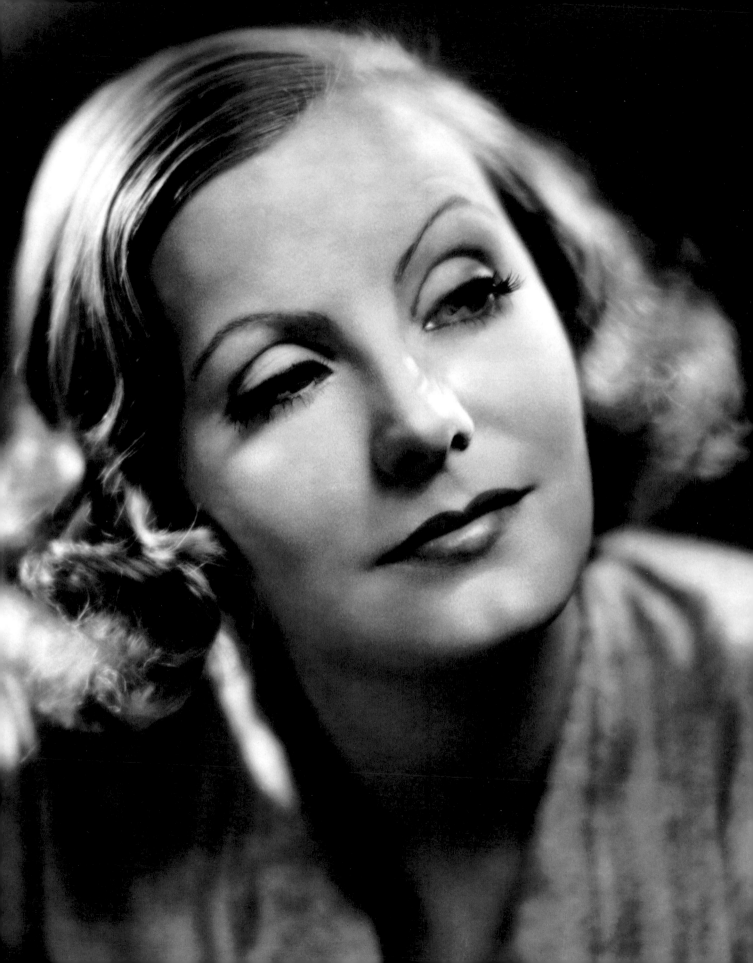

Greta Garbo

Garbo was born Greta Gustafsson in 1905 in Stockholm, Sweden. She was fascinated by the theater and would reportedly hang around watching the actors come and go. After leaving school, she modeled hats for the department store where she worked, which led to a full-time modeling career and later commercial work. She won a scholarship to the Royal Dramatic Theatre training school in Stockholm, where she was discovered by the Swedish director Mauritz Stiller, who became her mentor. They were both signed to MGM by Louis B. Mayer, who saw their film *The Saga of Gosta Berling*.

After this, Garbo moved to Hollywood in 1925, where the studio instructed her to lose weight, pull back her hair to showcase her bone structure, and fix her teeth. Apart from the elegant planes of her face, Garbo's most focused-on feature was her eyes, which she made up very specifically, applying a thin layer of petroleum jelly over her eyelids, covering it with neutral powder and then blending a dark shade into the crease of her eye, before adding eyeliner made from petroleum and charcoal. It was a stark look for the time, which was to influence makeup for years to come, as can be seen in the graphic linear makeup of the sixties. Her famed luminescence on-screen is supposed to have been achieved by the use of a light makeup base from Max Factor, Silver Stone No. 2, which was popular among movie actors because it had a touch of silver in it, creating a shimmery look. When not filming, she's reported to have worn "just a dash of powder, a little lipstick, and eyebrow pencil."[18]

Along with her accent and voice, Garbo's style represented a sophisticated foreign ideal of femininity and was a huge influence on the look of the 1930s. *Vanity Fair* showed how Garbo's look was affecting her peers as well as audiences with a feature titled "Then Came Garbo" in 1932, and Cecil Beaton has been quoted as saying that, "Before Garbo, faces were pink and white. But her simple and sparing use of cosmetics completely altered the faces of the fashionable women."

Unlike some of the stylized looks that had been so popular in the 1920s, Greta Garbo's cool, polished beauty has maintained its appeal. In 1950, nine years after she made her last movie and effectively disappeared from public life, Garbo was voted the most beautiful woman in the world by *The Guinness Book of World Records*. There's no denying that her face is hypnotic: Writer and philosopher Roland Barthes summed it up when he wrote that "Garbo still belongs to that moment in cinema when capturing the human face still plunged audiences into the deepest ecstasy, when one literally lost oneself in a human image."

The Beauty Pioneers

VISIONARIES AND VAUDEVILLE

As the nineteenth century drew to a close, a group of key figures began to emerge in the world of makeup; they are the pioneers who would create the modern cosmetics industry as we know it today. They have a number of things in common. A lot of their stories hinge on being in the right place at the right time (and having the nous to know that, of course); what's certain is that when they spotted an opportunity, they seized it. Amazingly, the industry actually grew and prospered over the course of two world wars and the Great Depression. During the First World War, women got a taste for earning their own money and, understandably, didn't want to give it up. They had disposable income for the first time and couldn't get enough of cosmetics, which were an affordable touch of luxury and increasingly available. Democratized and empowered, young women used makeup to express themselves and set themselves apart from their mothers and grandmothers for whom makeup had been frowned upon; suddenly they could emulate their screen idols and have fun doing so.

The other important thing to know about the growth of the beauty business was location. While the rise of commercially produced cosmetics had previously been concentrated

At the beginning of the twentieth century, a group of entrepreneurs emerged; working within Hollywood and the beauty salon business, they began supplying cosmetics to newly independent women, and, in the process, created the immense beauty industry we know today.

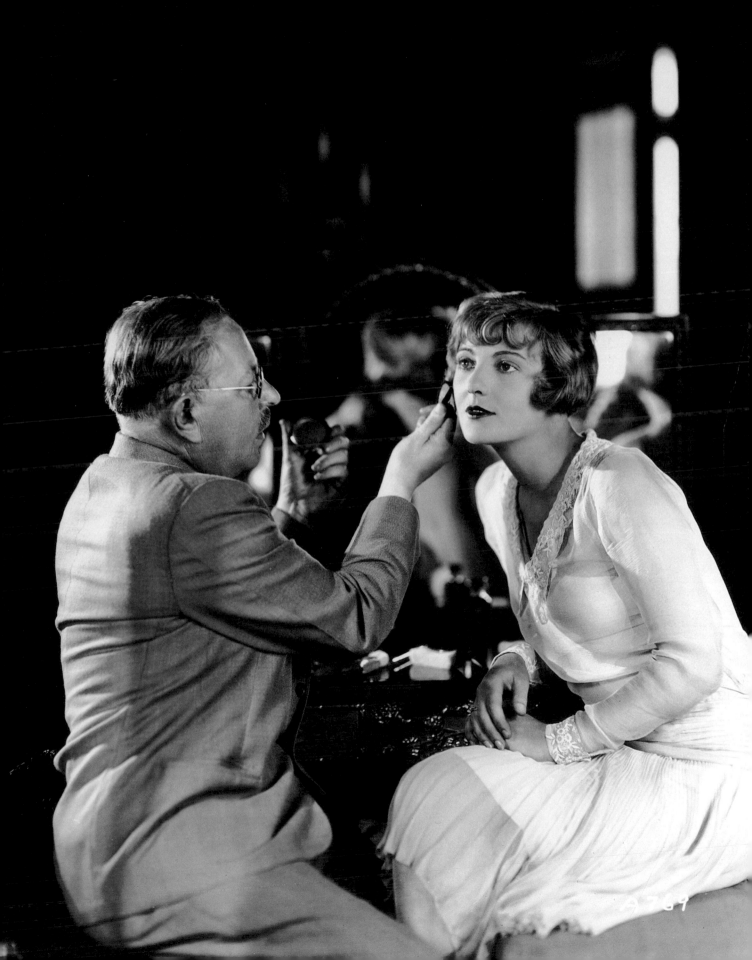

in Europe, by the end of the Second World War, the United States had undoubtedly become the main producer of makeup. By 1945, US beauty product sales had reached an astonishing $805 million.[1] This was partly due to the emergence and growth of Hollywood but mainly owing to the wars. European cosmetics companies were busy with the war effort, making foot talc and camouflage cream, and were generally low on resources, so the United States—though it produced some of those items, too—was able to steam ahead. Helena Rubinstein expanded her business to the United States in 1914, the same time as Elizabeth Arden was starting out and exporting European beauty back home. And both George Westmore and Max Factor positioned themselves perfectly in Los Angeles, just as Hollywood was about to get big. Later on, Charles Revson and Estée Lauder would sense the changes coming—for the former, the untapped market in nail polish, and the possibilities of TV advertising; for the latter, the importance of unconventional marketing, and the room for a scientific beauty brand (to be fair, Helena Rubinstein had also come to this realization).

An uncanny knack to foresee the next big thing and to be in the right place at the right time isn't the only similarity between the earliest pioneers. Self-made mavericks, who came from humble, often very poor, beginnings, and had to fight their way, tooth and claw, to success. They dreamed of changing their lives and preemptively did so by changing their names, or inventing fantastical stories about their backgrounds—which can make it difficult to separate fact from fiction in their biographies. They were amazing marketers who invented the fantasy of beauty and the concept of creating and selling a dream.

The Heyday of Hollywood

GEORGE WESTMORE AND THE WESTMORES

To say the modern makeup industry started in Hollywood is no exaggeration—and in those days, the Westmores *were* the makeup industry. During this golden era, at one time or another a Westmore headed up the makeup departments at Paramount, Universal, Warner Brothers, RKO, 20th Century-Fox, Selig, Eagle-Lion, First National, and a dozen other film studios.

But the family's origins were far from the glitz of the Hollywood Hills. George Westmore was born on the Isle of Wight, in Great Britain, in 1879. He worked as a baker and barber, and served in the British army for a period until he was pronounced "medically unfit," at which point he opened his own hair salon. A combination of success and—probably more influentially—an innate sense of wanderlust led him first to Canterbury in England, then Canada, and finally the United States. A move to Cleveland in 1913 was the point at which George began to move beyond hair to painting women's faces. He did all his makeup training on prostitutes, as they were the only women who painted their faces—apart from actresses. Every day after work, he would take his rouge pots and practice painting the bordello ladies, applying rouge to nipples, ankle bones, hip bones, and the backs of thighs, as well as to faces. He also started training his young sons in the art of wigmaking.

George loved going to the movies to watch the big stars of the day, such as Charlie Chaplin, Mary Pickford, and Lilian Gish, but he noticed that their wigs were badly made, and that the makeup used on-screen looked ludicrous (actors still did their own and hadn't really adapted theatrical techniques for film, painting their faces as if trying to project to the last row of the theater rather than a movie camera

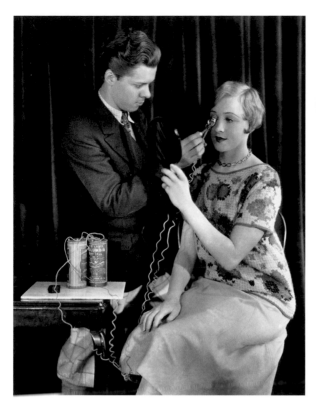

Westmore started a dynasty and set Hollywood precedent when he created the first studio makeup department in 1917.

In 1935, the House of Westmore was opened and the brothers began selling their own line of salon and consumer makeup products.

that was just a few feet away). The makeup not only looked amateur but also had no continuity, meaning that the actors often appeared completely different from scene to scene.

George knew the fledgling movie industry desperately needed his skills, so he made his way to Hollywood. After starting out at the hair salon Maison Cesare, he convinced the Selig studio that they needed an on-site makeup department. George set up the first ever studio makeup department in 1917, clocking in from five to eight each morning, after which he worked a full day at the salon. One day, actress Billie Burke walked in, and noticing how thin her hair was, George promised to make a wig for her. He worked fast and, astonishingly, presented her with a bespoke ventilated wig the very next day. At the same time, he took the liberty of telling her that her makeup was wrong. When he finished restyling her, something still bothered him about her eyes, so he cut bits of hair from the back of her wig and pasted them to her eyelashes one by one—probably creating the earliest individual lash extensions.

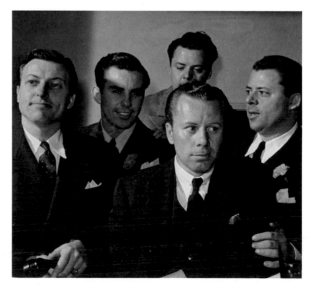

A Lasting Legacy

While the name Max Factor is world famous (and not undeservedly so), most women don't realize how influential the Westmores were in shaping women's appearances, from eyebrows and lips to hairstyles. All the iconic movie stars passed by the Westmores' makeup chairs at some point in their careers, and Cecil B. DeMille would not make a film without a Westmore by his side. As Frank Westmore put it in his autobiography, "It was Ern Westmore who—when working with Bette Davis—with a few swipes of his lipstick brush, changed the shape of millions of women's lips all across the world." Steering away from the rosebud shape favored by Clara Bow and most starlets of the time, which he felt wouldn't suit Bette, Ern gave her lips a completely new shape. When she looked in the mirror afterward, she said, "I never considered myself a great beauty, except for my large eyes, which I knew were my best feature. Somehow the mouth Ern designed made them look even better. With my new lips, my face came together and I began to feel rather beautiful." Bette once said she owed her entire career to the Westmore brothers. When you are inspired by a makeup trend today it's very possible it has its roots in a style first developed by a Westmore.

By this point the movie industry was really taking off. George and another wigmaker named Louis realized that Hollywood was going to need a lot of makeup. But, they wondered, who really knew makeup? The answer, of course, was actors—they needed to know makeup to get a job! It might seem crazy now, but the makeup industry in Hollywood was originally started by two wigmakers and a handful of actors when George and Louis approached fifteen or so actors and formed a little group known as the Motion Picture Makeup Artists Association.

In 1923 George's son Perc was the second Westmore to set up a makeup department for a film studio (First National, which later became Warner Brothers). All of George's sons—Mont, Ern, Wally, Bud, and Frank—would eventually follow suit.

In April 1935 they opened the House of Westmore—"the epicenter of glamour not only of Hollywood but of the entire world."[2] The idea for the lavish salon was Perc's and came after he and Ern were invited by Max Factor to develop, in their spare time, the "Percern" wig, the first commercial toupee utilizing their father George's invisible lace base (still used today). After Max Factor's highly profitable merchandising of the wig, it occurred to Perc how silly it was to be working for the benefit of anyone other than his family. Salon Products, along with a retail line offering the general public a slice of the glamour, was born shortly after, available at the House of Westmore and stores throughout the United States.

As with many of the early beauty pioneers, the Westmore brothers were not above the idea of concocting an illustrious heritage. In Frank Westmore's memoir, he explains how Perc told people that the Westmores were of "noble birth" in England and how everyone lapped it up—except for actor Charles Laughton, who reportedly replied, "you're so full of s***, your eyes are brown." They became as famous in Hollywood as the stars whose faces they were making up. Along with that fame came plenty of money, though they managed to spend the lot—apart from Wally, who seems to have been the only levelheaded brother when it came to finances. Unlike Max Factor, who was a businessman, the Westmores were the

creatives, with all that entailed: family feuds, spending sprees, partying, fraternal jealousy, alcoholism, and too many marriages (and alimony payments) to keep track of, not to mention bad health and business acumen. All of which lead to the closure of the House of Westmore and the eventual failure of the product line business.

The next generation of Westmores entered Hollywood and have continued to this day creating movie-makeup magic and cementing their legendary reputation, which was quite rightly honored with a star in their name on Hollywood Boulevard in 2008.

MAX FACTOR

One of the most recognizable names in the beauty world, and the first to start manufacturing makeup on a large scale for regular women, Max Factor is rightfully credited with defining the makeup industry as we know it today. He was born in Poland as Maksymilian Faktorowicz in 1872—the official date given, although its veracity remains unclear. Somewhat unhelpfully, Max Factor (like Elizabeth Arden) claimed that he didn't know it himself!

Max's family was large—he was one of ten children—and poor. He and his siblings started working from a young age: He was nine when he was first apprenticed to a wigmaker and cosmetician. At fourteen he got his first paid job as a wigmaker, makeup artist, and costumer for the Imperial Russian Grand Opera. He worked there until he was eighteen, when he had to do obligatory military service. Next he moved to Moscow, and started selling his own cosmetics and wigs. It wasn't long before these caught the attention of the court of Czar Nicholas II; while this had financial benefits, it also meant that Max was entirely at the beck and call of the court. In *Max Factor's Hollywood*, he's quoted as saying of the time, "I had no life. A dozen people were always watching me, following me. I could see no one on my own. I was

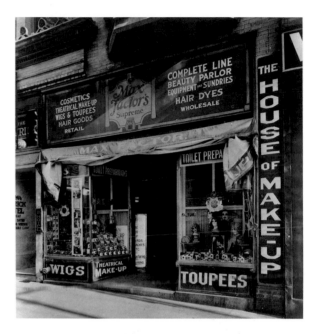

ABOVE: Max Factor's "House of Makeup" store in the heart of the theatre district of Los Angeles in 1917.

BELOW: Some of Max Factor's early consumer-facing packaging played up the brand's theatrical and Hollywood beginnings with their drama mask markings.

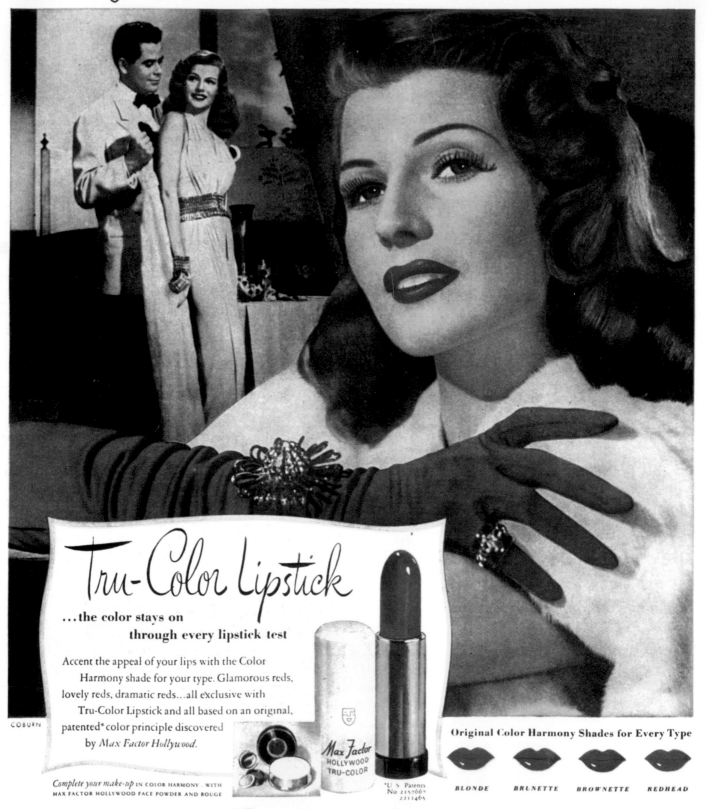

The Problem with Film

It wasn't just the unrefined theatrical greasepaint that made doing makeup for the movies difficult. A big part of the problem was the fact that early blue-sensitive orthochromatic film stock was insensitive to red, and made the actors' skin appear twice as dark as it really was and blue eyes appear white and turned anything red to black. This meant that regular makeup just didn't translate on-screen. Panchromatic film, which was sensitive to the entire color spectrum, was an improvement, but due to issues with expense and supply, it didn't really come into use until after 1926. And while it may have registered a broader range of colors, it still required Max Factor to produce specially tested panchromatic makeup products. In fact, with the constant development of filmmaking techniques, there was an increasing need for an understanding of colors and innovation in products. Actors and makeup artists relied on Max Factor to develop new textures and colors that would deal with these challenges—from the different lights that came with black-and-white talkies to the struggle with Technicolor. As veteran Hollywood makeup artist Howard Smit commented in an interview for the Television Academy Foundation's Archive of American Television, "Max Factor himself didn't have any secrets to share insofar as the doing of the makeup. His secrets were in his manufacturing; he was in the industry to *make* cosmetics. The connection makeup artists had with the Factor organization was just perfect because we worked with each other; they helped us to perfect the makeup we needed in those early days."

allowed only to make the court handsome. I had nothing for myself."[3] The situation wasn't sustainable—especially as he had secretly married, against the rules of the court, and had a growing family—and in 1904 Max decided to immigrate to the United States, to escape the stifling restrictions of working for the czar, and the disturbing growing anti-Semitism and pogroms. In a detail that seems almost too fantastic to be true, he is reported to have painted his face with yellow makeup in order to look unwell, and after being sent to a spa to get better, he made a dramatic escape, along with his family.

It was the US immigration authorities who changed his name to the one we recognize today. On reaching the United States, the Factors moved to St. Louis, Missouri, as this was where the 1904 World's Fair was being held, and Max knew he could sell his products there. Sadly, tragedy struck when his wife died suddenly, and he moved to Los Angeles in October 1908 to start over again. In an entirely visionary move, he opened up a store where he stocked Leichner stage cosmetics alongside his own concoctions, and the following year he officially founded Max Factor & Company. Although he was making and selling his own makeup, the bulk of his trade at this time was wigs. They would lead to his first big break in the movies, when he rented his wares to Cecil B. DeMille for *The Squaw Man* in 1914. Famously, three of Max's sons were extras in the movie so that they could more easily collect the wigs at the end of the day![4]

At this early time in the evolution of Hollywood, most makeup artists were still using theatrical makeup, and this just didn't cut it for film as the makeup would crack—a disaster onscreen. Max's makeup breakthrough came when, in 1914, he developed greasepaint in a cream rather than stick form— a thinner and more flexible product that didn't crack and which came in twelve shades. Word spread and

Max Factor was particularly successful at bringing his makeup products and popular Hollywood stars together in a mutually beneficial promotion of the makeup, movies, and actresses.

tailoring her products and pitch to her market, offering different products to the United States and United Kingdom at different times.

Her products and salons in London and later Paris thrived, but with the onset of World War I, she moved to New York with her family, and in 1915 she opened the first of many salons in the United States. On remembering first seeing the women of New York, Helena is reported to have said, "I recognized that the US could be my life's work."[13] Thankfully unaware that she thought them in such drastic need of her help, the well-heeled ladies of New York loved her range of products and impeccably marketed treatments. In 1928—just before the stock market crash—she sold her US business for the then eye-watering sum of $7.3 million (more than $90 million today), but after mishandling and the Depression, the company was worth a fraction of the original price. So in typical fashion, she bought it back at a hugely reduced rate, and proceeded to grow it to an even bigger and more successful company.

Rubinstein never actually retired, working right up until her death in 1965, by which point the cosmetics empire she had built spanned the world. Her company was left to her son Roy, who eventually sold it to Colgate-Palmolive, and is now owned by L'Oreal. As a brand, Helena Rubinstein may be less prominent than it used to be, but Helena's achievements shouldn't be forgotten. Her own typically no-nonsense take was that "if I hadn't done it, someone else would have," but the *New York Times* has described her as "probably the greatest female entrepreneur of all time."

ELIZABETH ARDEN

Born Florence Nightingale Graham, Elizabeth Arden grew up on a farm just outside of Toronto, the middle of five children. Reports of her exact date of birth have varied greatly (ranging from 1878 to

What's in a Name?

You can see why Elizabeth—or Florence, as she was known up until 1909—might have wanted to change her name from Florence Nightingale; the pioneering nurse had recently died, and besides, the association might have been confusing. But there was surely more to it than that. Elizabeth's competitor Helena Rubinstein had also made up her own name, and it seems impossible not to feel that these women wanted to completely remake themselves and control every aspect of their image and brand. It was also an irresistible opportunity to suggest a slightly more glamorous version of the truth (think of the Westmores' fib about their illustrious English heritage). It follows that popular mythology, encouraged by Elizabeth, has it that she chose her new surname while reading Tennyson's poem "Enoch Arden."[15] However, there's been a suggestion that the real inspiration was rather more prosaic, and that she came upon it when reading an obituary of a millionaire racehorse owner whose country estate was named Arden. Considering her love of horses, the latter explanation doesn't seem that unlikely.

Arden believed whatever shades of makeup a woman chose to wear depended on her personality and style rather than her hair color, challenging Max Factor's "Color Harmony" philosophy.

1886),[14] largely because Elizabeth herself lied about her age—she once said that even she couldn't remember the truth, as she'd changed her story so many times!

Her mother died of tuberculosis when Florence was just four and her father struggled to care for the children, with young Florence taking on the care of the family's horses. It sounds like a tough upbringing, but it seems to have been paramount in shaping her later life. Not only did it nurture her love of horses, but it also encouraged a desire to escape into another, better, richer world.

When she was twenty-six, Florence moved to New York.[16] She began working as a cashier at Eleanor Adair's salon on the illustrious Fifth Avenue. Her two years there had a great effect on her, introducing her to the benefits of yoga and massage and

the importance of describing a product in order to really sell it. In 1909 she left Eleanor Adair to go into business with Elizabeth Hubbard, who had her own small skincare range. They opened their salon, which was also on Fifth Avenue, clearly pitching it and their products to an affluent luxury market. Unfortunately—or rather, unfortunately for Elizabeth Hubbard—they fell out, and the partnership dissolved after only six months. Not only did Florence keep the premises, but she also adopted her ex-partner's first name!

In 1910, Elizabeth opened her new salon, naming it Salon d'Or. It was luxuriously decorated, with a striking red door that would later be integrated into the brand's identity. The decorations must have been expensive, and because banks didn't give loans to single women at this time, one wonders how

PURE PURE RED...the brightest new idea in makeup in a long, long time.
A zinging note of color that sings out today's fashion message pure and clear.
(Halfway shades look like yesterday, now that PURE PURE RED is here.)

Elizabeth Arden

NEW YORK LONDON PARIS

Elizabeth must have struggled to get it together. The fact that she did, and knew that the expenditure was worth it, just shows how savvy she was, and how she understood the emerging market that she was entering. In the years to follow, she'd repeat this belief "that one must spend money in order to make money."[17]

For Elizabeth, as for so many of the twentieth century's beauty pioneers, it really was all about the timing. In 1912 she went on a tour of Europe to research what was going on in the salons in Paris (she characteristically denied visiting Rubinstein's). At a suffrage march in New York earlier that year, Elizabeth had noticed that the women were wearing red lipstick as a symbol of emancipation, and in Paris she noticed that many of the women were wearing makeup—including around their eyes. She knew the tide against cosmetics was turning, and reportedly experimented with her makeup products on her staff when she returned to the United States, though it would take a while to interest her clients in these.

The trip to Europe was important for other reasons: It was on the journey back to the United States that Elizabeth reportedly met the man who would become her first husband, former salesman Tommy Lewis. She hired him to run the wholesale arm of her company, and he would be integral to its growth over the coming years. Tommy accompanied Elizabeth, along with one of her sisters, on another trip to Europe in 1920, this time to find wholesalers and potential salon spots. The company grew rapidly during this period: By 1925, there were Elizabeth Arden salons in nine cities in the United States as well as in Paris and London.[18]

Arden reportedly did all the copywriting for her ads, wanting to maintain strict control over the language and ensure the right shade of pink was used.

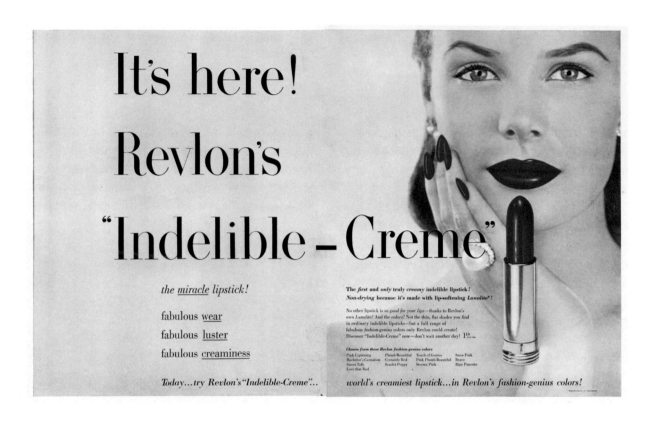

but they soon would be through the demand created by the ad. The ad had cost over three hundred dollars—their entire advertising budget for the year, and a huge amount for a fledgling company in the middle of the Depression. The gamble paid off and by 1938 Revlon nail polish sales were more than one million dollars (approx $16,000,000 today).

The strategic, if somewhat dishonest, advertising was indicative of Revson's strategy for success. There were nasty rumors of competitors' color charts going missing and lids being left unloosened so that the polish would dry up. One Revlon salesman recalls Revson saying, "You let the competitors do the groundwork and make the mistakes. And when they hit with something good, you make it better, package it better, advertise it better, and bury them."[23]

Some of his business practices may have been seemingly underhanded, his crushing of competitors ruthless, and his obsessive and overbearing tendencies the cause of rifts with employees and family members (and two wives), but there's no doubting

that Charles Revson was totally dedicated to his company, and had a remarkably strong work ethic. He meticulously tested his own products, including painting his nails before going to bed to check the polish's durability, and painting them in a variety of shades before going to sales meetings with beauty salons to hand-sell his product, so he could show them his company's range. This was cheaper than printing a color chart, but it also had strong novelty value. Above all, he knew how to *sell*. And it worked: Revlon polishes were available in drugstores, beauty salons, and department stores.

During the Second World War, Revlon received many government contracts, producing first aid kits and many other things, which helped to ensure that

ABOVE: Revlon was the first company to introduce the idea of matching your lipstick to your nail polish.

OPPOSITE: Taking a cheeky dig at Helena Rubinstein and Elizabeth Arden, Revlon named his men's grooming line, "That Man."

Although the film didn't appear in cinemas until 1963, Revson sensed the public's anticipation driven by the endless stream of paparazzi photos of Liz on set and released his *Cleopatra* inspired lipstick holder in 1962.

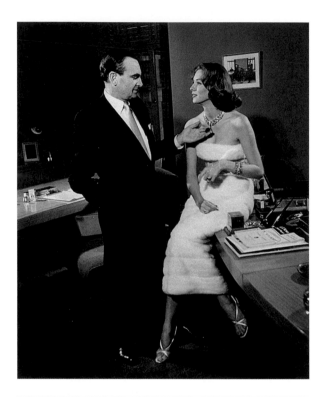

Fire and Ice

In the autumn of 1952, Revlon launched Fire and Ice, widely considered one of the most iconic and groundbreaking beauty campaigns. It was unique in that it sold lipstick and nail polish not just as luxury products—but sexy luxury products. Created by female copywriter Kay Daly, the two-page ad featured a glamorous photo by Richard Avedon along with an eleven-question quiz to discover if the reader was a "Fire and Ice girl" (defined as "easily the most exciting woman in the world"), an interesting selling tactic that equated your makeup with your (desirable) personality, and which clearly paid off.

they could continue selling their makeup even with the shortages. In 1940, Revlon began to sell lipsticks that matched their nail polish colors, an inspired decision that more than doubled their annual profits,[24] and soon after, they moved into rouge. By 1960, Revlon was the biggest seller of nail polishes, makeup, and hair spray.[25]

In line with Charles Revson's radical, fearless attitude, Revlon was the first beauty brand to embrace TV advertising. From 1955 until 1958, they sponsored *The $64,000 Question* game show, running three spectacular one-minute ads per week, which were broadcast live. Sales increased dramatically, with many products selling out. Despite a scandal over possible rigging of the game show, and Revlon's involvement in this, the company sped light-years ahead of its competitors.

Revson was diagnosed with cancer in the early 1970s. One of the last decisions he made at Revlon was in 1973 to hire Lauren Hutton for a huge and unheard-of yearly sum.[26] Charles Revson died in 1975 from pancreatic cancer at the age of sixty-eight. Though it continues to have a strong presence, Revlon is no longer in direct competition with luxury brands and is sold exclusively in drugstores today.

ESTÉE LAUDER

Born Josephine Esther Mentzer in 1908, Estée Lauder was brought up in the uninspiring area of Corona, Queens, to a Hungarian mother and Czech father who had both immigrated to New York.

In 1924, at the age of sixteen, Lauder began working for her uncle, a chemist, making skincare products and selling them to beauty salons. She eventually began experimenting with her own recipes.[27] From the beginning, she had a clear vision—and it was classy. In the 1930s, she decided to focus on creating luxurious packaging for her products. She

Cosmetic Espionage

Lauder had a well-founded wariness of Charles Revson. A *New York Times* article describes how, when she was developing Clinique, all meetings about the launch took place in a windowless room and "the project was code-named Miss Lauder, to disguise it as a teenage division." When the launch came, it infuriated Revson, as Lauder had known it would. He quickly retaliated with his Etherea line, a clear imitation. But Estée Lauder had one more trick up her sleeve and just before Revlon's range hit stores, "Clinique ran ads using the unannounced names of Etherea's products as adjectives to describe Clinique."[28]

also changed her name to Estée Lauder, suggestive of a European identity—sound familiar?—although the official line is that the name "Estée" was a variation on her family nickname, Esty, and that "Lauder" was a variation on the name of her first husband, Joseph Lauter. It wasn't until 1946 that she launched Estée Lauder Cosmetics.[29]

Her retail strategy was to sell in high-end department stores, which matched her view of the brand's customer: a refined woman who wanted high-quality products and packaging. Like her rival Charles Revson, Estée was a real face-to-face saleswoman and put in the work to make her products take off, visiting the stores and handselling herself. She put great stock in touching the customer, applying cream to their hand or wrist, and hooking them. Later on, even when the company had exploded, she would often insist on training her own staff to work in department store

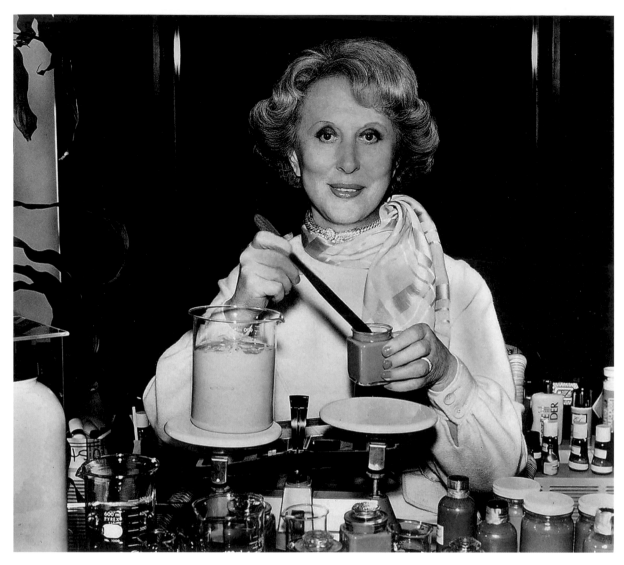

With her experience as a chemist, and an eye for sophisticated and sumptuous packaging, Lauder proved herself to be a formidable and forward-thinking businesswoman.

concessions. Estée Lauder's advertising fit in with her vision—unlike Revlon's all-singing, all-shouting color campaigns, she employed a sense of sophistication with black-and-white photography, and by using the same elegant blond model, Karen Graham, over many years.

In 1953, Estée Lauder had its first really successful product with Youth Dew, a bath oil that acted like a long-lasting perfume due to its high concentration of essential oils, which lingered on the skin. It became instantly popular, partly as it was seen as a good value. But it was the launch of Clinique in 1968, the

first "dermatologist-tested, fragrance-free cosmetic brand" that changed everything for Estée Lauder. Based on a three-step skincare routine (wash, exfoliate, moisturize), Clinique was groundbreaking in its pared back, "scientific" approach to skincare. It also employed a novel advertising campaign, using elegant still-life photos of the products—an approach it maintains to this day. In 1976 the company introduced Clinique Skin Supplies for Men, the first men's range to come from a women's brand.

Lauder died in 2004, having outlived all her rivals. She even reportedly attended Elizabeth Arden's

"If You Give, You Get"

Among Estée Lauder's most important innovations and legacies in beauty marketing was the introduction of the sample-size freebie and gift with purchase. With a limited budget for advertising, Lauder sent letters to the Saks mailing list offering a free gift with any in-store purchase. When Youth Dew hit the big time, she offered the perfume as a free gift when a customer bought a skincare product.

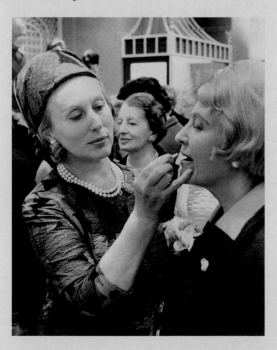

funeral. Not only a formidable woman in her own right, the company is still hugely successful financially, and a major beauty presence across the world, but it continues to be majority owned by the Lauder company—a rare feat. The Estée Lauder Company owns more than twenty-five brands, among them are giants such as MAC Cosmetics, Bobbi Brown, Aveda, Smashbox, and Tom Ford Beauty.

The Rule Breakers

The old guard maintained a stronghold over many cosmetic developments, but in the 1960s in Britain a revolution was happening. For the first time, there was full teenage employment: Girls had money in their pockets, and they didn't want to spend it on fussy enameled compacts. There was a need for fresh, fun makeup for a younger generation. Though this started in London with Mary Quant and Biba, it soon spread throughout the world.

MARY QUANT

Mary Quant opened her first fashion boutique, Bazaar, on the Kings Road in London in 1955. She launched her cosmetics range in 1966 at the height of the swinging sixties, after eighteen months of development. The mastermind behind it all, Quant has written that "people were stunned by the look of the whole brand." It's true that everything about it—like that famous Quant creation, the miniskirt—was completely different from what had come before, from the colors of the makeup itself, to the packaging and the advertising approach showing huge blown-up faces on billboards.

The iconic cosmetic crayons, which were literally a tin of colored crayons, had a typically naughty touch with the instructions suggesting you could use them to draw a flower anywhere! They gave people freedom to express their own creativity—a very different vibe from a little brush and a little tin.

Quant's packaging was inseparable from her clothes. She was creating makeup for a new modern woman, and it was encased in black-and-white plastic (the colors inside were often very much like that as well). She has written that her lipstick was "the symbol of the new, young career woman and they flashed

MARY QUANT COLOUR STICK
transparent skin colour

MARY QUANT EYE TINT
longlasting shadow tint

MARY QUANT TEARPROOF MASCARA
0.25 OZ. NET WT. 7G.

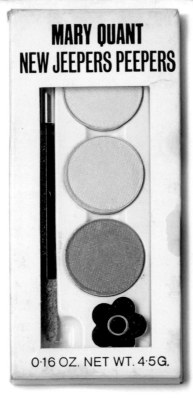

MARY QUANT NEW JEEPERS PEEPERS
0.16 OZ. NET WT. 4.5G.

MARY QUANT LICKSTICK

MARY QUANT NATURE TINT
see-thru make-up

MARY QUANT NATURE TINT
see-thru make-up

MARY QUANT FACE FINAL
compressed face powder
WITH PUFF
8.5g 0.3 oz. net wt.

ABOVE: Quant spent eighteen months developing her makeup range, which, with its playful and vibrant vibe, was a complete departure from the clichés of the early pioneers.

OPPOSITE: The stark monochromatic packaging, tongue-in-cheek names, and 'groovy' innovative products in Quant's first cosmetic line were as revolutionary as her fashion designs.

it across restaurants at each other. It was like being a member of a club."

The products themselves had playful names to match their looks, from Starkers foundation to Jeepers Peepers eye shadow and Bring Back the Lash mascara. The aim, according to Quant, was to replace "all those bogus French names, sold by middle-aged harridans. Mary Quant cosmetics were going to be sold by girls in miniskirts, looking like top models, or by dashing young men in jeans." It changed the way makeup was sold—the shops looked more like art stores, and there were no more "dowager saleswomen," as Quant cheekily said.

Quant's products were soon stocked all over the world. The tide had truly turned.

BARBARA HULANICKI

In contrast to the shiny futuristic newness of the sixties, the next decade had a decidedly more nostalgic feel. Barbara Hulanicki started Biba as a mail order business in 1963, selling cool and affordable clothes to young women. In 1964 she opened a tiny boutique in Kensington in London, and it soon became the place to be; in fact, by 1973 it had expanded to fill a six-story building that had once been a department store

Biba started selling makeup in 1970, and it soon became one of the most successful and profitable parts of their business. By the following year, the products were available from concessions in Paris, Milan, New York, California, and Tokyo, as well as three hundred Dorothy Perkins stores across the United Kingdom.

The packaging was cool and glamorous, sleek black and gold with a 1930s vibe. But the colors inside were very different from anything that had come before. Biba totally revolutionized what was considered acceptable for eye, lip, and face colors years before anyone else did. Blushers, eye shadows,

contouring products, and face glosses came in every shade, from blue to green to black. There were amazing metallic silvers, coppers, and golds, though the key Biba colors were distinctive, dusky, "bruised" shades—rusts, browns, mustard yellows, dark teals, mahoganies, and plums—a world away from traditional red, pink, blue, and green. In 1972 Biba also created the first ever range of cosmetics aimed at women with dark skin tones. Barbara Hulanicki has spoken about how, when she showed the factory the colors she wanted for Biba's range (brown, blue, and black lipsticks), they didn't seriously believe anyone would ask for such a thing. But with her gift for capturing the zeitgeist, Barbara had hit the nail on the head, and Biba's first brown lipstick sold out in half an hour.

The Biba eye look was not about the harsh graphic lines of the sixties but rather big, soft, round clouds of color. And wherever the Biba girls went, with their glossy metallic faces, huge, heavily lashed eyes, and strange lip colors, everyone sat up and noticed.

Biba offered something new to its customers—the chance to test the makeup before they bought it. This was totally revolutionary: Lots of hip young girls would come in and do their makeup at the counter before a night out. And it wasn't just the girls—Biba had a huge effect on men and glam rock, too. Angie Bowie was a fan and introduced David Bowie to the makeup. Basically, with Biba makeup it was a case of anything goes.

LEFT: Maverick fashion designer and entrepreneur Barbara Hulanicki turned the idea of acceptable makeup shades on its head.

OPPOSITE: Angelica Huston looking very 'Bibaesque' in 1973.

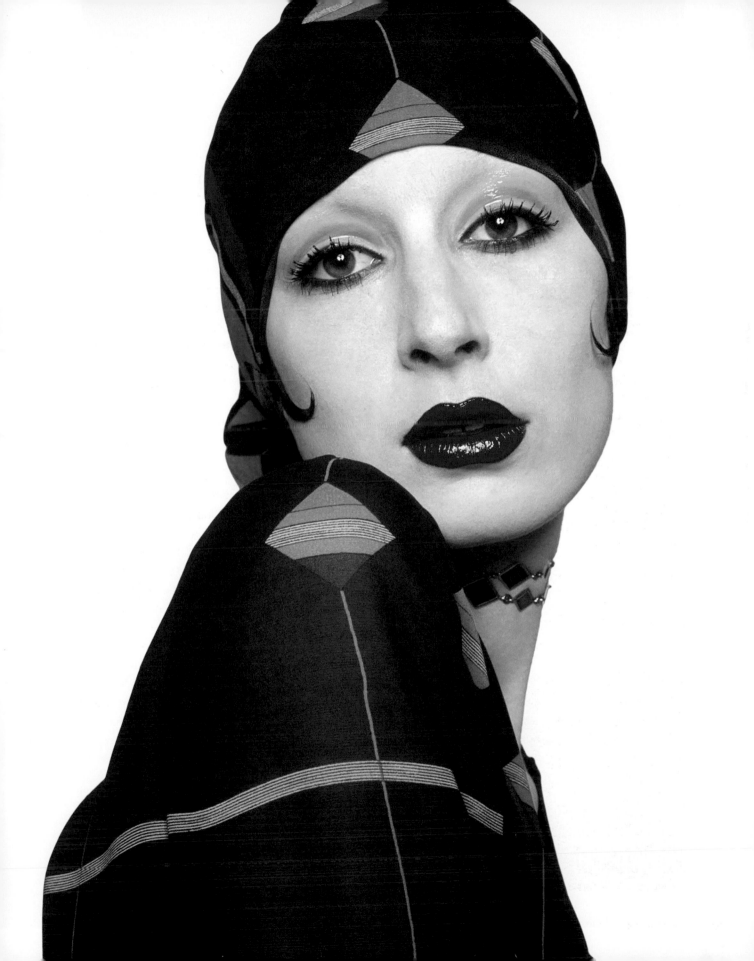

Marilyn Monroe

Marilyn Monroe was the ultimate bombshell, but she wasn't born that way. As photographer Milton H. Greene put it, "You don't just wake up in the morning and wash your face and comb your hair and go out and look like Marilyn Monroe. She [knew] every trick of the beauty trade."

A friend of Monroe's mother, who would later become Monroe's guardian, told Monroe at a young age that with a different nose and hair she could be like Jean Harlow.[31] It seems as though this stayed with her, as the first of the three key moments in Monroe's transformation from Norma Jeane into the icon we know today was when she dyed her hair (she starred in Howard Hawks's screwball comedy *Monkey Business* with full platinum blond hair in 1952). The second moment was when she reportedly had plastic surgery in 1950 on her nose and chin (these rumors have been confirmed by the notes from the office of Hollywood plastic surgeon Dr. Michael Gurdin, which were put up for auction and thus made public knowledge in 2013). The third was when she met her makeup artist, Allan "Whitey" Snyder.

Snyder was the makeup artist for Monroe's first screen test for 20th Century-Fox in 1946. She demanded that he do her makeup the same way as she did it for her modeling, even though he told her it wouldn't work for film. Sure enough, when she appeared on set, the talent director chided Snyder for his work, which made Monroe panic. Snyder reapplied her makeup, calming Monroe and earning her trust.[32] He would be Monroe's makeup artist for the rest of her life, and they had an incredibly close relationship—he helped with her much reported stage fright, and even did the makeup for her funeral (at her request), as well as being a pallbearer. Both Monroe and Snyder knew that the appearance of youth was an imperative in Hollywood, where stars, particularly women, had a short shelf life. All of the makeup Snyder used suggested "good health" and ensured that Monroe literally shone whenever the camera was on her. Coral cheeks, layers of glossed lipstick, fake eyelashes, dewy foundation—these elements were responses to the popular commercial fantasies of femininity that expressed the postwar American Dream; health, wholesomeness, and well-regulated erotic pleasure were available to all through the cinema screen.

Once they found *the* look—during preparation for *Niagara*, a 1953 thriller-noir—that was it. Monroe had many different degrees of her look. There was the "natural" version for personal appearances and "off duty" PR shots. Then there was the film version, which had to be adapted to the character she was playing, and then the fully made-up, all-guns-blazing version of Monroe. This glamazon look is associated more with the studio publicity machine (think of the promotional shots of her for *Niagara* in the gold-pleated dress—contoured, highlighted, and glossed up to the hilt), very different from her downtime look. Monroe was notoriously keen on protecting and moisturizing her dry skin and reportedly applied a layer of Vaseline or other heavy creams before her foundation. This would have given her a glow under the studio lights, imparting her skin with a beautiful sheen that had the added benefit of making her look ever so slightly soft-focus in front of the camera.

Appearing glowing and dewy were key components of Monroe's makeup; she always looked clean and fresh and never overly powdered, as she knew that moisture equaled youth. Channeling Greta Garbo's sleepy, heavy-lidded style for her eye makeup, she always wore a half set of fake lashes at the upper and outer eyelids to elongate her eyes and emphasize a sultry look, and sometimes added brown pencil under her eyes to make it appear as if a shadow were cast by the weight of her luxuriant lashes.

In Snyder's own words:

I can sit here and do the whole thing in my sleep. Put the base all over, lightly. The formula we used that perfectly matched her natural flesh tone was to mix a quart of Max Factor's suntan base, a half cup of ivory coloring, and an eyedropper of "clown white." Then, highlight under her eyes. Pull the highlight out over and across the cheekbones to widen. Highlight her chin. Eye shadow was toned, and that also ran out to her hairline. Then the pencil on top. I'd outline her eyes very clearly with pencil, but I'd make a peak right up—say almost three-sixteenths of an inch—above the pupil of her eye, and then swing it out there. And from there on out was where we put eyelashes. Also, the bottom line was shaded in with a pencil to make her eyes stand out fully and good. Her eyebrows came out to a point as far as I could get them to widen her forehead. So I'd bring them to a peak just outside the center of her eyes and then sweep down to a good-looking eyebrow. You couldn't go out much farther than that or it would look phony. Shading broke the bones underneath her cheekbone. I just brought a little line down there, a little darker shadow, so that it helped her stand out. Lipstick, we used various colors. At first, we had a hell of a time with Cinemascope—no reds photographed anything but auburn. We had to go to light pink.

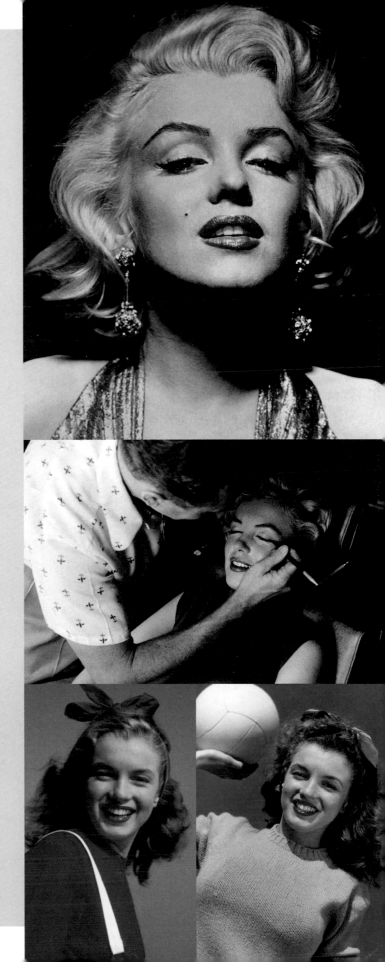

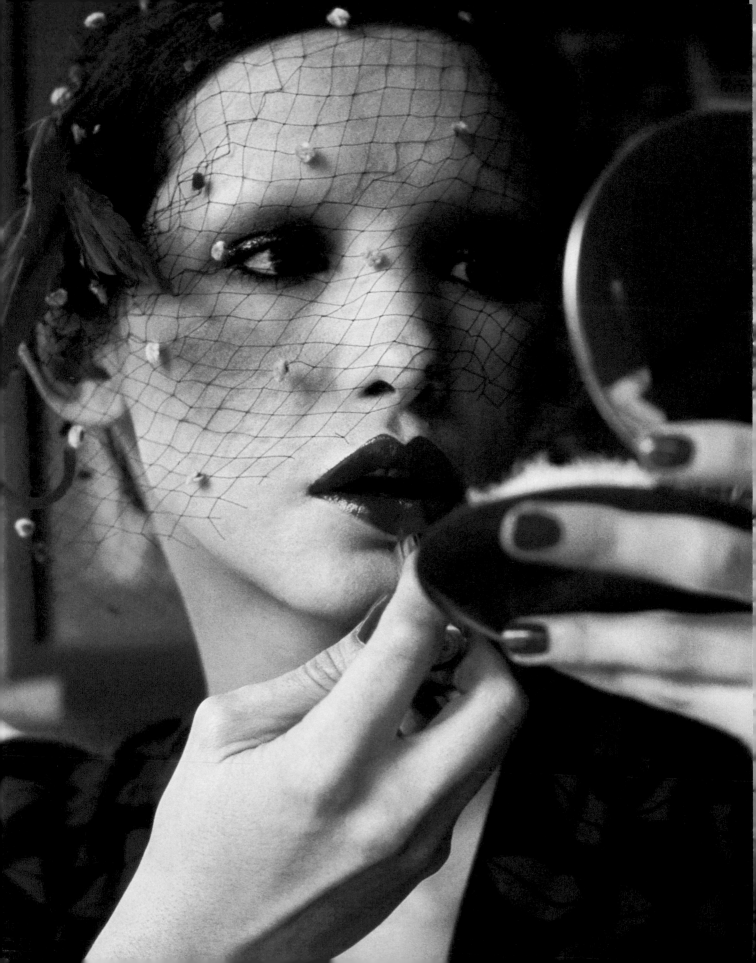

History in Your Handbag

FOLK REMEDIES TO GLOBAL BRANDS

Makeup bag essentials—mascara, lipstick, blusher, nail polish—are so ubiquitous today that it's hard to imagine a time without them. But many of the things we take for granted as we dig into our bags every morning were only developed in the past century, as makeup came into the mainstream. Before then, as we've seen, handcrafted pigments and home-made pastes jostled with some slightly dubious (if not downright dangerous) cures and charms. Over the past hundred and fifty years, these homespun remedies transformed into the evocative names that we are so familiar with today, from Rouge de Chanel lipstick to Bourjois blush pots and Maybelline mascara. The rise of these global brands meant that, by the mid-twentieth century, cosmetics for the privileged few had become makeup for the masses. But how did the beauty industry become the ever-growing and innovating powerhouse that it is today?

The business of commercial and factory-made cosmetics began in earnest in the eighteenth century in fashion-forward France. In many ways makeup was the most democratic of all "luxury" goods, as it was possible to produce and sell a pot of simply packaged rouge or powder cheaply (unlike, say, a silk dress), making it available to women beyond just the middle and upper classes. As Morag Martin points out in her book *Selling Beauty*,

Over the past century, cosmetics for the privileged few have become makeup for the masses. Female emancipation and the industrial and sexual revolution transformed the painted face and our makeup bags.

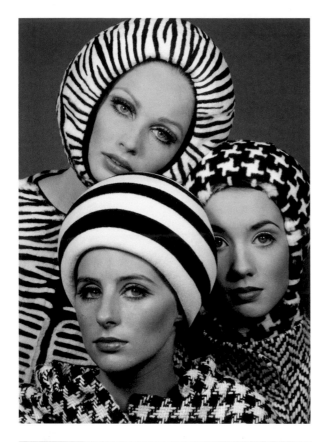

and scented fans for ladies to use at the opera to a magnificent fragrance fountain created for the Great Exhibition in 1851.

But what really earned Eugene Rimmel his place in beauty history was his 1860 creation of Superfin, the first commercial nontoxic mascara. As we know, women had been using various potions and pomades to darken their lashes for centuries, but Rimmel's pre-packaged and transportable blend of coal dust and petroleum jelly was revolutionary. Although quite messy and unstable, its popularity spread like wild-fire throughout Europe, and the words "rimmel" and "rimel" became synonymous with mascara, and still mean mascara in several languages.

Rimmel continued to work on mascara innovation, tweaking and improving Superfin, and eventually launched Water Cosmetique. This had been originally created much earlier as a mustache and beard colo-rant, known in theatrical circles as mascaro (popular with character actors, as well as mustachioed gen-tlemen), and was a mixture of soap and pigment in solid stick form, which was then mixed with water and applied with a brush to cover grays and add color. Eventually, the formulation was adapted, and in 1917 it was launched as one of the first block mascaras intended for use solely on the eyelashes and brows.

Around the same time (1917) on the other side of the pond, New York chemist T. L. Williams (founder of Maybelline) also launched a block mascara called Lash-Brow-Ine, described as "the first modern cos-metic produced for everyday use."[1] According to popular legend, Williams was motivated to create his mascara by his sister, Mabel (also the inspiration

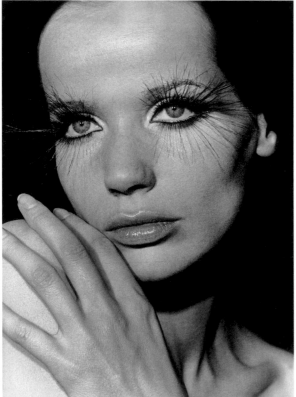

The sixties was a time when mascara overload really came into its own, with new applicators and formulas available, the fashion for building up layer upon layer and supplementing with falsies meant that lashes dominated the face.
TOP: Marisa Bevenson, BOTTOM: Veruschka

for his company's name, Maybell Laboratories, later Maybelline), after he saw her applying petroleum jelly blended with burnt cork to enhance her lashes, a tip she probably picked up in one of the many movie fanzines. Supposedly, his creation helped Mabel win back an erstwhile boyfriend, which, whether true or not, makes for a great story! Lash-Brow-Ine was only available by mail order at first (advertised in magazines), but the huge demand led to it being stocked in drugstores, and by 1932 one could buy a mascara package for just ten cents anywhere in the United States.

Of course, professional mascara had been developed previous to this for use in silent movies, with the first real product being made by Hollywood makeup artist Max Factor, who created Cosmetic, his own product for eyelashes. A waxy substance that came in foil-wrapped tubes, Cosmetic needed to be sliced and melted over a flame before it could be applied to the lashes (making them black but very clumpy). Needless to say, it wasn't available to regular women—its gloopy texture worked wonders on film, but wouldn't have translated to everyday life.

Although colored and waterproof block mascaras followed, the next really big innovation took a little longer to be refined. The change came when, in 1958, Helena Rubinstein launched Mascara-Matic, which was the size of a pen with a slim metal rod (the "brush" at the end was created by grooves in the metal) that could be pushed inside to access a black liquid product. The product effectively did away with the traditional "spit and brush" approach and allowed for a more precise application. Interestingly, a similar device was patented in 1939 by Frank L. Engel from Chicago, but never put into production, probably because of the pre–World War II timing, when investment in new cosmetics wasn't a priority. Whether coincidentally or not, Helena launched her mascara just as Engel's patent was expiring, unfortunately for him. New mascaras and innovations

Rubinstein's Mascara-Matic which launched in 1958 was the first ever tube and wand applicator type mascara.

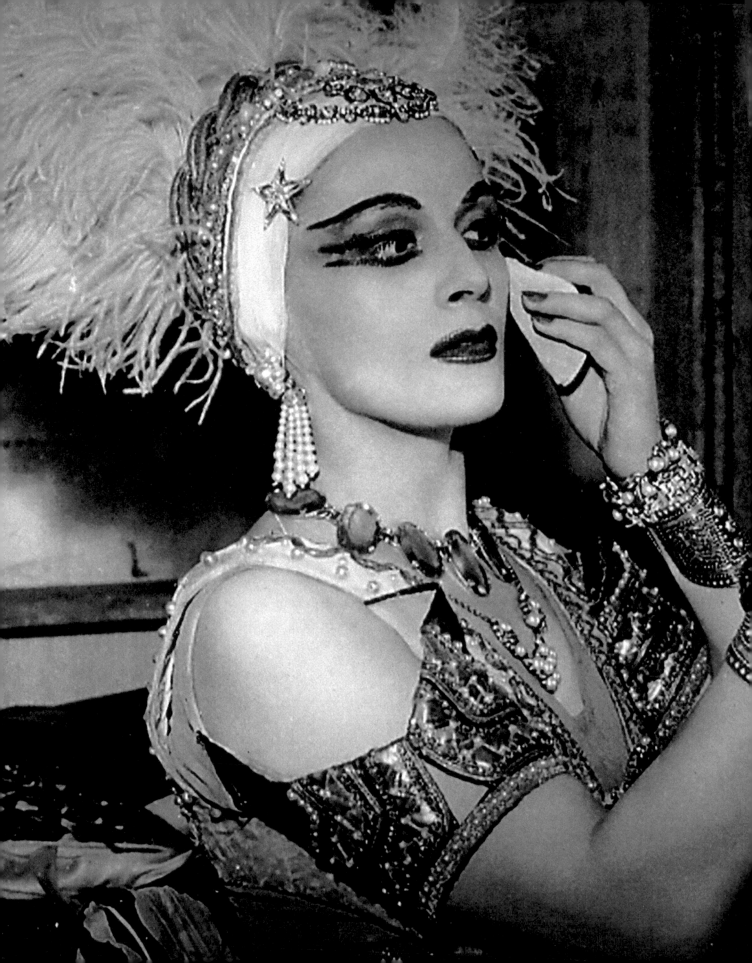

The touring ballet troupe Ballets Russes wowed audiences, which included influential names in beauty, with their painterly eye makeup and inspired collaborations with artists and fashion designers.

came thick and fast after Mascara-Matic, and it wasn't long before a new type of spiral brush made from nylon fibers was introduced. Of this new type of mascara, it was Maybelline's waterproof Ultra Lash in 1960 and then their water-based Great Lash mascara in 1971 that became the world's bestselling cosmetic products. After a relatively quiet period in terms of game-changing innovation throughout the eighties and nineties, the next milestone mascara moment came in the mid-2000s. German company Geka, an innovative brush and packaging manufacturer, developed a patented technology called Moltrusion. It had two components: one was a stiff plastic rod perforated with lots of tiny holes, and injected into the rod was a different type of exploding plastic to create flexible plastic bristles, perfect for combing lashes while delivering an even coat of "bulk" (the technical name for the black stuff). Geka partnered with Procter & Gamble to launch the world's first molded-brush mascaras for Cover Girl and Max Factor in 2005.

Having worked for various brands, I can tell you that the effort that goes into making a really great mascara and attempting to invent the next big thing in this category is enormous—and the competition is fierce. It's worth it, as mascara is a massive seller and one of the most lucrative moneymakers in the industry, mainly due to the fact that most women own mascara and have to replace it regularly, unlike other long-life products (powder blush, for example). In the past, the claims that brands made about their new mascaras could be wild, promising to quadruple the thickness of lashes, or double their length, and only recently have these claims begun to be policed. In 2007 the UK Advertising Standards Authority received so many complaints about two particular mascara ads—which showed famous faces with *very* long eyelashes—that it led to a ruling that all beauty advertisers have to include disclaimers stating if false lashes or Photoshop has been used to artificially enhance lashes. In recent decades

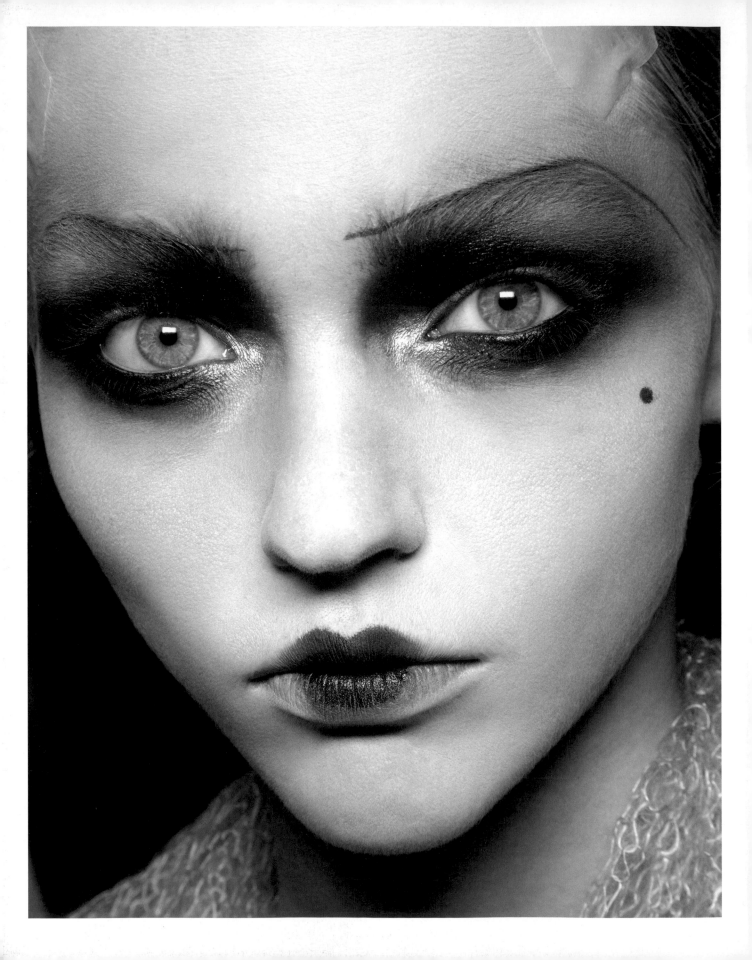

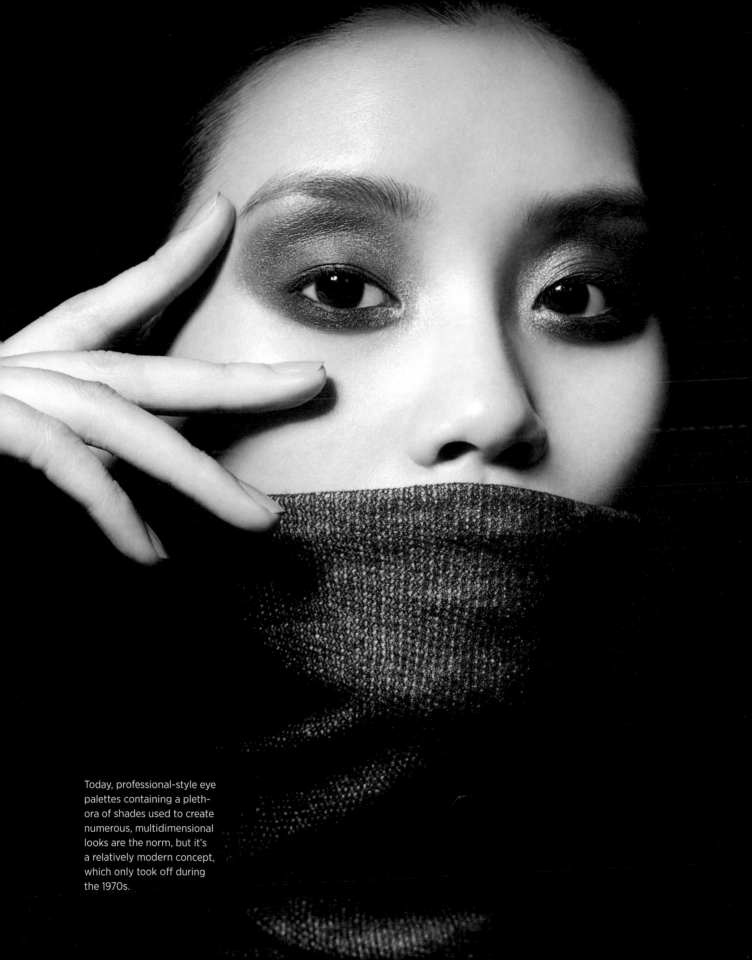

Today, professional-style eye palettes containing a plethora of shades used to create numerous, multidimensional looks are the norm, but it's a relatively modern concept, which only took off during the 1970s.

we've seen the launch of curved, double-ended, heated, oscillating, vibrating, and rotating mascaras, not to mention some very oddly shaped wands and brushes and the development of micro-tube technology. New mascaras are constantly released in the market, with around seventy-plus new ones launching into the average large beauty department store every year.

EYE SHADOW

We've already explored the origins of ever-popular kohl and eyeliner, but the eye shadow trios, quads, and palettes we carry around in our bags today have a relatively recent history compared with other essentials. The Romans used ash and saffron to color their eyelids, and the Egyptians used malachite to give their lids an iridescent green shimmer, but these early examples didn't continue, and colored eye shadow effectively went out of fashion for almost two thousand years.

As with most makeup, the theater played an important role in introducing the idea of colored eye makeup to the masses. The Ballets Russes and their eye-popping productions had a particularly important influence on people's perception of color and how it could be used. Diaghilev's *Schéhérazade* in 1909 in London is a notable example: Both Helena Rubinstein and Elizabeth Arden, arguably the most influential women and tastemakers in the makeup world of the time, have written of being influenced by the eye makeup worn by the Ballets Russes dancers during this production.[2] In 1914 Elizabeth Arden introduced eye makeup, including eye shadow, into her US salons,[3] though it would take a while for the trend to trickle down and become something found in regular women's handbags. It's worth remembering that the world was very much still in black-and-white at this point, which would have undoubtedly played a part in the slow growth of colored eye shadow. Films, movie magazines, and advertisements were mainly monochrome until the end of the 1920s (the United States introduced color advertising slightly earlier), and Technicolor didn't really take off for another ten or so years.

Pre-color Hollywood undoubtedly played a part in the growing popularity of eye products, with the heavily made-up eyes of vamps like Theda Bara and, as mentioned previously, the newfound popularity of exotic locations and desire for all things Egyptian, which had reached its peak with the excavation of Tutankhamen's tomb, encouraging a craze for kohl. But like colored eye shadow, heavily made-up or smoky eyes were not immediately embraced. The stigma that went hand in hand with wearing visible cosmetics would take a while to be overcome. The stage and screen may have made eyes more visible, but these were still actresses and performers playing a role. What's more, the fact that the vampy look was often paired with risqué costumes and characters of questionable morals created a connection in people's minds between this look and the type of person who would wear it.[4]

Though color eye shadow was around in the thirties, it was all about single colors. A Maybelline ad from 1930 (a year after the company first started producing eye shadow) describes how, of the four shades offered, "Blue is to be used for all shades of blue and gray eyes; Browns for hazel and brown eyes; Black for dark brown and violet eyes; Green may be used for eyes of all color and is especially effective for evening wear."[5] As this makes clear, the way in which eye shadow was worn was incredibly prescriptive and not very sophisticated—it was all about matching with your eyes or your hair or your clothes. It wasn't until the winter of 1949 to 1950 that fashion really began to turn to the eyes, focusing on shadows, eyeliner, and mascara, with greens, blues, and violets suddenly beginning to emerge (a major technological advancement that helped to enable this was the

introduction of artificial pearl into cosmetics following the Second World War).

In January 1950, *Life* ran a fascinating section on the new eye makeup, calling it the "biggest beauty news since lipstick." The piece breathlessly proclaimed, "When word came from Paris this winter that French models were wearing exaggerated make-up on their eyes even with street clothes, the U.S. cosmetics industry realized that here was a chance to exploit a comparatively untouched region of the American female face . . . Hollywood, which resisted short haircuts until defeated, insists that doe eyes will set things back fifty years, but cosmetics men disagree. Recalling that the first use of lipstick in the twenties caused a furor but soon made women feel undressed without it, they predict an equally essential future for drawn-on eyes."[6] Cosmetics man Charles Revson must have been pro the new eyes, as Revlon launched their Dreamy Eye makeup in 1950.[7] Again, though it was definitely out there, the trend was slow to spread to the average woman: Richard Corson notes that a survey of US university students in 1957 revealed that very few young women were wearing eye shadow, though most of them wore lipstick.[8] And though color was on the rise and compacts with two different eye shadows (such as blue and green) were available, they were still clearly designed to be worn separately. The concept of blending shades was a long way off: It would take the revolutionary sixties to move away from the matchy-matchy style that had been prevalent for so long.

Dramatic eye shadow really came to the fore during the filming of *Cleopatra* in 1962. Liz Taylor—in the first throes of her affair with Richard Burton and the paparazzi frenzy that followed the couple's every move—would often go out to dinner at various Rome hot spots still wearing the elaborate makeup from the day's filming. The photos would run in all the gossip magazines the following day, and the trend for heavy

Famous for her iconic eye look, British model Twiggy partnered with Yardley to create a range of eye makeup products (including this black-and-white matte eye shadow duo) and false lashes for sale in the US.

Egyptian eye makeup (albeit an updated sixties version) was created. Revlon jumped onto the trend and began advertising their Cleopatra-look products, including a trio palette of eye shadow and cake liner, in 1962, a year before the film was even released.[9] In 1962, Max Factor also released a jade-green eye shadow called Mermaid Eyes ("the most exciting look your eyes have ever seen")[10] and Blue Mist Powder Eye Shadow ("it gives eyes the same exciting matte finish as today's lips and complexions are wearing!").[11]

By the mid-1960s, as women became more liberated and the old rules began to seem less relevant, colored eye makeup was everywhere—from Coty's five eye shadow number complete with brush to Gala's Pick and Paint Eye Palette (shaped to look like a painter's palette, containing four shadows, an eyeliner, and two brushes), which all encouraged the consumer to have fun, be creative, and make their own rules. Yardley enlisted British model Twiggy to promote (and put her name on) an eye range of graphic mod-style black-and-white eye paint, which they sold in the United States.[12] The seventies saw the launch of a surge of trio palettes in previously unseen shades. In a complete about-face from the lurid mono brights of the fifties and the graphic monochromes of

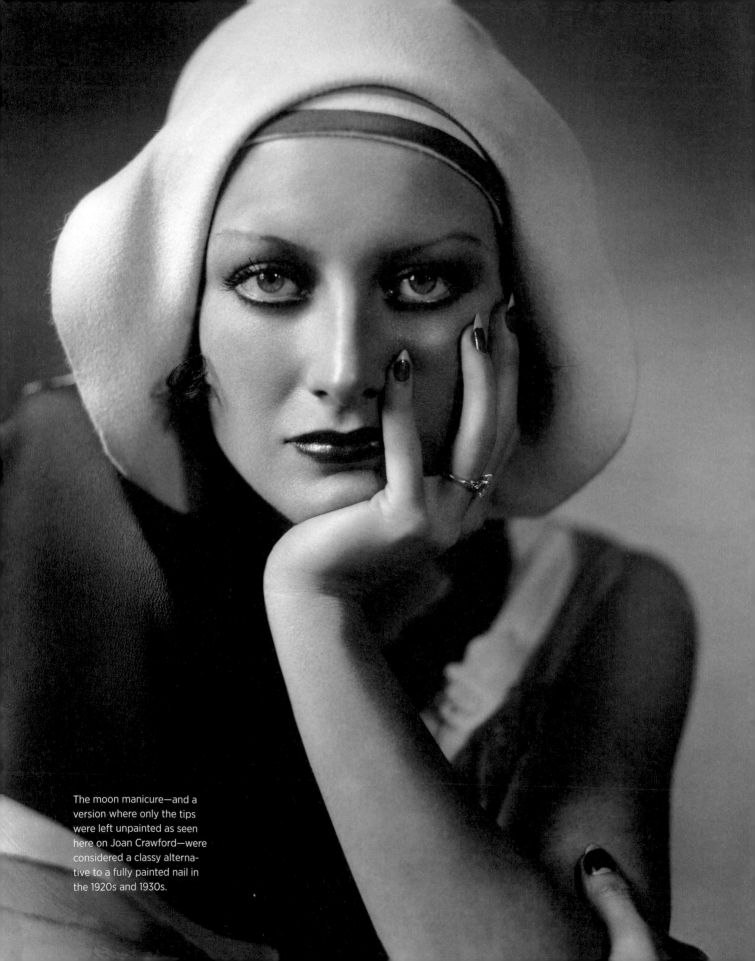

The moon manicure—and a version where only the tips were left unpainted as seen here on Joan Crawford—were considered a classy alternative to a fully painted nail in the 1920s and 1930s.

the sixties, sophisticated seventies eyes (exemplified by Biba) were all about dark, earthy colors—russets, browns, metallics, maroons, and bruised fruit shades in mattes and pearlized shimmers. The wider variety of colors and textures available in the palettes meant that shading and blending was not only possible but necessary. The work of makeup artists in editorials and advertising helped further this development, as it inspired more "professional looking" eye makeup, something that really grew during the "anything goes" eye makeup of the eighties. Since then, eye shadow has become hugely sophisticated and technical in a way it had never been before. These days making up your eyes with shadow is as much about highlighting and shading and sculpting and defining as it is about color. You don't just whack on one eye shadow—you blend three! Using eye palettes artistically and cleverly to make small eyes appear larger, or close-set eyes more wide set, is the norm. Eye makeup application now takes great skill and practice and good brushes and technique—and the beauty business is only too happy to provide us with thousands of palettes to choose from.

NAIL POLISH

Products like rouge and kohl have evolved over time, benefitting from technological developments, while essentially producing the same effects: drawing emphasis to the eyes or brightening the face. Nail polish is a different story. More than any other type of cosmetic, it really only came into being in the twentieth century, through the advent of the compound nitrocellulose. But, however modern that may seem, nails have been a focus for thousands of years, and today's intricate nail art can be traced back to early homemade stains and lacquers and techniques for buffing and polishing.

The very first nail paints appeared in ancient Egypt, where plant-based henna was used to stain nails

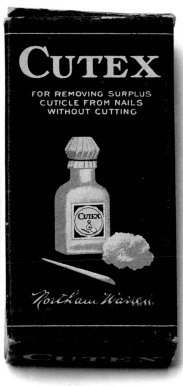

Cutex launched in 1911 in response to the growing nail care market.

yellow or orange. Colored nails signified social status, and the deep, dark shades created from kermes (a dye made from crushed beetles) or similar substances were restricted to royalty and their courtiers. Nefertiti's preferred nail color was reportedly ruby red, while Cleopatra's nails were stained a rust-red hue. Nail painting was also practiced by the ancient Babylonians, who considered well-kept nails to be a sign of civilization. Even Babylonian soldiers were reported to have painted their nails before going into battle (archaeologists have uncovered intricate manicure sets at the royal tombs at Ur). In Iran, henna was used to stain nails and by both men and women to strengthen and color hair (including beards). In some cases, lime and salt ammonia were added to the henna to darken the patterns. Henna was also used to paint intricate patterns on the hands and feet as a mandatory part of Iranian wedding ceremonies—a practice still popular today. China was a crucial and

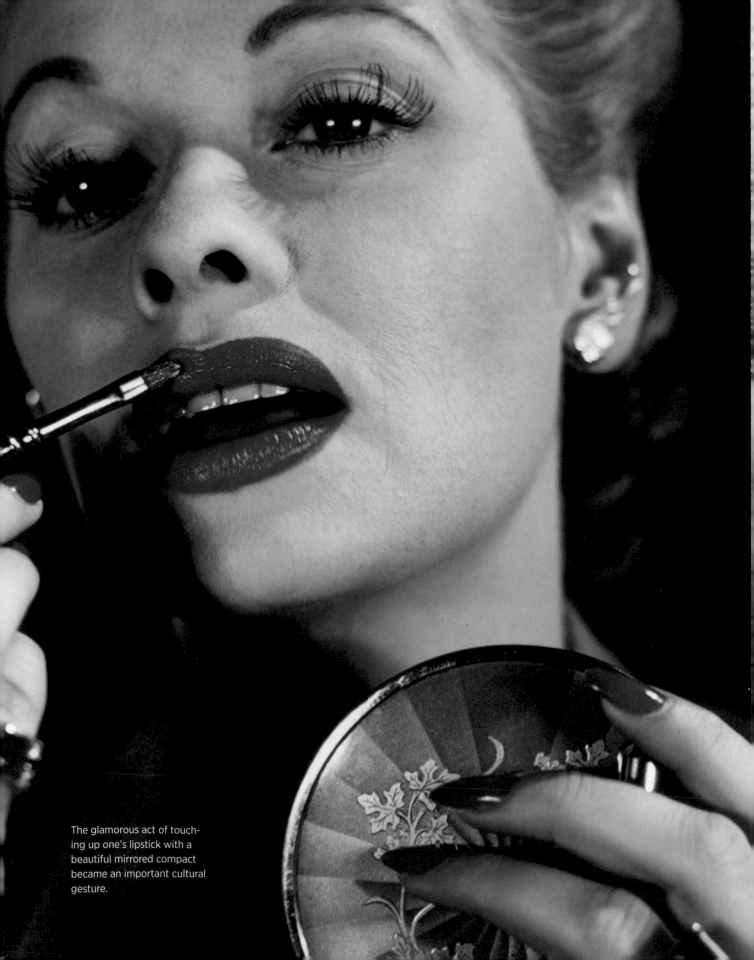

The glamorous act of touching up one's lipstick with a beautiful mirrored compact became an important cultural gesture.

lipstick was one of the most important gestures of the century.

However, for women at the beginning of the twentieth century, wearing lipstick was largely seen as morally questionable and of the realm of prostitutes and actresses. For this very reason, it became linked to the women's rights movement, with women campaigning for the right to vote at a march in New York in 1912 defiantly painting their mouths bright red. Revolutionary though it may have been, on a practical level, one couldn't really transport lipstick safely in her handbag. This changed around 1915, when lipstick began to be produced in metal cartridge containers. The Scovill Manufacturing Company of Connecticut produced the first tube lipstick container in October 1915 with side levers enabling one to push up the lipstick. In 1923 a slightly different container was patented in the United States, which allowed lipstick to swivel out of its tube, and more than a hundred other variations would follow.

One of the most popular brands at this time, especially for younger women, was Tangee, which boasted that it changed color on application according to the individual (even though it appeared tangerine orange in the tube, giving it its name) and was therefore more natural than the other brash lipsticks available. Crucially, Tangee was also cheap—around ten cents. As historian Madeleine Marsh points out, "Whether you were in Europe or the United States, you could buy a Tangee lipstick at shops like Woolworths or five and dime stores, and for the first time it wasn't hidden under the counter, you didn't have to ask a sales assistant to get it for you—making the whole process of buying a lipstick accessible and unintimidating."

While early ad campaigns had emphasized lipstick's enhancing of natural beauty, in line with the aversion to makeup appearing artificial, by the Second World War, women were actively encouraged to

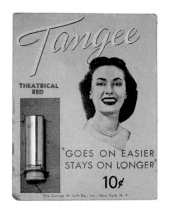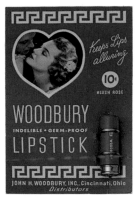

The popularity of inexpensive lipsticks such as Tangee and Woodbury made lipsticks much more accessible.

paint their lips bright red and glossy in order to keep up morale. Red lipstick was a mark of patriotism and showed a will to win—and this was reflected in the names of the lipsticks available at the time. In fact, having attempted to stop the production of cosmetics in 1942, the US War Production Board changed their tune and announced that cosmetics were "necessary and vital."[14] Rosie the Riveter became a wartime icon for a generation of women with her lipsticked mouth and painted nails (and strong arms), and Elizabeth Arden even created a makeup kit for the American Marine Corps Women's Reserve with a red lipstick that matched elements of their uniforms.

The next big innovation was "indelible" lipstick, which was developed by Hazel Bishop, an American chemist, in the late 1940s. Bishop's Lasting Lipsticks were hugely successful, but were eclipsed by Revlon. In 1940 Revlon had expanded from nails to lipstick, with the company's ever-prescient founder, Charles Revson, seeing the potential for matching nails and lips and capitalizing on this, introducing the company's lipstick with a huge color advertising campaign. In 1951 the company launched its Indelible-Creme lipstick and that, unfortunately, was pretty much the

end for Hazel Bishop. The golden age of lipstick was undoubtedly the 1950s, when a beautifully packaged lipstick along with an ornate powder compact were essentials in every woman's makeup bag to be pulled out for public touch-ups at any given moment. New innovations continued to be made—notably Cutex's introduction of flavored lipsticks in 1964, aimed, no doubt, at the growing teenage market—but for the next couple of decades, attention would shift to the eyes. Lip gloss sales eclipsed lipstick in the nineties, and for a while, lipstick appeared rather outdated to the younger generation. But in recent years this trend has been bucked; the focus is back on the timeless luxury and ritual that is bound up in lipstick, with many of the premium brands launching signature ranges encased in packaging reminiscent of a bygone era in terms of innovation and sumptuous design.

BLUSH

Rouge, the most enduring item in our makeup bags, has been a mainstay for thousands of years. As we know, early types of rouge were homemade from an array of animal-, mineral-, and plant-based ingredients. But it was only when rouge began to be mass-produced that its shades and varieties really expanded.

Before then, in the mid-nineteenth century, rouge was available as a powder, waxy pomade, or liquid infusion in a number of forms. It could be housed in a pot, bottle, paper or foil booklet, or in pieces of fabric. Different varieties had different names: Rouge containing carthamin was often Rouge de Carthame or Rouge Végétal, and a brighter rouge might be Rouge de Théàtre (Bourjois and Leichner produced a Rouge Fin de Théàtre in the early 1860s, though in the case of Bourjois, the label was later changed to Fabrique Spéciale de Produits pour la Beauté des Dames). The democratization of beauty meant that whatever

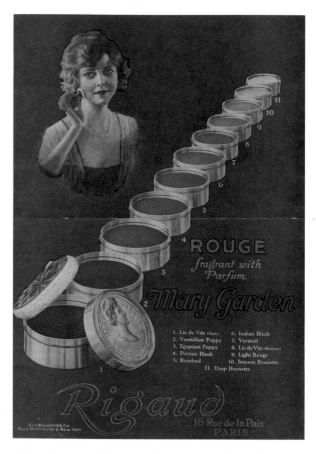

With an increasingly large selection of colors, price points, and formulations, blush has been a readily available and popular handbag essential for over a hundred years.

your budget, you could probably find a rouge that you could afford to buy. In 1830 in a boutique in rue Saint-Martin, Paris, pots of rouge ranged from five to eighty-five francs,[15] and Bourjois's little pots of powder rouge broke out from beyond their once-exclusive theatrical origins.

The fashion for compacts in the 1920s meant that a variety of stylishly packaged rouges (and face powders) flooded the market. But despite rouge's popularity over history, and though it was refined over the twentieth century, with synthetic reds developed and a wider range of colors available, the growing

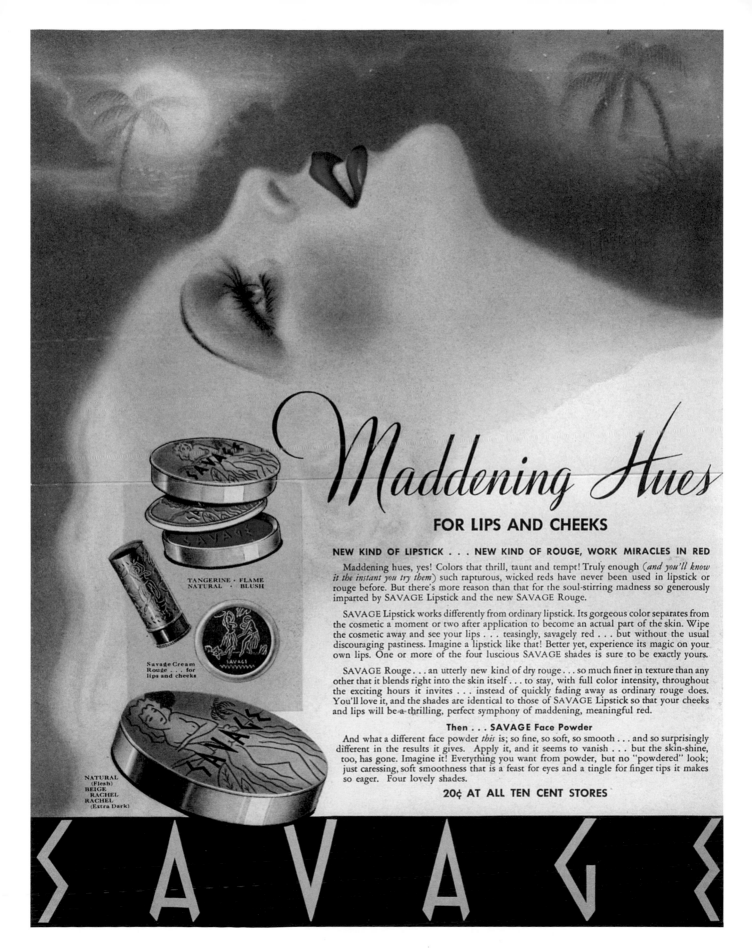

Maddening Hues

FOR LIPS AND CHEEKS

NEW KIND OF LIPSTICK . . . NEW KIND OF ROUGE, WORK MIRACLES IN RED

Maddening hues, yes! Colors that thrill, taunt and tempt! Truly enough (*and you'll know it the instant you try them*) such rapturous, wicked reds have never been used in lipstick or rouge before. But there's more reason than that for the soul-stirring madness so generously imparted by SAVAGE Lipstick and the new SAVAGE Rouge.

SAVAGE Lipstick works differently from ordinary lipstick. Its gorgeous color separates from the cosmetic a moment or two after application to become an actual part of the skin. Wipe the cosmetic away and see your lips . . . teasingly, savagely red . . . but without the usual discouraging pastiness. Imagine a lipstick like that! Better yet, experience its magic on your own lips. One or more of the four luscious SAVAGE shades is sure to be exactly yours.

SAVAGE Rouge . . . an utterly new kind of dry rouge . . . so much finer in texture than any other that it blends right into the skin itself . . . to stay, with full color intensity, throughout the exciting hours it invites . . . instead of quickly fading away as ordinary rouge does. You'll love it, and the shades are identical to those of SAVAGE Lipstick so that your cheeks and lips will be a thrilling, perfect symphony of maddening, meaningful red.

Then . . . SAVAGE Face Powder

And what a different face powder *this* is; so fine, so soft, so smooth . . . and so surprisingly different in the results it gives. Apply it, and it seems to vanish . . . but the skin-shine, too, has gone. Imagine it! Everything you want from powder, but no "powdered" look; just caressing, soft smoothness that is a feast for eyes and a tingle for finger tips it makes so eager. Four lovely shades.

20¢ AT ALL TEN CENT STORES

TANGERINE · FLAME
NATURAL · BLUSH

Savage Cream
Rouge . . . for
lips and cheeks

NATURAL
(Flesh)
BEIGE
RACHEL
RACHEL
(Extra Dark)

SAVAGE

vogue for tanning meant that rouge did not explode at the same rapid rate as the other essentials being transformed in this period. That being said, the late 1970s and 1980s saw a newfound respect and admiration for blush, with heavy, stripy application being the height of fashion—although the formulas offered were not that different from what had been around for the previous century. The nineties saw a big push in the blush category with exciting new formulations and packaging innovations that have brought rouge back to its historical heights of popularity. It remains an essential in every woman's bag, as nothing can make you look fresher, younger, or more awake faster than a touch of blush.

POWDER AND FOUNDATION

Even the Victorians condoned the secret use of a little powder, so it's no surprise that it was the first item to become an acceptable handbag staple in the twentieth century. As more women used it, they found that they needed to "touch up" while on the go. Though women would carry around loose powder (often housed in a little box or concealed in a piece of jewelry), or try and fashion their own containers, it wasn't ideal and spillages were an issue. As an answer to this problem, specially designed "compact" compressed powders (along with the puffs used for application) were produced and really took off in the 1920s. Just think that women's public bathrooms became known euphemistically as "powder rooms" in the late twenties.

By 1930, there were a staggering number of face powder types on sale throughout the United States: around three thousand.[16] One reason for powder's increasing popularity is that advances in technology meant that cosmetics companies started producing more shades—from rose to beige to tan. An appealing scent was also crucial to a powder, and many companies produced powders to match their already

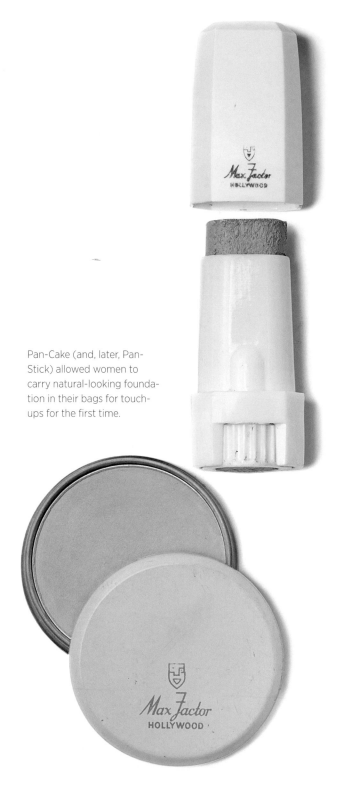

Pan-Cake (and, later, Pan-Stick) allowed women to carry natural-looking foundation in their bags for touch-ups for the first time.

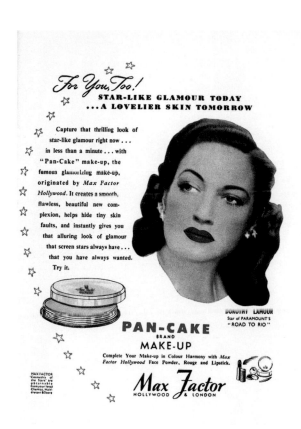

Factor's Pan-Cake (a cream powder that was applied with a damp sponge), that foundation really hit the big time. Not only was it *the* most favored product of the highly successful movie industry, but it was rolled out to consumers too, with ads featuring stars, including Claudette Colbert, who promised that Pan-Cake would create "a lovely new complexion . . . conceal tiny complexion faults" and stay on "for hours."[17] In 1948, Pan-Stik, a swivel-stick form of Pan-Cake, was launched: It was perfect for keeping in your bag for touch-ups, although foundation was still more of a dressing-table staple rather than a hand-bag necessity (a 1950 ad shows that it was available in five different skin shades—and two "exciting sun tan shades!").[19] It wasn't until the 1960s that lighter bases, such as Max Factor's Ultra-Light, become available.[19] These days, foundation is a makeup bag essential, coming in many different forms—from powder to liquid, cream, compact, and spray on. The past twenty years in particular have seen a complete revolution in formulas (mainly thanks to silicone); foundations now feel weightless and look more natural on the skin than ever.

BRONZER

As we've seen, for centuries in Europe and the Far East, pale skin was synonymous with wealth, youth, beauty, and a life of comparative ease (no toiling outdoors in the sun). So the move toward actually wanting to bronze your skin and appear tanned was a sizable shift. Gabrielle Chanel made sun-kissed skin chic after she accidentally caught too much sun, and the rage subsequently spread among the Riviera set. Chanel's friend Prince Jean-Louis de Faucigny-Lucinge summed it up when he said: "I think she may have invented sunbathing. At that time, she invented everything."[20] For Chanel, in a refreshing change from previous attitudes (good-bye, lead), beautiful skin was healthy-looking, glowing skin,

Pan-Cake was used in Hollywood before it was launched to the public where it won intense praise; it was the first consumer-facing foundation that didn't crack, was easy to apply, and had a long-lasting result.

successful perfumes, such as Guerlain's Shalimar Powder scented with Shalimar perfume.

As with so many other developments in makeup, foundation's origins were in the world of the theater. It was Max Factor who moved makeup on from the greasepaint sticks used for the stage by developing a creamy version that didn't crack on film, released in 1914. He made further developments to his innovation by blending the colors so that they matched different skin tones (helpfully) and working hard to devise an entirely new product that would suit Technicolor. But it wasn't until 1937, and the introduction of Max

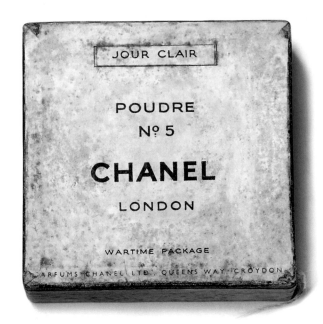

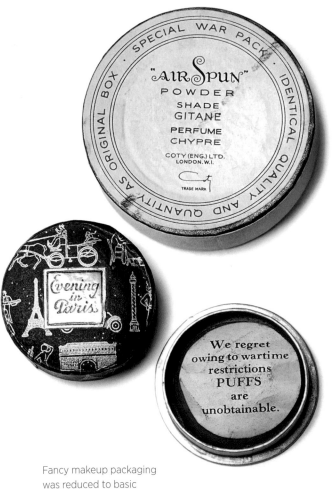

Fancy makeup packaging was reduced to basic cardboard containers during the Second World War.

Wartime

Coty was a market leader with its famous Air Spun powders, first introduced to the public in 1935. The fact that powder compacts were displayed in public before anything else explains why there was such a huge variety of styles available. Women loved showing off their compacts, and they were a status symbol. Through necessity, packaging was completely stripped back to the basics during the Second World War with all the brands from Chanel to Coty resorting to plain cardboard packaging. Puffs were also in short supply—one Bourjois powder came with a note inside explaining that there was no puff due to wartime restrictions. Postwar and throughout the 1950s, novelty and wildly decorative powder compacts at all price points were the norm, with a large majority of women in the Western world carrying one in their handbags at all times to be whisked out for touch-ups at a moment's notice.

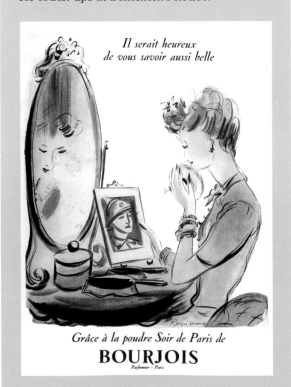

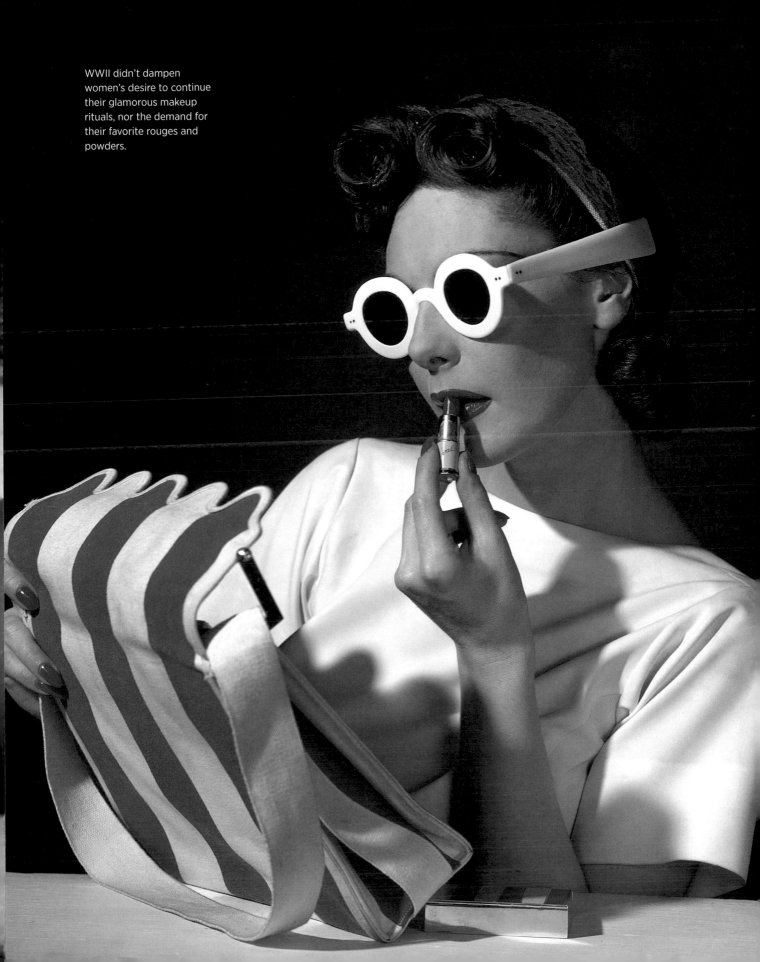

WWII didn't dampen women's desire to continue their glamorous makeup rituals, nor the demand for their favorite rouges and powders.

considered to be a bit vulgar—"*Vogue* has always felt that sunburn makeup, as such, when there is no basis of natural tan, is artificial and not in good taste, except for such occasions as costume parties . . ." Instead, the focus is what makeup to wear when you do have a natural tan: most important, a good powder in a shade to match your new skin tone (the article suggests that these were readily available) and an orangey-toned rouge and lipstick. The one concession to tanning unnaturally seems to be on the legs, because "men have always been women's severest critic in the matter of the appearance of legs, and they have not been slow in voicing their opinion that the average bare leg is not a thing of beauty until it has been improved by artifice."[21]

These days, with our knowledge of the skin damage caused by the sun, tanning unnaturally is the new norm. It's a market that is constantly improving and growing: In 2010 global self-tan sales were reported to be worth $530 million, and that number will only have grown as a multitude of new products catering to all different desires are released.[22]

The Origins of the First Brands

The majority of the twentieth-century's global cosmetic brands (with the exception of those pioneering individuals mentioned in the previous chapter) can be traced back to one of five main starting points: the theater, couture fashion houses, perfume

The 1940s and 1950s were the golden age of the novelty powder compact. (Clockwise) Wadsworth's 8 Ball, Volupte's "Gay Nineties Mitt," Kigu's Flying Saucer, Telephone Rotary after Salvador Dali for Schiaparelli, and BOAC Mascot Suitcase powder compact.

ateliers, soap manufacturers, and most recently, individual makeup artists looking to share their expertise with women.

THEATRICAL MAKEUP

Makeup and the acting profession are incredibly closely intertwined, so it's no surprise that the theater has played such a huge role in developing the products that we use today. Theatrical makeup companies, like the three below, were usually started by pioneering individuals who either worked or had an interest in the theater and wanted to improve on the limited offering of paints. Though at the beginning of their lives these brands were intended for use on the stage only, they soon moved into the public arena via actors and actresses, popular media, and advertising in theatrical programs.

BOURJOIS

Joseph-Albert Ponsin, an actor in Paris's theater district, was unimpressed with the standard greasepaint sticks that all actors used before going onstage. So in 1863, he left acting, and with the financial help of the writer Alexandre Dumas, he started making his own products, beginning with a complexion-lightening makeup, and soon expanding to include rouge. In 1867 he hired a business manager, Alexandre-Napoleon Bourjois, as he had overextended himself by creating additional companies in his other areas of interest, such as perfume. Ponsin's financial situation couldn't be turned around, so in 1868 he sold his business to Bourjois, changing the brand's name to the one we all know today. In 1879 Bourjois created their bestselling Java Rice Face Powder. Available in four shades (white, pink, natural, and Rachel, or beige), it was faintly perfumed and promised to "adhere to the skin, giving it a smooth freshness and youthful radiance." By 1900 more than two million boxes were being sold

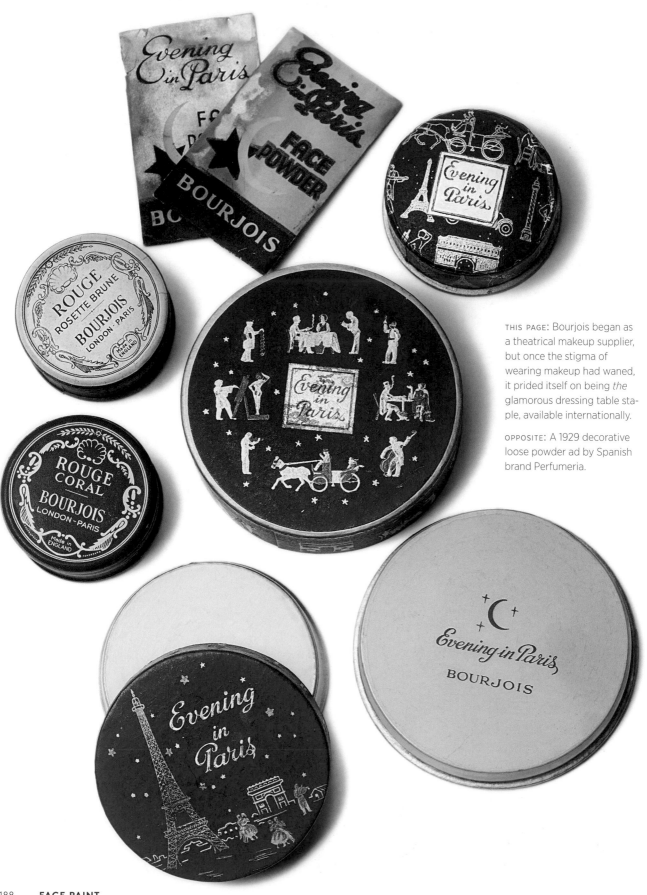

THIS PAGE: Bourjois began as a theatrical makeup supplier, but once the stigma of wearing makeup had waned, it prided itself on being *the* glamorous dressing table staple, available internationally.

OPPOSITE: A 1929 decorative loose powder ad by Spanish brand Perfumeria.

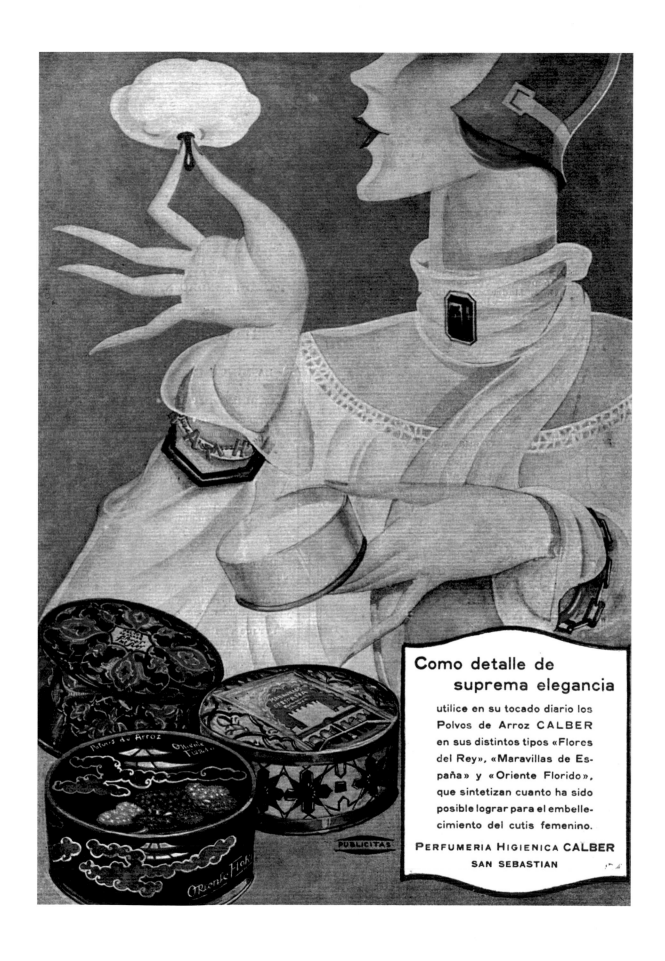

Como detalle de suprema elegancia

utilice en su tocado diario los
Polvos de Arroz CALBER
en sus distintos tipos «Flores
del Rey», «Maravillas de Es-
paña» y «Oriente Florido»,
que sintetizan cuanto ha sido
posible lograr para el embelle-
cimiento del cutis femenino.

PERFUMERIA HIGIENICA CALBER
SAN SEBASTIAN

PERFUME HOUSES

We've already examined the rise of Rimmel, the mascara and makeup empire that started off as a fragrance business. But Rimmel is far from being the only perfumer to cross over. As the following three global powerhouses demonstrate, the path from perfume to cosmetics is a well-worn one.

GUERLAIN

One of the oldest perfumeries in the world, Guerlain was founded by Pierre-François-Pascal Guerlain in 1828. It was a true family business: Pierre-François-Pascal made fragrances along with his two sons. He created scents for some of the most prominent members of society, including the French empress Eugénie (which earned him the prestigious title of Official Royal Perfumer), Queen Victoria, Queen Isabella of Spain, and Tsar Alexander III. The company soon moved into cosmetics, with Pierre-François-Pascal creating Blanc de Perle, a skin-whitening product, in 1857. In 1924, the company created a lipstick, Rouge d'Enfer, and opened a beauty institute at its Champs-Élysées store in 1939. Terracotta, one of the first modern bronzing franchises, was launched in 1984 and was a runaway success, fast becoming a cult classic. After remaining in the Guerlain family for five generations,[25] the business was acquired by Möet Hennessy Louis Vuitton (LVMH) in 1994.

COTY

Born Joseph Marie François Spoturno, François Coty trained as a Perfumer in Grasse before founding his eponymous company in Paris in 1904. In stark contrast to Helena Rubinstein's approach, Coty's philosophy was "Give a woman the best product to be made, market it in the perfect flask, beautiful in its simplicity yet impeccable in its taste and ask a reasonable price

François Coty understood the power of great design and commissioned the best artists, theatre designers, illustrators, and painters to create striking and covetable packaging.

for it." In 1908 he opened a Paris shop and commissioned the jeweler René Lalique to design the bottles for his perfumes—a completely novel move for the time. Although he continued to make bespoke fragrances for royalty and the aristocracy, his ultimate aim was to mass-produce exquisitely packaged, affordable luxury for all. They were hugely successful, and international expansion followed, with subsidiaries opening in New York and London. Coty launched its first cosmetic product, a face powder, in 1914 but it was the launch of Air-Spun powder in 1935—with package design by celebrated artist and theatre designer Leon Brakst (most famous for his work with the Ballets Russes) and a matching rouge two years later that really put it on the makeup map. Not only was the packaging the most recognizable and desirable in the market, but the process of "air spinning," instead of mechanically grinding, promised finer, more uniform particles and a smoother finish—very

different to the majority of powders, which at that time were often slightly gritty in texture. Coty died in 1934 but his family continued to grow the company in the spirit it was created. In 1996, the company acquired Rimmel, introducing it into the United States in 1999, and most recently Bourjois in 2014. They are also the market leader in creating affordable celebrity fragrances.

LANCÔME

Armand Petitjean worked as an executive at Coty and poached a number of its employees when he started Lancôme in 1935 (the name was inspired by the Château de Lancosme). The company began with six fragrances that same year—Kypre, Tendres, Nuits,

A 1930s advertisement showcases Coty's unique approach to beautiful packaging.

Bocages, Conquête, and Tropiques, each themed for a different continent—which were an immediate success. A skincare cream, Nutrix, came next in 1936, and a rose-scented lipstick, Rose de France,[25] followed soon after. In line with Petitjean's strong aesthetic sense, Lancôme cosmetics had beautiful, expensive packaging with silver- or gold-plated refillable lipstick cases. Unfortunately, by the time the sixties came around, this sort of luxe and elegant makeup was seen as a bit old-fashioned with the new vogue for cheap and cheerful plastic cases. In 1964 L'Oréal bought the company, adding it to its roster of brands. Sir Lindsay Owen-Jones was appointed CEO in 1988 and reestablished Lancôme as a leading luxury beauty brand with a quintessential French elegance, hiring actress Isabella Rossellini as the face of the brand (the first official ambassador for a beauty brand) and tripling its advertising budget. The impact on sales was massive, with US sales growing thirty percent from 1983 to 1988.[26] Today Lancôme is one of the most recognizable global beauty brands—still using the rose logo inspired by the roses surrounding the ruins of the Château de Lancosme—and particularly known for its skincare products, mascaras, and foundations, and a roster of strong, inspiring, and diverse spokeswomen.

COUTURE HOUSES

Couture houses don't just set the fashion for what clothes we'll all wear next season; they are also crucially placed to be the tastemakers for makeup, skincare, and perfume. Companies like Chanel or Dior can afford to be daring and fashion-forward in the products they produce, and the styles they set trickle down. Makeup, skincare, and perfume are hugely important parts of their business: With a lipstick or an eye shadow palette, people are able to buy into the glamour of a luxury brand—something that they might not otherwise be able to afford.

Christian Dior's first lipstick, Rouge Dior, launched in 1953 and was available in two packaging styles: the first, chic and simple for your handbag, or the incredibly ornate obelisk dressing table version.

DIOR

Though it was founded in 1946, Dior didn't start producing makeup until 1950. Crucially, this was two years after Christian Dior had designed the famous New Look (introducing a new shape in fashion), which had been a hit with fashion editors all over the world, especially Carmel Snow at US *Harper's Bazaar*. Red was emblematic of the brand—and the red Dior dresses became an in-house tradition—with everyone waiting for the red dress. So it makes sense that Dior's first foray into makeup was lipstick.

In February 1950, a document at the Dior archives shows that they produced three-hundred-and-fifty limited-edition lipsticks—though whether they sold them or gave them as gifts to special customers is unclear. But the first full range of lipsticks, Rouge Dior, was three years in the making, and it was 1953 when nine thousand lipsticks in eight shades were launched.

Ingeniously, Dior's lipstick came in two different designs, one for your dressing table that was fabulously decadent, encased in a crystal obelisk shape perfect for displaying, and one for your handbag, which was a chic, simple metallic case. Both were refillable. Special customers could get the dressing-table version in its own special box—there's one in the Dior archives that is hand-signed by Mr. Dior to his special client Mrs. Vanderbilt!

Christian Dior understood that there was a market to be reached for whom couture wasn't an option. In the words of Frédéric Bourdelier, the Brand Culture and Heritage Manager at Parfums Christian Dior, if you couldn't afford to dress in Christian Dior, then you could at least dress your smile in it.

More lipstick colors—very modern and vibrant oranges and pinks—were introduced in 1955, and by 1959 there were eighteen shades, including Bois de Rose. By 1959 the first powder compact had also been launched, with very chic, pared-back, art deco–style packaging and the additional offer of personalized

engraving; it was the ultimate in luxury makeup. Though the compact came two years after Christian Dior's death—so he never saw the final design—he had been very keen to launch a powder and had worked on the earlier stages.

Dior was the first European couture house to launch a range of nail polish at the relatively early date of 1962 (the cult Crème Abricot nail cream was released in 1963), so that one could match her nails to her lips. It's clear from the beauty advertising archives that by the mid- to late fifties, sales of the lipstick (and later the varnish) had spread quickly across the globe, and it was available in Australia, Kenya, Denmark, South Africa, Angola, and many other countries.

In line with the changing times, in 1965, Ultra Dior, a more girly and fresh range for the younger generation with plastic packaging, was introduced, selling alongside the old Rouge Dior for more traditional (less youthful!) customers. Toward the end of the sixties, when so much was changing, Dior's makeup started to become a little staid, so in 1967 the company employed Serge Lutens, a revolutionary French makeup artist who was just twenty-four at the time, to revamp the makeup line.

The new range launched in 1969 with a full collection of products and modern visuals by photographer Guy Bourdin. The new line included mono eye colors, gel crème shadows, and foundations. Somewhat oddly, it also included a block mascara cake, which seems like quite a retro direction for the time. Bit by bit, new products were released, including Diormatic mascara and eye shadow quad palettes (in 1973), with exciting new colors like dark purples and deep browns—a great breakthrough for the brand at that time. After 1973, Serge Lutens started doing all the photography and styling himself too, as he felt like he couldn't get exactly what he wanted from anyone else. He also hired actress Anjelica

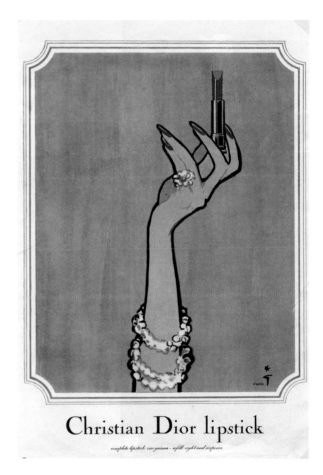

Christian Dior lipstick

complete lipstick: one guinea · refill: eight and sixpence

The influential illustrator René Gruau created the artwork for this 1953 Dior advertisement.

Huston to model the makeup, although this wasn't publicized.

A really interesting, slightly strange, and little-known story from this period is that Dior wanted to launch in Russia, but for various reasons, including the Cold War, this was very complicated. However, the soviet film industry based in Moscow asked if Dior could develop a range for them. As this was the only means of launching in Russia, Dior developed Visiora, a specialist range for stage, movies, and television (including fake blood) and launched into the

Soviet Union in 1973. Unsurprisingly, outside of the film industry, it was only available in a few exclusive shops, as the price point was extremely high.

Visionary makeup artist Tyen was appointed in 1980 and redesigned the range, launching entirely new packaging in two shades of blue with gold. He also introduced Dior's iconic 5-Couleurs eye palettes.

Dior Addict lipstick launched in early 2000, and in a reversal of the norm, the shape of the lipstick inspired the fragrance that came in 2002. Today Dior's makeup range is closely connected to the fashion runway. In 1973 they started producing two limited-edition collections and looks per year linked to their ready-to-wear fashion shows. In 1988 to 1989, it changed to four times per year, which is now the norm across all the premium brands.

Chanel and Dior paved the way for more globally successful makeup ranges from couture houses, including Yves Saint Laurent (1978) and Givenchy (1989). The tradition continues with Tom Ford Beauty (part of the Estée Lauder group) launching in 2006, followed most recently by the heritage Italian fashion brand Gucci.

TOILETRY GIANTS

These global corporations may have started as small, often family-run soap-making businesses, but they now own most of the brands we use today and thus control the beauty business. They're unified not only by their size but also their focus and investment in research.

PROCTER & GAMBLE

One of the biggest names in the business, Procter & Gamble was founded in 1837 by Alexander Norris and his sons-in-law. Its beginnings came from the most humble yet necessary of products: soap. Luck in the lab helped with some of its earliest successes:

A mistake when developing a soap mixture led to the invention of the floating Ivory soap in 1879 (the name alludes to a biblical reference, but also cleverly played to a Western desire for fair as well as clean skin). Another happy (and lucrative) accident while experimenting with formulas was the invention of Crisco, the cooking fat. In 1924, P&G set up a market research department—one of the first to be created—gathering masses of information about the habits of their interviewees. This would prove to be key to the company's growth and dominance. Over the years, it's bought a huge number of fragrance, beauty, and hair and skin companies, including Max Factor in 1991.

BOOTS

A household name in the United Kingdom, the high-street pharmacy chain Boots started when one John Boot set up an herbalist store in Nottingham in 1849. The less wealthy industrial classes, who couldn't necessarily afford a doctor, would prove to be a strong early market for John, though the business really took off when his son, Jesse, took over in 1871. Staying true to the company's roots, Jesse concentrated on keeping prices down by buying products in bulk and selling them for a lower price than his competitors. He had clear plans to expand into a nationwide chain: In 1890 there were ten Boots stores; by 1914 there were five hundred and sixty; and by 1930 (after the company had been sold to the United Drug Company of America—though it would be bought back by Jesse's son), there were a whopping one thousand.[27] In line with Jesse's early work on expanding the business's product range as well as its own brand items, in 1935 Boots introduced its No. 7 makeup range. Seventeen cosmetics, aimed at a younger market, launched in 1968. No. 7 quickly became something of a British institution, and its line of products is often British women's first experience of cosmetics. Their packaging has undergone many

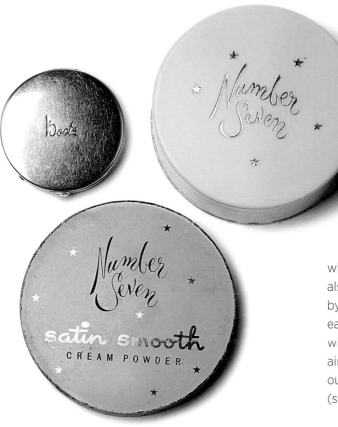

Although first launched in 1935 with simple, silver packaging, Boots No. 7 stopped production completely during WWII. It re-launched in the early 1950s with new Hollywood-inspired packaging covered in gold stars.

changes over the years, from the very luxe metallic gold etched with gold stars in the 1950s to today's sleek black plastic. No. 7 is now available in stores in many countries around the world, including Target in the United States. In 2012 American pharmacy giant Walgreens acquired a stake in the business and the full merger is now complete. The new company is known as Walgreens Boots Alliance, and to mark the end of an era, the headquarters will move from Nottingham to Chicago.

L'ORÉAL
The world's largest cosmetics company, L'Oréal was started by Eugène Schueller, who worked part-time at his parents' patisserie throughout his youth and while studying chemistry at the Sorbonne. He worked as an assistant pharmacist but was interested in hair dyes, and particularly the idea of making a long-lasting dye. In 1907 he applied for a patent for his dye and in 1908 started his own company. It was the right time for hair dye to take off: Hairstyles were changing drastically, with women wearing their hair shorter. Schueller also realized early on that he could sell his product by capitalizing on women's fear of aging, with an early L'Oréal ad proclaiming, "I no longer age—I dye with L'Oréal"[20]—this also had the effect of lending an air of respectability to hair dyeing, as it had previously been considered the domain of "loose" women (sound familiar?).

In 1957, Schueller's successors moved L'Oréal into the luxury and skincare sectors, acquiring the skincare company Vichy and, ten years later, Lancôme. Realizing it needed to expand its areas of expertise, L'Oréal created new laboratories for formulating skincare products, makeup, and perfume. Today the company owns a huge roster of some of the best-known names in makeup, including the Body Shop, Helena Rubinstein, Lancôme, Maybelline, Urban Decay, Shu Uemura, and YSL Beauté.

MAKEUP PROFESSIONALS
Though they may evolve or be acquired by a larger conglomerate, many brands are the brainchild of one talented individual. Makeup artists have been around since Egyptian times, and their influence on fashion, media, and consumers can be seen in the way they are now as recognizable and recognized as the faces they are painting. It seems only natural that they would utilize their practical knowledge of cosmetics—and the spaces in the market where there is a

need for something that hasn't yet been fulfilled—and begin creating new products, as well as using them. Max Factor made makeup work for women in their handbags initially, but it was the makeup artists of the latter half of the twentieth century who really took the "makeup artist brand" to dizzying global heights.

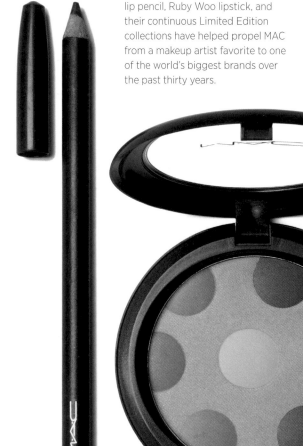

Iconic products such as the Spice lip pencil, Ruby Woo lipstick, and their continuous Limited Edition collections have helped propel MAC from a makeup artist favorite to one of the world's biggest brands over the past thirty years.

SHU UEMURA

Shu Uemura was born in Tokyo in 1928 and established one of the earliest makeup artist brands, becoming a name in the industry through his work in Hollywood—particularly when he made up Shirley MacLaine to appear Japanese (as was the practice at the time) for the 1962 movie *My Geisha*. In 1964 he returned to Japan and set up his own makeup studio, the Shu Uemura Makeup Institute in Tokyo, teaching the methods he'd learned in Hollywood. In 1967 he introduced the first oil-based cleanser to Japan, and started his own cosmetics company, Japan Makeup Inc,[29] the following year—he didn't change the name to Shu Uemura until later. His unique and modern take on Japanese beauty really took off globally when the brand gained cult status in the late eighties. A huge range of colorful, artist-palette-style, single-eye shadows, accessories (including his world-famous eyelash curlers), and creative false eyelashes—all in unique clear packaging with a distinctly Japanese feel—led to a huge growth in sales. The company was bought by L'Oréal in 2000 and its products are now available in eighteen countries.[30]

MAC

MAC (Make-up Art Cosmetics) was created in Toronto in 1984 by makeup artist and photographer Frank Toskan and hair salon owner Frank Angelo. Like Max Factor before it, MAC manufactured makeup for a new generation of makeup artists. Before it launched, you just couldn't get the colors and textures they offered. I remember

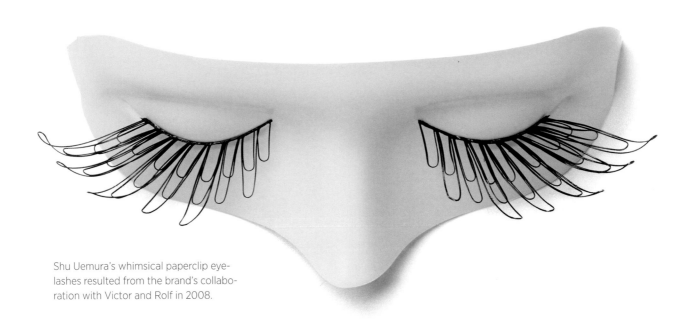

Shu Uemura's whimsical paperclip eyelashes resulted from the brand's collaboration with Victor and Rolf in 2008.

when I was starting out, the makeup I wanted for shoots just wasn't available in any of the mainstream makeup brands, so I would have to shop at theatrical makeup shops and art shops, mixing and blending my own—often using brow pencils as lip liners, concealers as lipstick, and lip gloss as eye shadow. MAC understood what makeup artists really wanted and knew that it would translate to the general public via makeup artists and models talking to the backstage journalists about their essential MAC products.

Soon after MAC launched, Linda Evangelista praised their brownish-colored Spice lip pencil, creating a huge buzz around the brand and making the pencil a 1990 must-have beauty staple (Madonna famously wore MAC's Russian Red lipstick on her Blonde Ambition tour). The company was an innovator in other ways, setting up the MAC AIDS Fund to support women, men, and children living with or affected by HIV in 1994, and donating all the money from sales of its Viva Glam lipsticks to the fund. In 1998, Estée Lauder bought the company out, and it became one-hundred-percent consumer-facing, although they continue to support the industry with a range of pro products, workshops, and makeup artist discount cards. They also continue to promote the brand as a backstage favorite, sponsoring show makeup at many of the fashion weeks around the world. Although the majority of sales center around "basics" (foundation, neutral eye shadows, and their classic lip colors), it's their continuous limited editions (too many per year to count!) that are used as PR eye candy to drive sales and keep the brand current.

BOBBI BROWN, ET AL.

One of the first makeup artists to achieve celebrity status, Bobbi Brown moved to New York in 1980, a year after she graduated with a degree in theatrical makeup. At that time, makeup was pretty extreme with lots of unsubtle eighties contouring and red lips. Bobbi was more drawn to healthy, natural looks, which was very different from what was on the market.

In 1988, when she was working on a shoot for *Mademoiselle*, Bobbi visited Kiehl's pharmacy, where she met a chemist who offered to create her ideal lipstick—creamy but not dry, unscented, with staying power, and most important, in a color similar to the color of people's lips. In an interview with *Inc.* magazine, Bobbi Brown said, "I thought, 'Wow. If I could make a collection of ten colors, I can't imagine a woman needing any other color.'"

Utilizing their practical knowledge, it was the makeup artists of the latter half of the twentieth century who really took the 'makeup artist' brand to dizzying global heights.

She started the business with a friend, publicist Rosalind Landis, and a mere ten thousand dollars, which seems a crazily small amount in today's world:

I was at a dinner party and I said to this woman, "What do you do?" She said, "I'm the cosmetics buyer at Bergdorf Goodman." I told her about my lipsticks and she said, "We have to take them." Later they said they couldn't take us. They had too much going on that season. I remember my stomach dropping when I got the message. I was at a photo shoot for Saks and telling the creative directors and art directors about this new line, and they said, "Oh, my God. We want it." I called Bergdorf back and said, "That's too bad, but don't worry, because Saks wants it." Bergdorf called me back ten minutes later and said, "Uh-uh. We're going to take it." I never even went to the right people at Saks. Now I know, that's called bluffing.[31]

The professional-makeup-artist angle was a hit and customers started asking for blush, eye shadows, pencils, and so on. In 1995, Estée Lauder bought Bobbi Brown. Leonard Lauder told Bobbi that her products were beating theirs in every store so he had

to! Bobbi Brown was one of the first brands to regularly use black models and show them as brides.

The success of Bobbi Brown led to a new sector of "professional" makeup artist brands. Like Bobbi, Trish McEvoy's eponymous company started after she recognized a gap in the market, and took off through word of mouth. Working as a makeup artist in the seventies, Trish was unable to find the type of good-quality makeup brushes that she was after, so she'd buy brushes from art shops and cut them into the shape she wanted. The brand Laura Mercier was born out of a more business-minded impulse after Janet Gurwitch, then the executive vice president of Neiman Marcus, saw an opportunity in the makeup market for another brand like Bobbi Brown. Janet joined forces with the French-born makeup artist Laura Mercier, who would give the company its name, in 1996. François Nars set up his sleek makeup range with its innovative black rubberized packaging in 1994 because, as he has said, "I just wanted a line that made sense, using my twenty-five years of experience."[32] The first true "celebrity" makeup artist, Kevyn Aucoin launched his range in 2001 after a series of highly successful makeup books aimed at empowering the average woman to look like a star; sadly, he died the following year and never saw the development of his brand. Makeup artist–led brands show little sign of slowing down, with British makeup artist Charlotte Tilbury recently launching her brand in the United Kingdom and United States.

A late 1980s/early 1990s look by superstar makeup artist, the late great Kevyn Aucoin.

Twiggy

If anyone was synonymous with the coltish, wide-eyed look that swept the fashion world, it was Twiggy. Born Lesley Hornby in Neasden, northwest London, in 1949, she dreamed of being a model, even though she was teased for being too thin. She once said, "Jean Shrimpton was my female idol; I had her all over my walls."[33]

Photographer Barry Lategan took the famous head shots that kick-started her career after she'd had her hair colored and cropped short by chic celebrity hairdresser Leonard. Afterward, a fashion journalist for the *Daily Express* spotted the shots and named her "the Face of 1966." Barry Lategan has said of the shoot: "Twiggy arrived with her cropped hair and lower eyelashes painted onto her face, she sat in front of my camera and she was dazzling."

There weren't any fashion makeup artists at this time, so models would do their own faces for shoots. Twiggy must have been a pretty accomplished makeup artist, as you can see from those first shots. The eyeliner was perfectly drawn, and she had really developed her own style. Her makeup was essentially a mod look with a heavy, dark eye and skin-tone mouth (using concealer or panstick to blank out the lips was usual, as the lipsticks on the market at the time weren't developed enough to fully give that look). The intricate eye makeup was the focal point, the lid itself filled in with white or pale-colored eye shadow with a black line along the upper lashes and another graphic line tracing

the area just above the socket line in a very round shape. Like many others in the mid- to late sixties, she was inspired by the look of thirties screen sirens, which required lots of false lashes—it wasn't unusual for models and fashionable girls to wear up to three (or even four!) sets at a time to get the look they wanted. Where Twiggy differed in her makeup was the drawn-on lower lashes. Biba founder Barbara Hulanicki once told me that Twiggy was the only one doing that back then. The lower waterline was left natural or filled in with a white pencil to further enhance the big, wide-open, and childlike look. Not a quick look to throw on in the morning, the entire makeup creation allegedly took around an hour and a half to complete.[34]

Twiggy's impact on the makeup of the period was huge, and she promoted a range of false eyelashes by Yardley in the United States, who were making the most of the Swinging London reputation. Twiggy Lashes by Yardley were released in 1967 ("What do you think made Twiggy what she is today? Her eyes, right?" read the copy),[35] along with mod-style eye shadow in black and white.

A couple of weeks after her first photo shoot, a double-page spread ran in the *Daily Express*, and Twiggy left school at the age of sixteen. A heady period of modeling internationally followed, until she was cast in her first film, *The Boy Friend* (directed by Ken Russell), in 1970, after which she retired from full-time modeling and pursued a career as an actress, TV presenter, and singer.

Photograph by Richard Avedon.

Elizabeth Taylor

Arguably as well known for her beauty, famous violet eyes, and eight marriages (two of which were to actor Richard Burton!) as her acting ability, Elizabeth Rosemond Taylor was born in London in 1932. Her parents were both American, so Taylor had dual citizenship, and before the outbreak of the Second World War, the Taylor family moved back to the United States, settling in Los Angeles.

Despite Taylor's initial reservations, her acting ambitions were encouraged by her mother, Sara, who had herself been in the theater before giving it all up to marry and start a family. Taylor's ascent to stardom was swift, and she was nine when she appeared in her first movie, *There's One Born Every Minute*. But refreshingly, unlike some other Hollywood starlets, she resisted being molded to a studio ideal. Her family should be given some credit for this, with her father reportedly refusing to let the studio pluck her eyebrows or alter her lip shape with makeup, or subject her to having a nose job!

When Taylor was nine and filming *Lassie Come Home*, her costar Roddy McDowall reported that, "On the first day of filming, they took one look at her and said, 'Get that girl off the set—she has too much eye makeup on, too much mascara.' So they rushed her off the set and started rubbing at her eyes with a moist cloth to take the mascara off. They soon learned that she had no mascara on. She has a double set of eyelashes. Now, who has double eyelashes except a girl who was absolutely born to be on the big screen?"

Many strong women working in Hollywood at this time started off learning from makeup artists, before going on to take control (or work in collaboration) and do their faces themselves, as no one knew their faces as well as they did. This was definitely the case with Taylor: Though she didn't wear makeup until she was older, she did like doing it. In a 2011 interview with designer Michael Kors, Taylor described how she always cut her hair and did her own makeup. Amazingly, she even did her face for one of her most legendary screen looks, the role of Cleopatra, as the makeup artist (Alberto De Rossi) was unavailable due to back surgery. Taylor described how she had studied his methods and sketches, and simply copied them.[36] It's also been reported that one day on the set of *Cleopatra*, they wanted to do a very early morning shot with extras. Union rules meant that the makeup department wasn't able to do it, so Liz made them all up!

Celebrity perfumes are common now, but Taylor's was one of the first and has been described as the "mother of celebrity fragrances." Passion was the first to launch in 1987, but her best-known offering is White Diamonds (aptly named for her well-publicized love of diamonds), which launched with Elizabeth Arden in 1991 and was worth $200 million at the time of her death.

Elizabeth Taylor's trademark glamour is still just as iconic and relevant today: Her influence is often seen in fashion and beauty magazines and on young starlets. Yet in another way—in common with other icons of the past—she's also the antithesis of current Hollywood actresses, who are keen to be seen as "normal" people. You would never catch her in a T-shirt and jeans; until her death in 2011, at the age of seventy-nine, Taylor always dressed like a film star, with her hair and makeup done, and loaded down with her customary jewels.

Grace Jones

A truly iconic star of the 1970s and 1980s, Grace Jones continues to inspire a new generation of stars today with her unconventional and fierce take on beauty and androgynous style.

Born in 1948 in Spanish Town, Jamaica, Jones was raised with her brother by her grandparents while her parents worked in the United States. In 1965, when she was twelve, she moved to Syracuse, New York, to live with her mother and father. The move and change wasn't an easy one, and Jones reportedly ran away with a motorcycle gang before ending up in New York City.[37]

She began modeling in the early 1970s and was fairly successful, although she has said that people in the industry had a hard time with her Jamaican features and that "Modeling was all in between things, just to pay the rent."[38] By the late 1970s, she was a fixture on the city's disco scene, and it was while inside the infamous discotheque Studio 54 that she was discovered and offered a recording contract with Island Records. While promoting her first album, she met French photographer Jean-Paul Goude, who would have a great influence on her. He produced album covers and music videos and encouraged Jones's style, which he has described as a "mixture of threat and beauty."[39] By 1989, she had released nine albums and achieved mainstream musical success, as well as modeled for Andy Warhol, Keith Haring (who famously painted her body and had Robert Mapplethorpe photograph it), and Helmut Newton, and acted in films including *Conan the Destroyer* and the Bond movie *A View to a Kill*, though music was more to her taste.

When asked in 2010 whether she purposefully constructed a persona to go with her look, Jones replied, "No. I think the scary character comes from male authority within my religious family. They had that first, and subliminally I took that on. I was s*** scared of them."[40] Although it's hard to pin down her look—naturally, for someone who enjoys pushing the boundaries, it has evolved over time—Jones has been variously known for her flattop haircut and bold makeup, especially her blush, used in liberal quantities to contour and angle her sculptured features, and bright multilayered eye shadow. As she famously said herself, like all the best icons, "I wasn't born this way. One creates oneself. I believe whatever I dream. Whatever I dream I want to do."

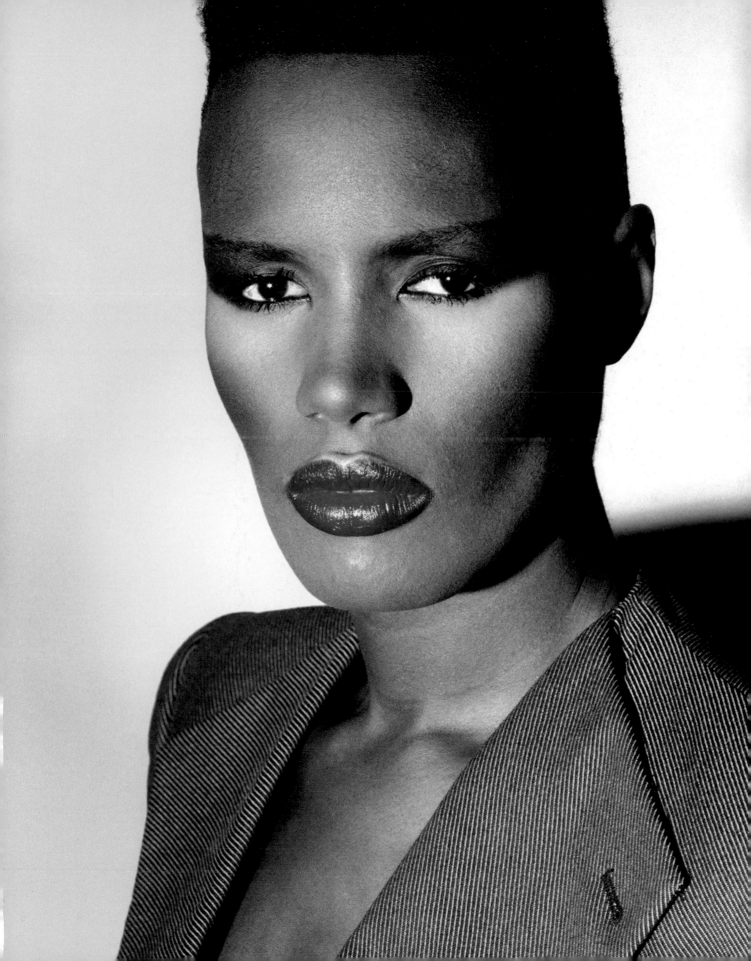

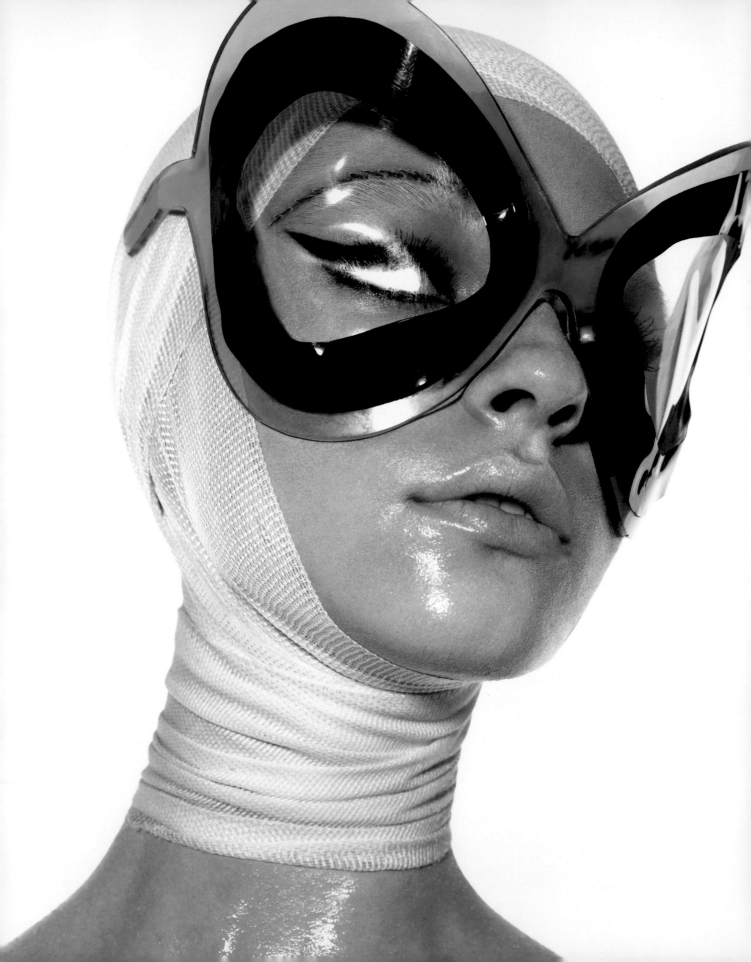

The Bleeding Edge

INTO THE FUTURE

For more than a hundred years, the beauty business has embraced science and sold it to women in a way that no other industry has. Unlike many other household products aimed at women that are marketed for their effectiveness or benefit, beauty products have historically engaged their audience in complicated chemistry. Modern cosmetics talk about their components as if they expect all women to have a PhD in organic chemistry!

In the past, makeup trends would have pushed the development of new technology—just look at the history of mascara. But nowadays trends are very much technology led, and a huge amount of money is spent investing in new avenues. Obviously this is driven by a desire to make better products, but cosmetics companies also use technology as a hook for marketing departments to hang a trend on. The only way you can tell a story about a product now is by talking about what it can do that's different. So you might introduce a new range of lipsticks "that last for sixteen hours." But you couldn't launch a lipstick just because it comes in a new shade of pink, because there are no new shades of pink. Makeup trends, from smoky eyes to classic red lips, tend to come around again and again, so the products used to create them need to be able to deliver something different from what came before and do it better; that's the crucial difference.

Ever forward looking—the cosmetics industry has always been keen to embrace science from a technological and aesthetic point of view.

211

For me, the things that have totally changed the cosmetics industry beyond belief in the twentieth century are advancements in pearl technology, the introduction of cosmetic-grade silicone, and the development of truly long-lasting, comfortable formulas. In my experience as a working makeup artist, these three things have sped up the process of application and cut blending and touch-up time in half! I'm as interested in looking forward to new innovations as I have been in looking back. I'm fortunate to have worked as a creative director for major makeup brands, which has given me the chance to work with some of the best cosmetics laboratories around the world. The creativity in these labs is just mind-blowing—the imagination and originality that goes into the science behind makeup is equal to the creativity of what you can do with the end product.

Forward-Facing Technology

With the exception of the industrial production of synthetic glitter in 1934, the major developments in makeup have all taken place over the past twenty years. A move from natural to synthetic can be seen not just in glitter, but also in pigments. Véronique Roulier, head of L'Oréal Luxe labs, says all of their pigments are synthetic. Why? Because you can control the quality and the purity more easily. Natural pigments are so unpredictable: They can change color or go off. That being said, iron oxides are still used; they're just synthetic versions these days—so in some ways we're looping right back to the makeup of ancient Egypt!

Good Old Glitter

From as early as the Paleolithic era, mica (a mineral whose name probably derives from the Latin word

micare, meaning "to flash") was used in cave paintings to make them sparkle. Like many great discoveries, the method for producing tiny particles of modern man-made glitter was a mistake. The inventor might seem an unlikely one: Henry Ruschmann was a machinist and cattle rancher from New Jersey, who happened across a method for cutting colored plastic to create tiny sparkling fragments in 1934. Henry didn't know what he'd created—but he could tell that it was something special. So to protect his discovery, he founded Meadowbrook Inventions, a family-owned business, which still exists today on the grounds of the original cattle farm. Amazingly, it remains the biggest manufacturer of glitter in the world (appropriately, the company slogan is "Our glitter covers the world").

Diamonds and Pearls

Classically, pearl makeup was produced using natural mica (the same material used as a prehistoric glitter) as well as fish scales. The lustrous shimmery effect of pearl-based formulas first became popular in the sixties, with the new wave of fun and playful makeup, though the stuff available then was all fairly unsophisticated.

Today we have the most incredible, subtle effects, thanks to the revolutionary advances in pearl technology over the past twenty years, which have fundamentally changed every type of makeup. The importance of pearl can really be highlighted by the fact that, according to Véronique Roulier, L'Oréal has twenty pigments but over one thousand pearls. There has been a focus on developing pearls over pigments, as this is what adds special effects to all makeup products.

The development of the use of pearl in cosmetics was inspired by the technology of the car industry (in fact, the paint for pearl pigments still comes from

The Ultimate Glow (In the Dark)

It may seem pretty unthinkable that anyone would sell, let alone buy, a radioactive lipstick or powder today, but when radium was first discovered by Marie and Pierre Curie in 1898,

there were no regulations in place to control the safety of new beauty products, or ensure that they were tested before they were released.

Following the Curies' major scientific break-through, which changed the face of science *and* medicine, many people believed that radium was an almost magical substance and could cure anything. So it's unsurprising that radium started being used as the new wonder ingredient in makeup.

There were two main purveyors of radioactive cosmetics: the London-based Radior and the French Tho-Radia. Radior started advertising its products around 1917 and they had no shortage

of takers, with Boots, Harrods, and Selfridges all stocking them! For the woman who wanted that radioactive glow, there was a wide variety of items to choose from: powder, rouge, night cream, and pads that you could strap to your face.

Tho-Radia—so called as it contained both thorium and radium—was set up slightly later, in 1933, by a pharmacist, Alexis Moussali, and a possibly invented Parisian doctor, Alfred Curie (no relation to Marie or Pierre . . .). They offered a similarly wide range of products (including lipstick and toothpaste) and made a very clear link in their advertising between beauty and science, with a tagline under the ad proclaiming the product to be "méthod scientific de beauté."

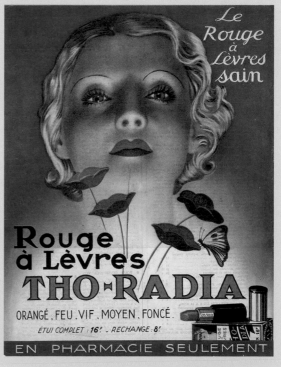

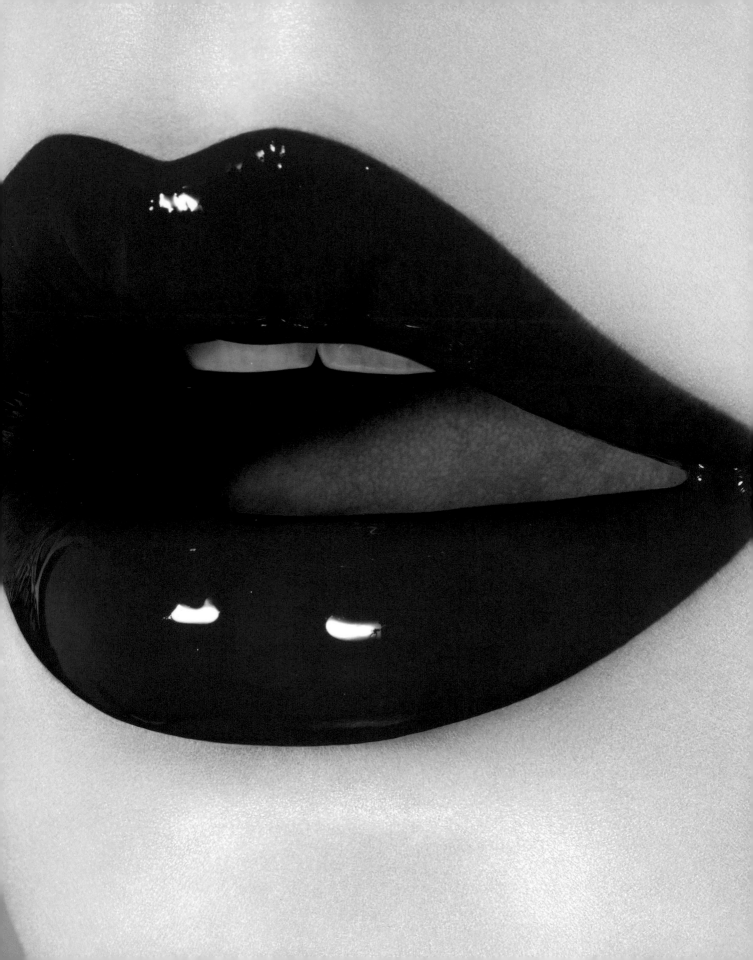

car manufacturers). Car paint was revolutionized in the eighties, and suddenly one could get incredible iridescent paint with previously unseen depth and shine.

The first step in the evolution from natural mica was the move to using a transparent synthetic pearl. These are smaller and more uniform in shape than natural particles and have the crucial property of transparency, creating a very luminous effect. It's the quality of transparency that allows light to travel through the pearl that has made the difference in the subtlety of today's products. Pre-synthetic pearl makeup had a crude look (think of 1970s eye makeup and highlighters) due to the large, jagged metallic particles that just sat on top of the skin.

Very fine satin-finish synthetic pearls are often used for highlighters, blushers, and foundations, as they give a much more subtle, glowing sheen.

From a makeup artist's point of view, highlighters always used to appear a bit metallic. But now they are so natural-looking that it's as though the luminosity is a real and intrinsic part of the skin, like it's coming from *within*, instead of just sitting dully on top of your face. It looks very youthful, but with a polish.

After this came pearl made from glass particles—called borosilicate glass. Like synthetic transparent pearls, these are coated with pigments; however, with glass particles, the power of reflection is increased, allowing color changes using the natural prism of light. It may sound complex, but just think of a chandelier when the sunlight hits it—the principle and effects are the same.

The next, more extreme level of pearl development is where the glass particle is coated with metallic silver or gold pigment, so that it acts like a mirror. This

is mostly used in lipstick, eye shadow, or eyeliner. If you've ever wondered how your eye shadow can look so incredibly metallic, this is the answer!

There's a flawless, polished professionalism to the makeup available now—and pearl plays a massive part in this. It's a perfected look that still appears natural, with sheen and an almost hyperreal quality.

Slip Into the Future

Silicone came into makeup technology via the medical industry. It's been used for years to coat the instruments used in internal operations to ensure they glide smoothly. If you've gone into a department store recently to test any makeup or skincare product and waxed lyrical about how amazingly soft, silky, and smooth it feels on your hand, then it definitely contains cosmetic-grade silicone.

In the past fifteen or so years, silicone has been integral to lipstick formulation and development. Early lipsticks were made with oil, generally vegetable-based (such as castor oil), wax, and the all-essential pigments (the element that gives the lipstick its color). The key properties of this type of classic lipstick were that it added color and was comfortable on the lips, but it didn't have much else going for it. What's more, the vegetable oil went off after time—if you've ever smelled an old lipstick, you may have noticed this very particular scent!

The development of long-lasting makeup and the increasing use of silicone are very closely linked—silicone has played a huge part in making lipsticks wear better. Science-wise, the first products to be developed as specifically long-wearing were lipsticks. This happened in the early to mid-twentieth century, when bromo acids were introduced into lipstick formulas. These prototype lipsticks acted like a dye, creating an indelible stain, but once the moisturizing ingredient wore off, they would have dried

Silicone technology allows today's lipsticks to apply smoother, feel more comfortable, and wear longer on our lips.

ABOVE: Glass pearl technology gives a truly mirrorlike finish to today's metallic pigments.

OPPOSITE: Modern glitter was invented by a cattle rancher from New Jersey.

your lips like nothing else, leaving them feeling like sandpaper.

The late 1990s saw a revolutionary addition to lipstick formulas. They still contained wax and the all-essential color pigments, but now they had the addition of silicone oil, which evaporated from the lips on application. ColorStay from Revlon was the first of this new breed of lipstick. It was exceptionally long-lasting, but people soon found that it wasn't that comfortable to wear, as it was too matte and dry (due to the fact that the wax and pigment alone weren't giving continuous hydration to the lips).

Moving on from this, the next important advancement released (around 2000) was Max Factor's Lipfinity from Procter & Gamble. This lipstick had a two-step process. The first base coat was full of volatile silicone oil and polymers, which helped the pigment to stick to lips. Afterward, one applied a second shiny coat containing nonvolatile silicone oils—which were completely incompatible with the base coat, meaning that they wouldn't interfere with the color and mess up the original stain. Also, the top coat didn't evaporate. There were other benefits to this: Silicone oils wear well, as they're not sticky, meaning that this type of top coat didn't immediately slide off your lips when you ate or drank.

The final frontier was finding a way to combine both volatile and nonvolatile silicone oils into one single lipstick bullet. This new generation of lipsticks was inspired by Japanese technology for mixing these two crucial properties. In these lipsticks, the two incompatible oils are made into an emulsion (a mixture of two or more liquids that cannot normally be blended) without water. You might wonder how this is possible if they're incompatible—the answer is that a technique was discovered in which another ingredient, essentially an emulsifier, is added, enabling them to mix. This might all sound a bit complicated (it is) and a bit unstable (it's not). You can still add extra active ingredients to this type of lipstick mixture to treat the lips, like vitamin E, and a small quantity of vegetable oil for its moisturizing skincare benefits.

Essentially, the difference between lipsticks of the past and now is that new lipsticks are made using mainly silicone oils, with the addition of a very low

level of plant oils, which enables them to sit on *top* of the skin and be long-wearing, without drying the lips.

What is really interesting about the use of silicone—both to improve the quality of makeup in general, and to further its long-wearing properties—is that the technology can be applied to all types of products. Nowhere is this more clearly demonstrated than the way in which the technology used in today's foundations is almost identical to that which is used in lipstick.

The very first type of liquid foundation was an emulsion based on the classic skincare formula of oil in water, or water in oil (depending on the volumes of each). Oil in water was good for foundation because the water gave it a fresh sensation on first contact with the skin. But when the pigment (that is, the color) was added to the water, the texture of the foundation tended to be very dry and have a sort of dragging sensation when applied. It also had a distinct lack of playtime—which is industry jargon for the amount of time you get to apply and blend makeup before it dries.

A big switch came in the late nineties with inverse emulsion—so, using water in silicone oil—which gave foundation freshness, a lot of playtime, and a good "slippy" application. Following this, the next step for this type of formulation was the addition of volatile silicone oil for a long-lasting foundation—just as with lipstick.

The breakthrough in long-lasting foundation technology was to combine both silicone oils *and* polymers. This had the effect of creating a flexible mesh-like film on the face. Some of the first foundations to launch using this technology were Revlon ColorStay, Lancôme Teint Idole, and L'Oréal Color Resist. There was still a problem with this type of foundation, though. Some consumers felt that it didn't seem fresh enough, as it could feel very slippery while they waited for the silicone to evaporate (which could take a while). So, again, as with lipstick development, the global cosmetics industry took inspiration from Japanese technology and began mixing more water into foundations, giving them a lighter, fresher feel.

The following generation of foundations, which came out around 2000, was also inspired by Japan and the process used to make primers. These were water in silicone oil emulsions with a high level of water in the solution; they were hard to stabilize, but crucially contained alcohol (this is the main difference). A lot of formulations are now made to this pattern, resulting in thinner and more liquid foundations that have a fresher and lighter texture and feel on the skin but which still cover imperfections and perfect the look of the skin—light-years away from the thick formulas of old.

To date, the latest phase of this technology has been foundation with no water at all (anhydrous). Instead of water, anhydrous foundations contain a lot of alcohol and a lot of volatile silicones, which means that they evaporate very quickly when applied.

Though foundation has evolved a lot, its components haven't changed that much, and the essential emulsion remains. It's by mixing the components differently that you end up with a different product. Really, foundation is all about personal preference, so while the cosmetics industry is always innovating and striving to create the next big thing, it all depends on whether you like using a product that is more water-, alcohol-, or oil-based. That being said, the novelty of the new is always alluring! At the end of the day, whatever effect you like, we've come a long way from the too-greasy or too-dry, thickly painted faces of thirty years ago.

Silicones, polymers, and elastomers—along with pigments— create a flexible, mesh-like finish across the skin in today's foundations, and, in the future, this technology will continue to develop and improve.
Photograph by Irving Penn, © Condé Nast. *Vogue*, September 2012.

Madonna
The Ultimate Makeup Chameleon

The bestselling female recording artist of all time, Madonna is a chameleon and master of reinvention, more so than any other icon, with her ever-changing look having played a crucial part in her ongoing success over the past three decades. As she so famously said, "I am my own experiment. I am my own work of art," or, in the lyrics of "Vogue": "Beauty's where you find it."

Madonna was born Madonna Louise Ciccone in 1958 in a suburb of Detroit. In 1976, she left high school for a dance scholarship at the University of Michigan, but dropped out after a couple of years to move to New York City, where modern dance was really happening. After throwing herself into the club scene, she got her first single deal in 1982. "Holiday," "Borderline," and "Lucky Star" brought her fame, and three years later she was playing Madison Square Garden.

Even Madonna's first iconic makeup look, which complemented the punky styling of multiple bangles and lacey gloves (inspired by eighties downtown stylista Maripol), had an air of the screen goddess about it—albeit in an eighties way. All the hallmarks were there, from the black-winged liner and smudged-out shading line at the socket to the red lips.

Madonna has spoken of the strong influence since childhood of the golden age of film and Hollywood stars, and you can trace this throughout her career. For the video for "Material Girl," she re-created Marilyn Monroe's "Diamonds Are a Girl's Best Friend" look from *Gentlemen Prefer Blondes*; "Express Yourself" was inspired by the silent movie *Metropolis*; and 1990's "Vogue" presented a visual and lyrical homage to the roster of actors who had inspired her, including Marlene Dietrich, Jean Harlow, Carole Lombard, and Rita Hayworth. She's embraced many more looks—almost too many to write about here.

In addition to singing, acting, and following her own style agenda, Madonna is also a published author and a savvy businessperson with multimedia companies.[1]

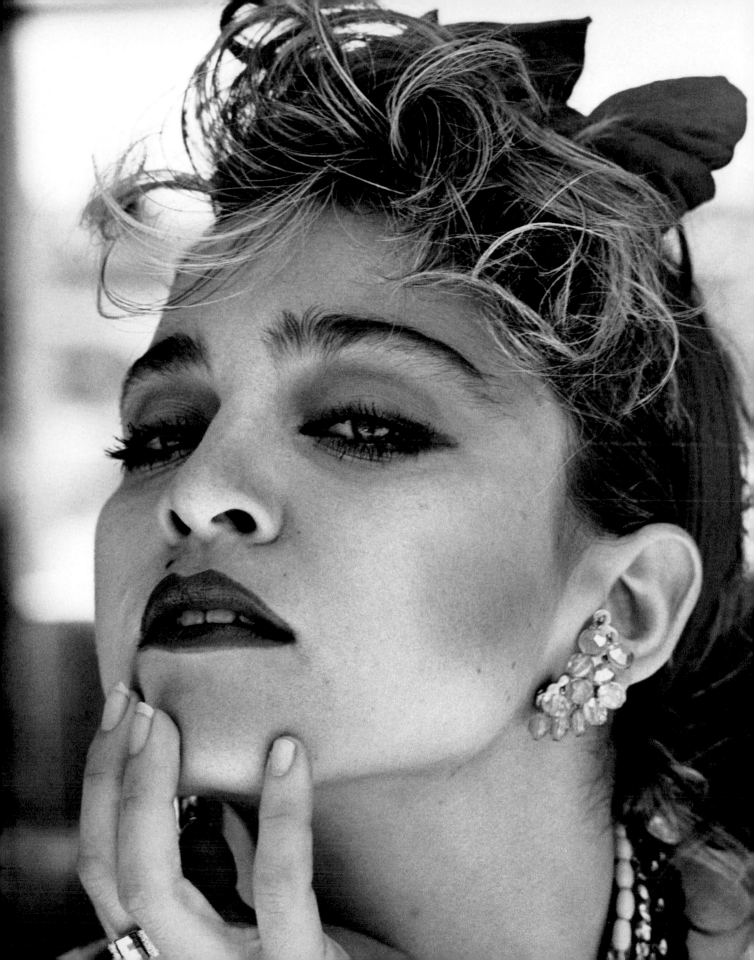

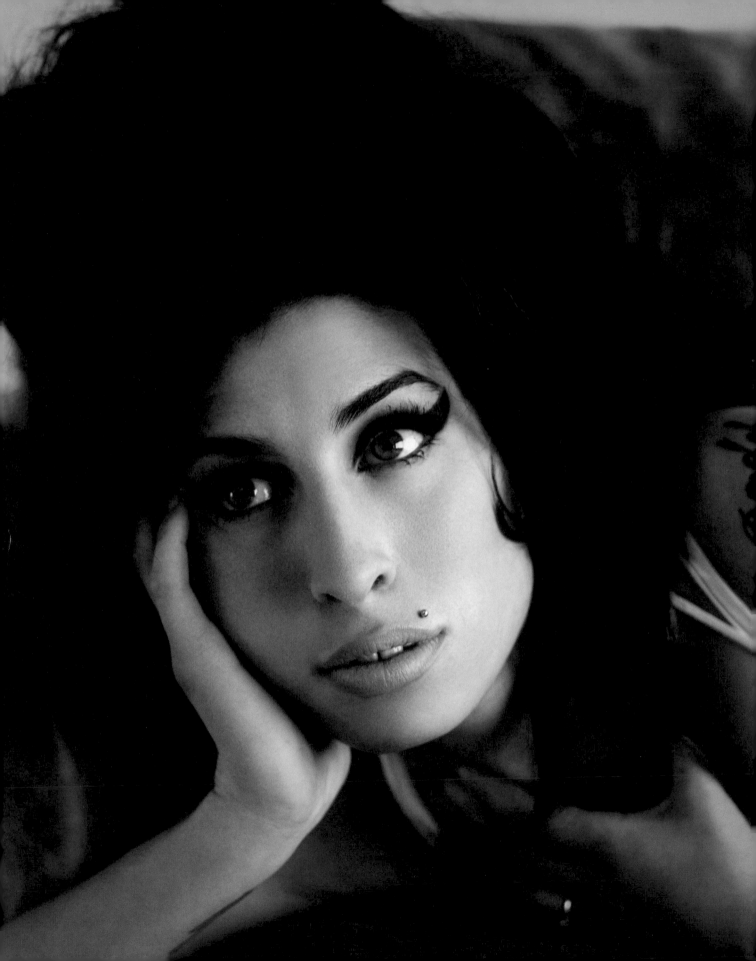

Amy Winehouse

Today's celebrities tend not to hone in on and stick with one particular look. When there are so many choices available, they prefer to chop and change it up according to mood or trend. Talented British singer and songwriter Amy Winehouse was an exception, however, and she had such strong personal style that, next to her distinctive voice, it became her signature. Hanging around Camden in London, an area famous as a magnet for youth culture, Winehouse's identity was a cultural mash-up. Like many of the other icons in this book, the singer was inspired by what had come before her, and there are clear visual references to diverse cultural touchstones such as Cleopatra, Betty Grable, Vargas vixens, and 1960s girl groups like the Ronettes in her pinup-style clothing, infamous beehive hair, and exaggerated makeup.

Winehouse's US makeup artist, Valli O'Reilly, revealed that she designed her own look. She said: "She pretty much had it down with the eyeliner and everything. It was second nature to her . . ." Though her style was strong, it was actually quite simple.

O'Reilly said they'd often have just fifteen minutes to pull it all together. For her retro red lips, she used a creamy Rimmel lip pencil and a lipstick by Uni in China—an intense, retro, matte blue-red that married perfectly with her vintage-inspired look. The thick slashes of flicked eyeliner that were Winehouse's signature were always on there—she was rarely, if ever, seen without them. She liked to use a Rimmel liquid eyeliner with felt-tip applicator, and sometimes she'd use it to draw on a beauty mark, too. Winehouse didn't really need false eyelashes, since her natural ones were thick and long, but her eyebrows were a little bit sparse, so O'Reilly used to fill them in with brow powder to create a more defined, retro shape.

Winehouse died tragically young at the age of twenty-seven, but her influence continues to be felt in popular culture, both among her fans and other celebrities. Lady Gaga created an Instagram homage to her look, and Jean Paul Gaultier paid his respects with a Winehouse-inspired fashion collection in 2012.

expressed this desire through Debbie Harry–style blush and lip gloss or an emo smudged black eye. Whether we want to look like our favorite screen idol, celebrity, model, or singer, we are communicating something about ourselves to the outside world, displaying that we belong to a group.

Somali supermodel and entrepreneur Iman sums it up in her foreword to photographer Art Wolfe's *Tribes*: "From the runway of a haute couture designer to a tribe in the depths of the Brazilian rainforest, we all share in common a basic human desire to present ourselves as something beyond what we are. Our worldly conditions may differ dramatically, but as human beings we are comprised of stock impulses, no matter what our level of industrial revolution."[2] Our gut instinct to look our very best is driven by our primal instincts to reproduce.

The modern-day face of beauty in the cyber age is that of digitally enhanced flawless perfection, from Hollywood A-listers to the filtered and smoothed-out social media photos posted daily by millions of young women all over the world. Technological advances in makeup and beauty products allow us to adjust our skin tone, texture, face shape, and identity with comparative ease. Whether we look to the East or the West, the lines between race, gender, and status are becoming increasingly blurred. There is a move toward a homogenized, globalized beauty ideal, where perfection is more important than individuality.

How many of us even five years ago were regularly priming, sculpting, highlighting and contouring our faces, or faking our lashes à la the latest reality TV star? In historian Madeleine Marsh's view, "the makeup business today is all about the quest for perfection combined with ruthless commerce." A huge contrast to our grandmothers' generation, when popping on a face-brightening slick of lipstick was considered well made up, now a new heightened

level of beauty grooming where ten-plus makeup products on our faces seems expected. Is the fun of creating makeup looks to express ourselves and using makeup to conceal our flaws so we can put our best faces forward being overtaken by the pressure to look absolutely red-carpet picture-perfect 24/7? This pressure seems to be feeding a new kind of narcissism among the selfie generation, with many feeling they need to be flawlessly made up at all times.

"We have to remember that the airbrushed perfection we see on celebrities and flawless Facebook images are not a true representation of life. These looks aren't necessarily achievable on a daily basis," says psychologist Elaine Slater. "There's a wide spectrum when it comes to wearing makeup. Yes, there's the extreme, almost cartoonish flawless look at one end, barefaced at the other. But there is a middle ground of everyday makeup that's about being the best you can be—healthy, radiant, youthful—not about being someone else."

Now it seems the average gal needs to know as much about makeup application as the most accomplished makeup artist to take her application technique to a professional level. Although social media can make us all feel like we have to be "on" at all times, it also has a positive side. YouTube and beauty blogging has opened up a community where we can share information, and beyond the bedroom-vlogger approach, we can see into the world of makeup expertise in a way we couldn't before. I remember seeing the first beauty vloggers and thinking how great it is that young women, who are essentially consumers, are telling it like it is.

No amount of glossy advertising and strategically placed editorial coverage can capture a viewer's imagination like an actual review from someone who is not being paid by the company—though this has recently become skewed as Vloggers accept payment from

> *"Beauty is in the eye of the beholder and it may be necessary from time to time to give a stupid or misinformed beholder a black eye."*
>
> —Miss Piggy

brands to give favorable reviews. Today the most powerful impetus to buy a product is peer-to-peer recommendation on independent beauty forums. The positive reaction to my own tutorials—from women all over the globe, from India to Australia, from teens to those in their fifties and upward—stands testament to this. It also demonstrates and affirms what a bonding and confidence-boosting experience makeup can be. The ritual of makeup application can be relaxing as well as fun.

On a superficial level, most of us don't think about why we do our makeup in a certain way—and there isn't a simple answer to that question. The beauty debate heated up in the early nineties with the publication of Naomi Wolf's *The Beauty Myth*, in which she claimed the wearing of makeup (as well as diets, having plastic surgery, etc.) are a "violent backlash against feminism that used images of female beauty as a political weapon against women's advancement."[3] Later a wave of postmodern feminism put forward less radical thinking. Liz Frost, for example, states in her 1999 paper "Doing Looks" that "makeup can no longer be viewed as an optional extra but rather as a central identificatory process which can offer meanings such as pleasure and creative expression."[4] That we have options seems a more realistic view, as Slater sums up: "Makeup is what you make of it. It is a choice."[5]

Cosmetics can be a means of empowerment, so long as lots of different types of beauty are "acceptable" in society and we don't have to conform to just one ideal as our ancestors in ancient Greece or Renaissance Italy did. "In an ideal world, there isn't just one thing we should be," says Marsh. "There isn't a perfect face or one perfect look. There's paradox at the very heart of every woman's makeup bag, and like all paradoxes, it can't be solved."

I adore makeup. It's creative. It's fun. Whether I'm applying it to my own face or someone else's, I love the fact that you can conceal a temporary blemish on your chin and immediately feel more confident—a touch of blush to feel healthier and a coat of mascara to look and feel wide awake. As the saying goes: look better; feel better. I personally like to have makeup-free days when the world has to accept me as I am. Other times a bold red mouth is the order of the day, just for the hell of it. If you need to be strong and powerful, a stripe of war paint may just give you the edge. Some women wear none, some wear a little, and others apply a full face on the train to work each morning. In many parts of the world, we've come a long way.

Ultimately, nothing empowers a woman more than the right to a good education, and the freedom to choose whether to wear a red lip and smoky eye . . . or not.

ACKNOWLEDGMENTS

There are so many people to thank that I don't know were to start; suffice to say it's taken an army. I was rather naive at the outset believing I could do most of the research with the help of just one friend. What was I thinking?! The more I did, the more it became clear what a mammoth job was ahead of me. Every bit of research opened another area to explore and more evidence to validate. I want to thank all the academics, archeologists, scientists, historians, artists, and psychologists whose books and papers I have read over the past twenty years and whose words may not have made it into this book, but who have influenced and inspired me. I also want to thank my agent Janelle Andrew at Peters Fraser & Dunlop for her infectious enthusiasm and encouragement, as it was she—having been a fan of my website, and particularly my posts about the history of makeup—who managed to convince me that I was capable of turning a personal passion into a volume that others would want to read. Thanks also go to my calm and patient editor David Cashion and all the team at Abrams Books in New York for giving me this wonderful opportunity and for allowing me to approach it in my own way. Massive thanks go to Nikki McClarron for being a great picture editor and a lovely, smiley face to work with; I truly value all the hard work and long hours she put in to make my (visual) dreams come true. Likewise to Muffie Jane Sproat for the additional picture research, support, and great ideas. Huge, huge appreciation goes to Jacqueline Spicer for generously allowing me access to her thesis and the precious work she is doing on renaissance makeup, cosmetics, and *Gli Experimenti*. Big hugs and kisses to the visionary historian Madeleine Marsh for inspiring me with her energy and for letting me borrow and photograph some of her fabulous vintage makeup collection for this book. Behind every busy woman there's an entire network of amazing women to acknowledge and they include Karena Callen, Catherine Turner, and Sophie Missing for all the advice, extra research, and editorial support; my good friends Sophia and Debora, and my mum, for listening to me moan during the darkest moments of this long process; and my beautiful right-hand girls Jessie Richardson and Joy Ayles for helping me make the time to complete this book (and for just being generally fantastic—you rock!). For their youthful enthusiasm and exceptional hard work, I am grateful to Josh Dell and Rebekah Blankenship for helping me with the nitty-gritty research and for giving up part of their summer breaks to do so. Also, my thanks go to the British Museum for entertaining my requests and sending so much information. Immense gratitude is owed to Jo Mottershead and Spring Studios London for allowing me generous use of their staff and all their facilities on two occasions. Thank you to the Condé Nast Archive—and particularly Brett Croft and Harriet Wilson—for allowing me to take root in their Aladdin's cave of a library; I had so much fun reading through all the beautiful, original copies of *Vogue* and photocopying my research.

I want to express my appreciation to Robin Muir for the cool chat and insight into early magazines. I'm extremely grateful to all the wonderful brands who helped me get all my ducks in a row, particularly Frédéric Bourdelier, Brand Culture and Heritage Manager at Christian Dior, for making me feel so welcome and for spending so much time with me. Also, a huge thank you to super woman and head scientist at L'Oréal Luxe Makeup Labs, Doctor Veronique Roulier, and to GEKA Manufacturing Corporation for giving up their time to help me. Humble thanks are owed to Marlene Dietrich's grandson, Peter Riva, for talking to me about his grandmother and enabling me to write an insightful and accurate account of her makeup routine, foibles, and great character. In addition, I'm indebted to makeup artist extraordinaire Valli O'Reilly for her time and knowledge .

To bring my words to life, I needed images and I am very grateful to Cuneyt Akeroglu for being so supportive and enthusiastic about this project and for shooting a great cover. A huge debt of gratitude goes to all the photographers and picture agencies involved for their generosity and time: Solve Sundsbo, Liz Collins, Irving Penn Foundation, Richard Avedon Foundation, Condé Nast Archives, Trunk Archive, Matt Moneypenny, Mert Alas and Marcus Piggot, Art + Commerce, Art Partner, Getty Images, Corbis Images, Bridgeman Library, Mary Evans Picture Library, Richard Burbridge, Advertising Archives, Michael Baumgarten, Raymond Meier, Serge Lutens, Mario Sorrenti, Patrick Demarchelier and special thanks to David Edwards for creating the icing on the cake in the shape of the wonderful still life shots of vintage makeup that appear throughout the book.

I also want to sincerely thank all the readers, fans, and followers of my website and videos; thanks for letting me geek out about ancient powder compacts, musty old lipsticks, vintage tales of beauty, and for letting me know I wasn't alone in my obsession.

Last but not least, my brilliant and lovely husband Robin. When I first announced I was thinking of doing a book he cautioned that books were "a test of endurance" and "a nightmare." I thought you were just being negative, but once I found myself deep in this process, I had to admit that (for once) you were right. Thank you for holding my hand and helping me so much throughout this two-year endurance test and for making the book look exactly as I hoped it would. I couldn't have done it without you. Thanks also to our two wonderful boys, George and Luke, for just being great.

ENDNOTES

Prologue

1 http://www.fda.gov/
Cosmetics/GuidanceReg-
ulation/LawsRegulations/
ucm074201.htm [FD&C Act,
sec. 201(i)]

Red

1 Nancy Etcoff, *Survival of
the Prettiest: The Science of
Beauty* (New York: Anchor
Books, 2000), 107-108.

2 Sally Pointer, *The Artifice
of Beauty: A History and
Practical Guide to Perfume
and Cosmetics* (Sutton
Publishing, 2005), 19.

3 Etcoff, *Survival of the Pret-
tiest,* 101.

4 Malcolm Kirk, *Man As Art:
New Guinea,* (New York:
The Viking Press, 1981), 21.

5 Prof. Hamed Abdel-reheem
Ead, "Cosmetics in Ancient
Egypt," http://www.levity.
com/alchemy/islam23.htm
(accessed 25 Jan 2015).

6 Monica H. Green, ed.,
*The Trotula: An English
Translation of the Medieval
Compendium of Women's
Medicine* (Philadelphia:
University of Pennsylvania
Press, 2002), 120.

7 Lionel Casson, *Everyday
Life in Ancient Egypt*
(Baltimore: John Hopkins
University Press, 2001), 32.

and Robin Gay, *Women in
Ancient Egypt* (Cambridge:
Harvard University Press,
1993), 129–135.

8 Farmanfarmaian, Fatema
Soudavar, "'Haft Qalam
Arayish': Cosmetics in the
Iranian World." *Iranian
Studies* 33 (Summer-Au-
tumn 2000): 285-326.

9 Aristotle, Aristotle in 23 Vol-
umes, Vol. 21, translated by
H. Rackham. (Cambridge,
MA, Harvard University
Press; London, William
Heinemann Ltd. 1944),
section 1254b.

10 Matthew Dillon and Lynda
Garland, *The Ancient
Greeks: History and Culture
from Archaic Times to the
Death of Alexander,* (New
York: Routledge, 2013), 144.

11 Mary Eaverly, *Tan Men/
Pale Women: Color and
Gender in Archaic Greece
and Egypt, A Comparative
Approach* (Ann Arbor: Uni-
versity of Michigan Press,
2013), 128.

12 Xenophon, *The Shorter Soc-
ratic Writings,* ed. Robert
C. Bartlett, *Oeconomicus*
trans. Carnes Lord (Cornell
University, 1996), 72.

13 Parody and Subversion
in Ovid's "Medicamina
Faciei Femineae," Patricia

A. Watson, Mnemosyne,
Fourth Series, Vol. 54, Fasc.
4 (Aug, 2001), 457–71.

14 *The Love Books of Ovid
Being the Amores, Ars
Amatoria, Remedia Amoris
and Medicamina Faciei
Femineae of Publius Ovid-
ius Naso,* 154.

15 John Donne, *Juvenilia: Or
Certain Paradoxes and
Problems* (1633).

16 St. Cyprian (ed. The Rev.
Alexander Roberts, D., and
James Donaldson, LL.D.,)
"On The Dress of Virgins,"
in *The Ante-Nicene Fathers,
Translations of The Writings
of the Fathers down to A.D.
325,* Revised and Chrono-
logically Arranged, with
Brief Prefaces and Occa-
sional Notes, by A. Cleve-
land Coxe, D.D., (Volume V)
(Authorized Edition) (T&T
Clark, 1995,) 434.

17 Georg Brandes, "Shylock:
a monster of passionate
hatred, not avarice," *Shake-
speare: The Critical Edition:
The Merchant of Venice,* ed.
William Baker and Brian
Vickers.

18 House of Commons Journal
Volume 6: 7 June 1650, in
*Journal of the House of
Commons*: Volume 6, 1648-
1651 (London: His Majesty's

Stationery Office, 1802),
420–22.

19 Pointer, *The Artifice of
Beauty,* 102.

20 Morag Martin, *Selling
Beauty: Cosmetics, Com-
merce, and French Society,
1750–1830* (Baltimore:
Johns Hopkins University
Press, 2009), 27.

21 Melissa Hyde, *Making
Up the Rococo: François
Boucher and His Critics* (Los
Angeles: Getty Research
Institute, 2006), 87.

22 Richard Corson, *Fashions
in Makeup: from Ancient
to Modern Times* (London:
Peter Owen Publishers,
2004), 249.

23 Max Beerbohm, "A defence
of cosmetics" (New York:
Dodd, Mead, and company,
1922), 4-5.

24 Antonia Fraser, *Marie Antoi-
nette: The Journey* (New
York: Anchor Books, 2012),
36–37.

25 Madame Campan, *Memoirs
of the Court of Marie Antoi-
nette* (Middlesex: Echo
Library, 2007), 139.

26 Fraser, *Marie Antoinette,*
145.

27 Campan, *Memoirs,* 63.

28 Fraser, *Marie Antoinette,* 93.

29 Caroline Weber, *Queen
of Fashion: What Marie*

Antoinette Wore to the Revolution (New York: Picador, 2007), 66.

30 Ibid., 63.

31 Ibid., 73–74.

32 Fraser, *Marie Antoinette*, 266.

33 Ibid., 528.

White

1 Etcoff, *Survival of the Prettiest*, 105.

2 Sarah B. Pomeroy, *Spartan Women* (Oxford University Press, 2002), 131–4.

3 Ovid, "The Art of Beauty," in *The Art of Love and other Love Books of Ovid* (New York: The Universal Library, 1959), 231.

4 Corson, *Fashions in Makeup*, 54–5.

5 Lopez E., Le Faou A., Borzeix S., Berland S., "Stimulation of rat cutaneous fibroblasts and their synthetic activity by implants of powdered nacre [mother of pearl]," *Tissue Cell* 32 (February 2000): 95–101.

6 Green, *The Trotula*, 75.

7 Clement of Alexandria, *Paedagogus*, Book 3 Chapter 2.

8 Jacqueline Spicer, *Painted Breasts and Shamefast Blushes: Contextualising Cosmetics in Caterina Sforza's Gli Experimenti* (2010), M.S.c. Thesis, University of Edinburgh, UK, 20.

9 Annette Drew-Bear, "Face-Painting Scenes in Ben Jonson's Plays," *Studies in Philology* Vol. 77, No. 4 (University of North Carolina Press, 1980), 397.

10 George Bate, *Pharmacopoeia Bateana, or, Bate's dispensatory translated from the second edition of the Latin copy, published by Mr. James Shipton*, London, 1694.

11 Ibid.

12 Farah Karim-Cooper, *Cosmetics in Shakespearean and Renaissance Drama* (Edinburgh: Edinburgh University Press, 2012), 11.

13 Green, *The Trotula*, 139.

14 Thomas Tuke, *A Treatise against Painting and Tincturing of Men and Women* (London : Printed by Tho. Creed, and Barn. Allsope, for Edward Merchant dwelling in Pauls Church-yard, neere the Crosse, 1616).

15 Giovanni Lomazzo, *A Tracte Containing the Artes of Curious Paintinge, Carvinge and Buildinge* (Oxford: By Ioseph Barnes for R.H., 1598).

16 Corson, *Fashions in Makeup*, 324–25.

17 Lucinda Hawksley, *Lizzie Siddal: The Tragedy of a Pre-Raphaelite Supermodel* (London: Andre Deutsch, 2009), 113.

18 Ibid., 23.

19 Ibid., 42–43.

20 Ibid., 83.

21 Jan Marsh, *The Legend of Elizabeth Siddal*, (London: Quartet Books, 1989), 59.

22 Sarah Jane Downing, *Beauty and Cosmetics 1550–1950* (Oxford: Shire Library, 2012), 35.

23 Anna Krugovoy Silver, *Victorian Literature and the Anorexic Body* (Cambridge: Cambridge University Press, 2002), 12.

24 Marsh, *The Legend of Elizabeth Siddal*, 27–28.

Black

1 King James Bible, Matthew 6:22.

2 Henry Misson, *M. Misson's Memoirs and Observations in his Travels over England. With Some Account of Scotland and Ireland. Dispos'd in Alphabetical Order. Written originally in French*, trans. Mr. Ozell (London: Printed for D. Browne, 1719), 214.

3 "Wooden cosmetic pot of Ahmose of Peniati," British Museum digital record, https://www.britishmuseum.org/explore/highlights/highlight_objects/aes/w/wooden_cosmetic_pot_of_ahmose.aspx.

4 *Analytical Chemistry*, January 15, 2010 (American Chemical Society).

5 Corson, *Fashions in Makeup*, and Doug Stewart, "*Eternal Egypt*" (Smithsonian, June 2001).

6 Ivan Morris, *The World of the Shining Prince: Court Life in Ancient Japan* (New York, Tokyo, and London: Kodansha International, 1994), 204.

7 Fatema Soudavar Farmanfarmaian, "Haft Qalam Arayish: Cosmetics in the Iranian World,", *Iranian Studies*, 33 no. 3/4 (2000), 285–326.

8 Carolyn Graves-Brown, *Dancing For Hathor: Women in Ancient Egypt* (London: Continuum, 2010), 70.

9 Vinod Mehta, *Meena Kumari: The Classic Biography* (India: HarperCollins, 2013), 45.

10 Ginette Vincendeau, *Brigitte Bardot*, (London: Plagrave Macmillian, 2013), 54.

11 "1929–1940 Life and Career," Audrey Hepburn's Official Site, http://www.audreyhepburn.com/menu/index.php?idMenu=61&pg=1.

12 "1940–1948 Life and Career," Audrey Hepburn's Official Site, http://www.audreyhepburn.com/menu/index.php?idMenu=50&pg=0.

13 Alexander Walker, "Hepburn, Audrey (1929–1993)," Oxford Dictionary of National Biography, Oxford University Press, 2004; online edn, Jan 2008 <http://www.oxforddnb.com/view/printable/52107> accessed 9 Nov 2014.

14 Lloyd Shearer, "Makeup Tips from Europe's Most Famous Makeup Man," *Reading Eagle,* June 5 1966, 12.

Media and Motivation

1 Jeremy Taylor, *A Discourse of Auxiliary Beauty or Artificiall Handsomenesse In Point of Conscience between Two Ladies* (Printed for R: Royston, at the Angel in Ivie-Lane, 1656), 48.

2 Marjori Ferguson, *Forever Feminine: Women's Magazines and the Cult of Femininity* (Exeter, NH: Heinemann Educational Books, 1983), 99.

3 Ferguson, *Forever Feminine*, 15–16.

4 "Billie Burke, Sweetest, Highest Paid Actress of the Day, to Write Exclusively For You," *The Day Book* (Chicago), June 10, 1912.

5 Kathy Peiss, *Hope in a Jar: The Making of America's Beauty Culture* (Philadelphia: University of Pennsylvania Press: 2011), 47.

6 Annette Kuhn, *An Everyday Magic: Cinema and Cultural Memory* (London: I.B. Tauris Publishers, 2002), 110.

7 Sarah Berry, *Screen Style*, quoted from Madame Sylvia, "If You Would Have Figure Like Harlow," *Modern Screen* (November 1935), 22.

8 Carol Van Wyck, "New Tricks for the New Year," *Photoplay* (January 1937), 60.

9 "Eye Makeup Styles for Types" in "Beauty Shop," *Photoplay* (April 1933), 71.

10 "Famous Eyebrows" in "Beauty Shop," *Photoplay* (April 1934), 84–85.

11 Van Wyck, "New Tricks for the New Year," 60.

12 Hollywood Max Factor Color Harmony advertisement in *Modern Screen* (April 1938), 79.

13 Hollywood Max Factor Color Harmony advertisement in *Photoplay* (January 1934), 109.

14 Ronald Genini, *Theda Bara: A Biography of the Silent Screen Vamp, with a Filmography* (McFarland and Co., 2012), 16.

15 Helena Rubinstein, *My Life for Beauty* (New York: Simon & Schuster, 1966), 48.

16 David Stenn, *Clara Bow: Runnin' Wild* (New York: Cooper Square Press, 2000), 21.

17 Ibid., 277.

18 Barry Paris, *Garbo*

(Minneapolis: University of Minnesota Press, 2002), 229.

The Beauty Pioneers

1 Geoffrey Jones, *Beauty Imagined: A History of the Global Beauty Industry* (Oxford: Oxford University Press, 2010), 137.

2 Frank Westmore and Muriel Davidson, *The Westmores of Hollywood* (Philadelphia: J.B. Lippincott Company, 1976), 104.

3 Fred Basten, with Robert Salvatore and Paul Kaufman, *Max Factor's Hollywood: Glamour, Movies, Make-up* (Santa Monica, CA: General Publishing Group, 1995), 17.

4 Fred Basten, *Max Factor: The Man Who Changed the Faces of the World* (New York: Arcade Publishing, 2012), 25–27.

5 Ibid., 37.

6 Basten, *Max Factor's Hollywood*, 126–131.

7 "Max Factor Chronology" from Max Factor PR.

8 Basten, *Max Factor's Hollywood*, 157.

9 Michèle Fitoussi, *Helena Rubinstein: The Woman Who Invented Beauty*, trans. Kate Bignold and Lakshmi Ramakrishnan Iyer (London: Gallic Books, 2013), 30.

10 Ibid., 38–40.

11 Lindy Woodhead, *War Paint: Madame Helena Rubinstein and Elizabeth Arden—Their Lives, Their Times, Their Rivalry* (London: Virago, 2003), 33.

12 Ibid., 48.

13 Mark Tungate, *Branded*

Beauty: How Marketing Changed the Way We Look (London: Kogan Page, 2011), 21

14 Lindy Woodhead, *War Paint: Helena Rubinstein and Miss Elizabeth Arden, Their Lives, Their Times, Their Rivalry* (London: Virago, 2003), 57.

15 Lewis, *An Unretouched Portrait*, 52.

16 Woodhead, *War Paint*, 59.

17 Ibid., 145.

18 Ibid., 146.

19 Ibid., 279-80.

20 Ibid., 210.

21 Ibid., 211.

22 Mary Tannen, "When Charlie Met Estée," *New York Times*, February 24, 2002, http://www.nytimes.com/2002/02/24/magazine/when-charlie-met-estee.html

23 Andrew Tobias, *Fire and Ice: The Story of Charles Revson, the Man Who Built the Revlon Empire* (New York: William Morrow, 1976), 63.

24 Woodhead, *War Paint*, 258.

25 Tobias, *Fire and Ice*, 148.

26 Woodhead, *War Paint*, 422.

27 Jones, *Beauty Imagined*, 163.

28 Tannen, "When Charlie Met Estée."

29 Jones, *Beauty Imagined*, 163

30 Westmore and Davidson, *The Westmores of Hollywood*, 69–70.

31 Lois Banner, *Marilyn: The Passion and the Paradox* (London: Bloomsbury, 2012), 38.

32 Ibid., 118–19.

33 Dennis Hopper, "The Society of Models:

Conversations with Lauren Hutton, Christy Turlington, Kate Moss and Naomi Campbell." *Grand Street*, no. 50, Autumn 1994, 136.

34 Derek Blasberg, "Lauren Hutton: The Wild One," *Harper's Bazaar*, January 13, 2011, http://www.harpersbazaar.com/celebrity/news/lauren-hutton-interview-0211.

35 Jenna Lyons, "The Inconoclast: Lauren Hutton," *Interview*, http://www.interviewmagazine.com/culture/lauren-hutton.

36 Blasberg, "Lauren Hutton."

37 Lyons, "The Iconoclast."

38 Blasberg, "Lauren Hutton."

39 Alex Simon, "Lauren Hutton: No Nip/Tuck Required," *Venice*, November 2007, http://thehollywoodinterview.blogspot.com/2008/02/lauren-hutton-hollywood-interview.html.

History in Your Handbag

1 Teresa Riordan, Inventing Beauty: A History of the Innovations That Have Made Us Beautiful (New York: Broadway Books, 2004), 17.

2 Ibid., 7.

3 "Cosmetics timeline," Cosmetics and Skin website, http://www.cosmeticsandskin.com/cosmetic-timeline.php.

4 "Maybelline," Cosmetics and Skin website, http://www.cosmeticsandskin.com/companies/maybelline.php.

5 Ibid.

6 "1950 Eyes," *Life*, January 30 1950, No author credited, p63-64 and 66.

7 "Revlon," Cosmetics and Skin website, http://www.cosmeticsandskin.com/companies/revlon.php.

8 Corson, *Fashions in Makeup*, 544.

9 "The new Cleopatra Look as only Revlon does it! (1962)," The Makeup Museum, http://www.makeupmuseum.org/.a/6a00e553d45a2a8833019aff1cbf0f970d-pi.

10 "Mermaid Eyes by Max Factor Advertisement," *Life*, June 1 1962, 8.

11 "Eyes Speak: The Soft Look by Max Factor Advertisement," Flickr, https://www.flickr.com/photos/icahu-acream/3268882631/in/pool-60sbeautyproducts.

12 Corson, *Fashions in Makeup*, 568, 584.

13 Riordan, *Inventing Beauty*, 207.

14 Madeleine Marsh, *Compacts and Cosmetics: Beauty from Victorian Times to the Present Day* (South Yorkshire: Pen and Sword, 2014), 136.

15 Tungate, *Branded Beauty*, 17–18.

16 Jones, *Beauty Imagined*, 102.

17 Marsh, *Compacts and Cosmetics*, 86.

18 Ibid., 142.

19 Ibid., 172.

20 Sophie Wilkinson, "A Short History of Tanning," *Guardian*, February 19, 2012, http://www.theguardian.com/commentisfree/2012/feb/19/history-of-tanning.

21 *Vogue*, June 1929, 94.

22 Eva Wiseman, "Tanning trends: beyond the pale," *Guardian*, August 7, 2010, http://www.theguardian.com/lifeandstyle/2010/aug/08/fake-tan-pale-skin-celebrities.

23 Marsh, *Compacts and Cosmetics*, 37.

24 Anna Chesters, "A brief history of Guerlain," *Guardian*, March 26, 2012, http://www.theguardian.com/fashion/fashion-blog/2012/mar/26/brief-history-guerlain.

25 Anna Chesters, "A brief history of Lancôme," *Guardian*, March 19, 2012, http://www.theguardian.com/fashion/fashion-blog/2012/mar/19/brief-history-lancome.

26 Tungate, *Branded Beauty*, 66.

27 Marsh, *Compacts and Cosmetics*, 93.

28 Tungate, *Branded Beauty*, 57.

29 Linda Watson, "Shu Uemura: Creator of a global cosmetics brand," *Independent*, February 27, 2008, http://www.independent.co.uk/news/obituaries/shu-uemura-creator-of-a-global-cosmetics-brand-787839.html.

30 "The Path of Beauty," Shu Uemura website, http://www.shuuemura-usa.com/the-path-of-beauty/discover-the-path-of-beauty,default,sc.html.

31 Bobbi Brown, "How I Did It: Bobbi Brown, Founder and CEO, Bobbi Brown Cosmetics," *Inc.*, November 1, 2007, http://www.inc.com/magazine/20071101/how-i-did-it-bobbi-brown-founder-and-ceo-bobbi-brown.html.

32 Jan Masters, "Meet François Nars—the make-up mogul," *Telegraph*, October 7, 2007, http://fashion.telegraph.co.uk/news-features/TMG3361706/Meet-Francois-Nars-the-makeup-mogul.html.

33 "Twiggy," interview by Sue Lawley, *Desert Island Discs* (London: BBC Radio 4), January 13, 1989.

34 "Twiggy's beauty secrets: Eyes and lips," *Daily Mail Online*, September 20, 2008, http://www.dailymail.co.uk/home/you/article-1056252/Twiggys-beauty-secrets-eyes-lips.html#ixzz3Hdx8RGtg.

35 "Artificial (False) Eyelashes," *Cosmetics and Skin* website, http://www.cosmeticsandskin.com/cdc/false-eyelashes.php. and "An Interview with Barry Discussing Twiggy," by Barry Lategan, http://www.barrylategan.com/Twiggy.html.

36 Michael Kors, "Michael Kors Talks to Dame Elizabeth Taylor," *Harper's Bazaar*, March 23, 2011, http://www.harpersbazaar.com/celebrity/news/elizabeth-taylor-jewelry-hair.

37 Bob McCann, *Encyclopedia of African American Actresses in Film and Television* (Jefferson, NC: MacFarland, 2009), 184.

38 Miranda Sawyer, "State of Grace," *Guardian*, October 10, 2008, http://www.theguardian.com/music/2008/oct/12/grace-jones-hurricane.

39 *Queens of Disco*, directed by Jeff Simpson (BBC: March 6, 2007).

40 Simon Hattenstone, "Grace Jones: 'God I'm scary. I'm scaring myself,'" *Guardian*, April 17, 2010, http://www.theguardian.com/music/2010/apr/17/grace-jones-interview.

The Bleeding Edge

1 Madonna's website, "MDNA SKIN Launches in Japan On February 12," http://www.madonna.com/news/title/mdna-skin-launches-in-japan-on-february-12.

Afterword

1 Malcolm Kirk, *Man as Art* (San Francisco: Chronicle Books, 1993), 16.

2 Art Wolfe, *Tribes*, (London: Thames and Hudson Ltd, 1997), 19.

3 Spicer, Painted Breasts and Shamefast Blushes, Quoted from Art Wolfe's *Tribes*, 8.

4 Spicer, Painted Breasts and Shamefast Blushes, Quoted from Liz Frost's '"Doing Looks": Women, Appearance and Mental Health' in Women's Bodies: discipline and transgression. (London, Cassell): 117-137, 10.

5 Quote direct from Elaine Slater.

PHOTO AND ILLUSTRATION CREDITS

All product shots, unless otherwise noted, are photographed by David Edwards.

INDEX

Page references in *italics* refer to illustrations.

ABOUT THE AUTHOR

Lisa Eldridge is one of the most respected and experienced makeup artists in the industry. The list of celebrities she has made up reads like a who's who of the world's most glamorous women, including Kate Winslet, Katy Perry, Keira Knightley, and Emma Watson. With over twenty years in the business, her expertise and consultation have been used across all media platforms, from popular television programs to journalism in leading fashion magazines and newspapers. Eldridge was one of the first top celebrity makeup artists to launch how-to video tutorials and did so on her exceptionally popular website. She maintains a high editorial profile working with many of the best fashion photographers, including Mert & Marcus, Sølve Sundsbø, Peter Lindbergh, and Patrick Demarchelier. With hundreds of glossy covers in Eldridge's portfolio, many of the most prestigious fashion houses and beauty brands have sought her knowledge, artistry, and collaboration on their advertising campaigns and fashion shows, among them Chloe, Alberta Ferretti, and Prada. Currently working as the Global Creative Director of Lancôme, she also developed a makeup range with the Japanese cosmetics giant Shiseido. Having previously lived and worked in Paris, New York, and Los Angeles, Eldridge is now based in London.

For more information, visit www.lisaeldridge.com